Insider's Guide

How and Where to Photograph Birds in Southern Africa

Isak Pretorius

JACANA

Published by Jacana Media (Pty) Ltd in 2014
Second and third impression 2015
Fourth impression 2016
Fifth impression 2017

10 Orange Street
Sunnyside
Auckland Park 2092
South Africa

+2711 628 3200

www.jacana.co.za

ISBN 978-1-4314-0930-3

Design by Shawn Paikin
Set in Sabon 9.5/13pt
Job No. 002723
Printed and bound by Creda Communications

Also available as an e-book:
d-PDF ISBN 978-1-4314-0931-0

See a complete list of Jacana titles at www.jacana.co.za

Contents

Acknowledgements ... vii

Foreword by Shem Compion .. viii

Preface .. x

1 **Choosing the right equipment** .. 1

 Introduction .. 2

 What's in Isak's bag? ... 4

 Cameras ... 6

 Lenses .. 23

 Support systems .. 35

 Other accessories .. 45

2 **Different modes for different applications** 51

 Introduction .. 52

 Aperture ... 55

 Shutter speed ... 62

 ISO ... 67

 Triangle of exposure: aperture vs shutter speed vs ISO 72

 Creative modes .. 76

 RAW vs JPEG ... 86

 White balance .. 89

3 **Making good exposures** ... 93

 Introduction .. 94

 Metering ... 96

 Exposure compensation .. 102

Histogram.. 106

Flash... 112

4 How light affects photography **119**

Introduction... 120

Colour and quality of light.................................... 124

Direction of light... 140

5 How to make sharp images **155**

Introduction... 156

Focus point selection ... 159

Focus drive ... 167

Support system... 170

Focus and recompose technique 173

6 Designing your images **177**

Introduction... 178

General guidelines .. 180

Action and birds in flight 210

Bird portraits .. 215

Compositional sins .. 219

7 Getting up close to your subject **227**

Introduction... 228

Get to the bird's level.. 232

Get close on foot.. 239

Get close in a vehicle .. 242

Get close by boat.. 246

Get close in a hide ... 247

The thinking photographer 250

8 Capturing bird behaviour 255
 Introduction 256
 Setting the camera for action 260
 Learning behaviour 280
 Technique 287

9 Bird photography hotspots 301
 Introduction 302
 Kruger National Park in South Africa 305
 Marievale Bird Sanctuary in South Africa 310
 Giant's Castle in South Africa 316
 Kgalagadi Transfrontier Park on the border of
 South Africa and Botswana 321
 Okavango River in Botswana 326
 Okavango Delta in Botswana 332
 Chobe River in Namibia 338
 Bird Island in the Seychelles 343
 Other hotspots 349

10 Different settings for different shots 353
 Introduction 354
 The process of bird photography 360

Glossary 362

About the author 370

To my parents Hannes and Alta Pretorius:

You showed me the beauty of nature and shaped my journey to live my passion.

Acknowledgements

When I think back to my journey from childhood to engineer and to finally a professional wildlife photographer, I can't help but notice how I've met the right people at the right time. People that have shared in my passion and others who facilitated the changes I had to go through in order to live my dream. This journey was too perfect for it not to have been meant.

To my family, Hannes, Alta, Gerda and Petro, thank you for your support and shared experiences in nature.

Thank you to Hedrus van der Merwe from Outdoorphoto who noticed a passion and got me to buy my first lens.

To my good friend and colleague Shem Compion, thank you for inspiration and for inviting me to the C4 family.

Thank you to everyone with whom I've shared countless hours in a hide, next to a dam or a vehicle, pointing our lenses at anything that might fly. You have played an integral role during my initial journey: Wim van den Heever, Verena Ludemann, Dave Barnes, Margo Coetzee, Kobus Tollig, Amelia Vermaak, Johan van Graan, Dion Lifton, Eric Landsberg, Geurt Bloem, Andre Cloete, Martin Harvey, Johan Mader, Judith Gawehn, Go Yamagata and Joey Nel.

Thank you to the Jacana team, in particular to Carol Broomhall, for your patience and for making this book possible.

To Liz Hart, finding you has completed the circle for me where I can live and enjoy my passion indefinitely with my soul mate. Your constant support and encouragement is the foundation of my dreams. Thank you.

Foreword

Bird photographers are a unique group of people. They are even more unique than their cousins, bird watchers, who often go to inordinate lengths in search of new bird species. Bird photographers love their subject, but they are more focused than bird watchers and it is this difference, I believe, that makes them so unique. Only once you start observing a bird and trying to capture the small intricacies of its beauty, do you really begin to appreciate the value of decent cameras and lenses. The camera equipment is just peripheral though, as birds offer a whole host of ways to be photographed, and each different aspect of light, composition and angle can make for a compelling image. The issue, however, is the broad distance between observing a bird and making a beautiful image of it.

Isak Pretorius's reputation as a bird photographer began when he started publishing images of common bird species in very creative scenes. Even before I met Isak in 2007, I had seen his inventive and technically perfect images, recognising that he was a 'name to watch' in the photographic industry. Since then Isak has risen to become one of the most proficient bird photographers in the world. He has diversified to also photographing mammals, but when he received the coveted 'overall winner of the bird's category' in the BBC Wildlife Photographer of the Year Award in 2013, it was officially confirmed that birds are Isak's speciality!

I have worked with Isak on many occasions on safari and watched him teach photography to people. He has a clear and precise manner of teaching, which enables him to get complex techniques across quite simply. Combined with his talent for also getting excellent bird photographs, Isak falls into that small sphere of people who can teach as well as they can photograph. If ever there was someone who can show you the intricacies of bird photography, then Isak Pretorius is that

person. This book narrows that distance between observing a bird and taking a great picture by explaining in clear and legible manner how to go about capturing amazing bird photographs.

By reading *Insider's Guide to Bird Photography in Southern Africa*, not only will you learn a great deal, and not only will your photographs improve immeasurably, but you will also gain invaluable insight into what drives a great bird photographer. That in itself is enough reason to buy the book.

Shem Compion
Wildlife photographer, author,
founder of C4 Images and Safaris

Preface

It is not difficult to understand why bird photography is one of the fastest growing pastimes in the world and the most popular genre in nature photography. Birds are everywhere. They have the most beautiful colours; they vary in shapes and sizes; they are fascinating and are always doing something entertaining; they can fly; and with your careful consideration of light and positioning for angle you can make even the dullest little brown bird look strikingly beautiful. Anyone can do it. Whether you are old or young, male or female, or live in Johannesburg or in the middle of the Kalahari, this hobby is not limited to anyone.

Our passion as bird photographers is to create beautiful pieces of art as an expression of our own creativity and a way for us to have an intimate experience of nature. It's almost as if we have an obligation towards the birds to make them look as beautiful as we can. This passion is what makes us get up early on Saturday mornings to be at a bird hide before sunrise, sell our cars to buy long lenses, and sit in the hot sun and wait for hours for a bird to take off from a perch to capture it in its most beautiful posture. This is something that other photographers don't seem to understand. It's not about just photographing another 'bird on a stick' or a 'record shot'. We have an unquenchable desire to continuously create more stunning and striking images. A bird against a great backdrop with perfect front lighting is a good representation of how striking it is, but if you can photograph it taking off in a stunning posture, large in your frame, then that has *real impact*!

Like all genres of photography, you have to apply creativity and have technical knowhow of camera settings to get the shot that you envisage. Small birds in action will probably be the fastest moving subjects you'll ever photograph – and that requires great hand–eye coordination. For

great bird photographs you also need to know your subject's behaviour and apply all manner of skills to get close to them. And then you have to be there at the right time in the best light. As if that's not challenging enough, this pastime involves the heaviest and most expensive camera equipment on the market. So when you finally get that great photograph with the bird in a stunning display of colour and behaviour, then you not only feel a great sense of achievement, but you also feel ready for the next challenge ... the next photo, the next bird and the next destination in an endless cycle of bird photography passion and desire.

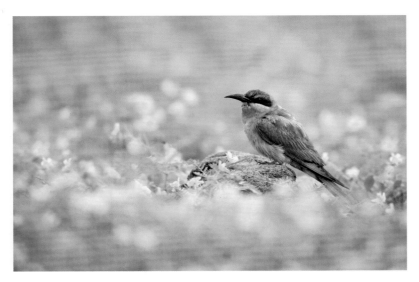

Saturated prime colours, combined with a carefully considered subject placement, and out-of-focus flowers in the foreground and background, elevates this image to the realm or art instead of a mere record shot of this species – the ambition of all bird photographers.

Southern Carmine Bee-eater, Okavango Delta in Botswana | *1/1000 sec at f/5.6, ISO 650 Canon 1D X + 600mmf/4 lens + 1.4x* | *Aperture Priority, +1 ev*

This book is a simple guide and brief introduction to bird photography for anyone interested or already involved with this activity.

- The book shows you what equipment you need.
- Camera settings that you need for the different types of photos are given.
- It shows how to look at light and composition to create spectacular pieces of art.
- A few destinations for bird photography are listed – these may be around the corner from where you live or you may need to make a dedicated trip there.
- It also gives tips and highlights on all facets of bird photography, such as what techniques to use to capture a bird in flight, or where to go to get a good photo of an oxpecker on an impala.

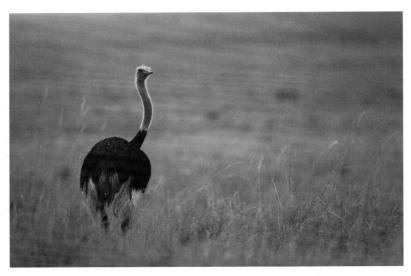

Birds come in all shapes and sizes and different species require different techniques to create striking images of them in their typical environment.

Common Ostrich, Maasai Mara National Reserve in Kenya | *1/250 sec at f/4, ISO 1600*
Canon 1D Mark IV + 600mmf/4 lens | *Aperture Priority, -2/3 ev*

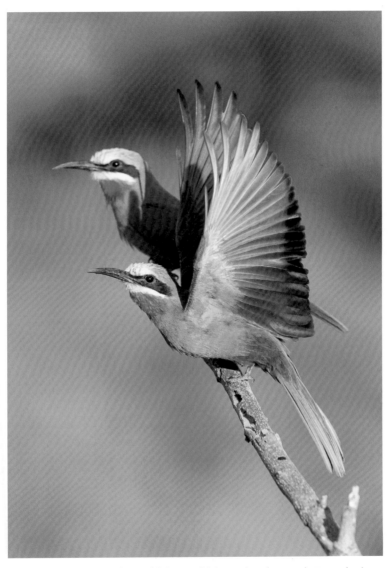

Bird photography is not about a bird on a stick but rather about a photographer's careful consideration of light, background and the anticipation of that perfect moment to capture a bird in a spectacular posture.

White-fronted Bee-eaters, Mashatu Game Reserve in Botswana | *1/2500 sec at f/5.6, ISO 1600* | *Nikon D3S + 200-400mmf/4 lens* | *Manual Mode*

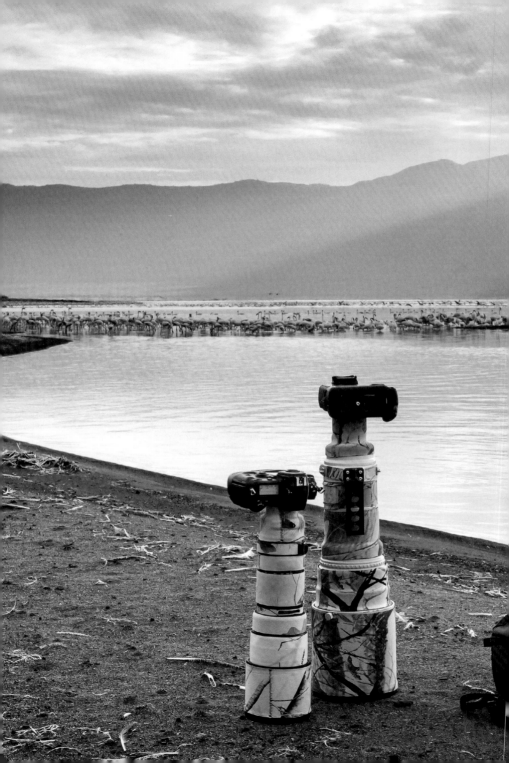

Choosing the right equipment

Landscape, Lake Bogoria in Kenya
1/100 sec at f/11, ISO 200 │ *Canon 5D Mark II*
+ 24-70mmf/2.8 lens │ *Aperture Priority, 0 ev*

Introduction

Bird photography is the genre of photography that probably utilises the latest technical advancements in DSLR cameras and lenses the most. Birds are small and fast and it's difficult to get close to them. Therefore, bird photographers require long lenses, cameras that can focus fast and accurately and tracking systems that keep birds in focus even when they move erratically and at incredible speeds. You need cameras that can take an almost unlimited number of photos in rapid succession, equipment that can withstand the elements, support systems to make it easy to handle the heavy equipment and a bag full of accessories to make sure you utilise all opportunities to make you 'get that shot'.

You can be creative, with the best technical skills, but if the camera equipment doesn't meet the crucial requirements for a bird photographer, then chances are that you'll fail in your attempt to get the shot. The craftsman can only be as good as his tools. Bird photography is different to the other genres of photography and needs a specific set of tools.

The camera body and lens are the most important part of the kit. A great camera is no good if you have a poor-quality lens – a great lens will deliver clear images, but without a good camera attached to it you'll only be able to take portraits in good light. The correct support systems and accessories can also help you take better photos, but they are not a prerequisite and don't add nearly as much value as the camera body and lens.

KEY POINTS

- Bird photographers need a **DSLR camera body** with the following features:
 - **sturdy and robust** for protection against small accidents and the elements
 - **good battery life** with backup batteries to last at least 3000 photos on a single charge
 - at least **10 megapixel resolution**, regardless if it's full frame or crop factor
 - fast burst rate of at least **8 frames per second** to take a series of photos in rapid succession
 - **sophisticated autofocus and tracking system** for sharp images of birds in flight
 - **large buffer memory of at least 12 RAW images** so that you can take a series of shots at the camera's peak performance levels
- **A long focal-length lens** is the workhorse lens of bird photographers and should be the first investment you make. Any lens from 400mm to 800mm would suffice for portraits of birds where they are large in the frame, as well as for bird behaviour, such as birds in flight. **Medium-zoom** lenses like a 70-200mm and a **wide-angle lens** like a 16-35mm lens can be welcome additions to your lens arsenal for a variety of shots.
- Invest in the **best quality lenses that you can afford.** Try a few before you buy one and remember that a good second-hand lens works just as well as a new one.
- Look at buying lenses with a **small minimum aperture**, like f/4 or f/2.8 as they will typically produce a smoother out-of-focus background in your images.
- Buy a **memory card** that is large enough to store a whole day's worth of RAW images. I recommend **at least 32 GB**, but preferably more. The speed of the card is just as important as its capacity, so look for a card that can 'write' at speeds just as fast or faster than your camera can 'write'. **100 megabits per second** is a good benchmark.
- Invest in a **good carbon fibre tripod** that can **support up to 8kg** of camera and lens weight. If you look after your tripod, you'll only have to buy one in your life. Fluid heads and gimbal heads both offer support and smooth panning motion. Try both out to see which one suits your style of photography. I prefer **a fluid head that offer smooth resistance** and absorbs any vibrations.
- An **external flash** will be stronger than an on-camera flash and is an **essential accessory**. It also recycles at a faster speed, allowing you to take more photos with flash in rapid succession, and will not drain your camera's battery.
- Buy a **well-padded camera bag** that fits more photographic gear than you anticipate. If you're planning to travel by air, then make sure the bag fits the dimensions of the typical large aeroplane's overhead compartments.

What's in Isak's bag?

Having the right equipment with you on a bird photography outing is essential, but you are often restricted by what you can afford. The other restriction is the sort of equipment that can be transported to your destination when luggage weight and space are an issue. Here is a glimpse into my camera bag to get an idea of what is most essential to have with you.

Essential equipment

- Camera body
- Super telephoto lens
- Telephoto zoom lens
- Wide-angle zoom lens
- Large memory card(s)
- Flash
- Flash extender
- Tripod
- Tripod head

If space and weight allows

- Second camera body
- Remote release
- Flash battery pack and cables
- Off-camera flash extender cable
- Flash bracket
- More lenses

Don't forget

- Spare camera battery
- Spare flash battery
- Camera battery charger
- Laptop
- Memory card reader
- External hard drive(s)

Other camera bag essentials

- Cash
- Plasters
- Rubber bands
- Cable ties
- Allan key
- Pen
- Lenspen
- Snack bars
- Coffee sachets
- Tissue
- Wet wipes

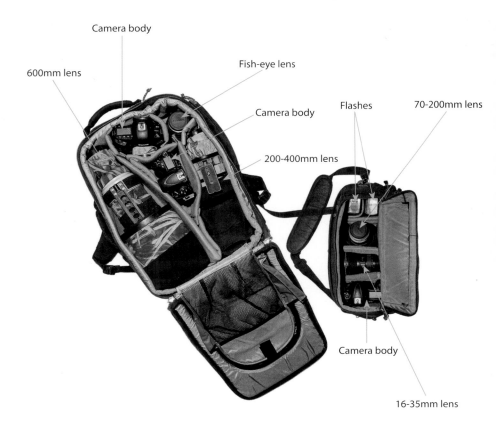

Camera body

600mm lens

Fish-eye lens

Camera body

Flashes

70-200mm lens

200-400mm lens

Camera body

16-35mm lens

 ISAK'S TIPS

Remember that convenience plays an important role when deciding what equipment to buy or take on your photographic trip. A light, easy-to-manoeuvre camera and lens combination will allow you to get more shots than having too many cameras and lenses. These can be confusing when you have to choose a combination as a photographic opportunity arises, or worse still, not being able to lift up a heavy lens when a Pel's Fishing Owl unexpectedly flies right past the game-viewing vehicle.

Cameras

The arrival of the digital camera has revolutionised photography. Bird photography in the days of film was a technical challenge and producing a sharp and well-exposed image was an achievement in itself. To photograph bird behaviour, such as birds in flight, was very difficult and nearly impossible to achieve with a film camera. These days, with the technology built into the digital camera, any beginner can pick one up and, in the auto mode, aim the lens at a bird and take even better photos than in the film days. Although the principles of photography stay the same (exposure through aperture, shutter speed and sensor sensitivity, and focusing through the lens), today the digital camera takes care of the technical part of photography, which leaves us to focus on the creative part. That allows us to push the limits of what cameras can do and results in producing more spectacular and creative photographs. In the film days if you got a photograph of a sharp and correctly exposed bird, it was considered to be a good photograph. Today by comparison, you'll need to get a photograph of a bird in flight, with its wings fully stretched in golden light for it to get the same attention. Not only does it force us to produce better photos, it allows us to capture ones that were impossible to capture before.

One of the greatest features of digital cameras is that you get instant feedback. You can see the image moments after you've taken the photo, allowing you to adjust settings to get the exposure, sharpness and composition perfect. In the days of film you had to wait to get your prints back from the lab before you knew if that spectacular photo of the African Fish Eagle taking the fish in glorious morning light came out the way you had hoped. This happens typically only weeks after your trip and by that time if the image was blurred or out of focus you would not remember what settings you used and what caused the unsatisfactory

results. Digital cameras have an LCD screen at the back of the camera where you can see the settings you used for each photo. For any beginner in photography this makes the learning curve much faster with regard to understanding the settings and getting to a level where you can take technically perfect photos.

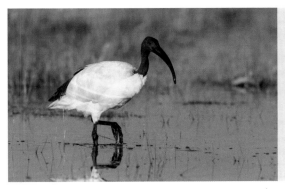

Film cameras did not have the autofocus tracking ability and high burst rate that today's DSLR cameras offer, and combined with the cost of film, most film camera photographers mostly took portrait photos only of birds such as this African Sacred Ibis.

African Sacred Ibis, Marievale Bird Sanctuary in South Africa | *1/1250 sec at f/8, ISO 200*
Canon 20D + 600mmf/4 lens + 1.4x | *Aperture Priority, -2/3 ev*

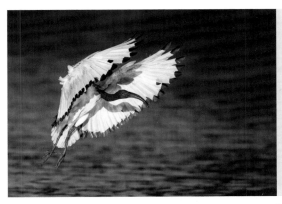

Since the arrival of digital cameras you are no longer limited to the 24 or 36 photos that could fit onto a role of film – instead you are able to take hundreds of photographs at no extra cost. This was the start of the bird behaviour and bird-in-flight era where the DSLR cameras made it easy to get shots that were previously impossible.

African Sacred Ibis, LC de Villiers Sports Grounds in South Africa | *1/2500 sec at f/7.1, ISO 320*
Canon 1D Mark II N + 600mmf/4 lens + 1.4x | *Aperture Priority, -1 ev*

7

Digital single-lens reflex (DSLR) camera

Digital single reflex cameras (DSLR) refer to the professional style cameras that work with prisms and mirrors allowing you to look through the lens to see the exact photo that the camera will take. Not only is the advantage to have a clear view in real time and composing the photo perfectly in camera, but DSLR cameras have other important advantages:

- **Interchangeable lenses:** this allows you to use different lenses on the same camera body. You are thus not limited to a specific focal range, but can put on a telephoto lens if you want to get a portrait shot of a small bird and then put on a wide-angle lens if you want to take a 'bird in its environment' shot of a large bird that is close to you.

- **Fast focusing:** the focusing mechanism is based on the live image projected through the lens and not on a digital projection like in compact digital cameras and smartphone cameras, making the focusing much faster. Fast focusing is essential in bird photography because birds move quickly through the air requiring the camera to change the focus fast in order to get a sharp image.

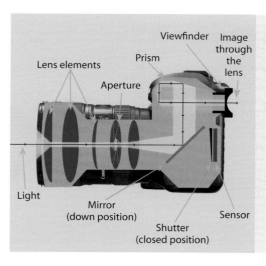

When you look through the viewfinder it is like looking through the lens itself. In a DSLR camera, the light that enters the lens is directed to the viewfinder by a mirror and prism inside the camera.

In DSLR cameras the image through the lens is directed upwards into the body of the camera with a mirror located in front of the digital sensor when in the 'down' position. The image is then directed through the viewfinder with a prism that allows the photographer to essentially see what the lens sees and what the sensor will capture when the photograph is taken. As you take the photo the mirror flips to an 'up' position for a moment, exposing the sensor to the image through the lens and capturing the photograph before the mirror flips down again, directing the light away from the sensor and through the viewfinder again. This flipping of the mirror is the 'click' that you hear when you take the photo – for that split second when the mirror is up, the photographer cannot see anything through the viewfinder.

DSLR cameras are larger and heavier than compact cameras, allowing your hand to fit more comfortably around them. They are sturdier, making them more resistant to knocks and bumps, more resistant to the elements like rain and high temperatures, and they use larger batteries for increased battery life. A great advantage of a larger camera body is that there can be more buttons and dials fitted onto the body to give the photographer more controls to tweak the settings effortlessly without going into the menu at the back of the LCD screen.

DSLR cameras can be divided into three categories, each with its own level of performance:

- **Professional**: these camera bodies are the largest, most robust with all the features of a DSLR body to allow you to control all the settings. Most of them do not have an on-camera flash. This is definitely the bird photographer's choice as its top features are utilised. It does come with a hefty price tag though, but a good second-hand body, even of the previous model, offers great value for money. Most professional camera bodies are full frame with the larger physical sensor size having the advantage of producing higher quality images with less noise and better contrast.

- **Advanced amateur**: these camera bodies have the advantage of being lighter and more compact with most of the features of the professional bodies, and they have an on-camera flash. Since they are smaller, their battery life is slightly shorter and they're made from a softer and lighter material so they are not as protected against the elements as

a professional camera body. They are suitable for bird photography and with good photographic technique can deliver stunning photos of bird behaviour.

- **Entry level:** these camera bodies are usually the same size or slightly smaller than the advanced amateur cameras but with less features. They are great if you are starting photography or if you have a limited budget. They produce excellent quality portrait photos, but bird behaviour photos might be more of a challenge. The reduced features means that some settings are more difficult to access or not adjustable at all, like setting the flash exposure compensation separately from the camera's exposure compensation, for example. The camera sensor is also physically smaller with a 1.5 or 1.6 crop factor (Canon = APS-C, Nikon = DX), gaining focal length artificially, but sacrificing image quality ever so slightly.

Camera model	Class	Crop factor	Megapixels	Max FPS	Fit for Action Bird Photography	Price
Canon						
1D X	Professional	Full-frame	18	14	Excellent	R 80 000
1D Mark IV	Professional	1.3x	16	10	Excellent	N/A (discontinued)
5D Mark III	Advanced Amateur	Full-frame	22	6	Good	R 35 000
6D	Advanced Amateur	Full-frame	20	4.5	Medium	R 22 000
7D Mark II	Advanced Amateur	1.6x	20	10	Excellent	R 20 000
70D	Advanced Amateur	1.6x	20	7	Good	R 14 000
700D	Entry-Level	1.6x	18	5	Medium	R 9 000
100D	Entry-Level	1.6x	18	4	Poor	R 6 000
1200D	Entry-Level	1.6x	18	3	Poor	R 4 000

Camera model	Class	Crop factor	Megapixels	Max FPS	Fit for Action Bird Photography	Price
Nikon						
D3X	Professional	Full-frame	24	3	Poor	N/A (discontinued)
D4s	Professional	Full-frame	16	11	Excellent	R 90 000
D810	Advanced Amateur	Full-frame	36	6	Good	R 52 000
Df	Advanced Amateur	Full-frame	16	5.5	Medium	R 41 000
D610	Advanced Amateur	Full-frame	24	6	Good	R 31 000
D7100	Entry-Level	1.5x	24	6	Good	R 18 000
D5300	Entry-Level	1.5x	24	5	Medium	R 13 000
D3300	Entry-Level	1.5x	24	5	Medium	R 8 000

A list of all the latest models available from Canon and Nikon at the time of print, October 2014. Included is my rating of how well the camera is suited for capturing action and behaviour in bird photography. This is, however, just a rating and does not mean that a camera rated as 'poor' can't deliver excellent results in the hands of a good photographer.

Compact digital cameras and smartphone cameras

Compact digital cameras are the smaller type designed for general photography – they are small enough to conveniently fit into your pocket and with just enough features to capture great photographs without having to worry about changing settings for specific applications. These cameras project a digital image either through the viewfinder or on the LCD screen on the back of the camera and thus do not show the live image through the lens like DSLR cameras do.

Since the camera's focusing system is based on the digital projection of the image that the sensor captures through the lens and not the actual image the lens sees, the focusing with these cameras is very slow without the option of focus tracking. These cameras also seldom have a system of interchangeable lenses and are fitted with wide-angle lenses or medium

focal range zoom lenses. Thus, without fast focusing or focus tracking capabilities, and fitted with lenses with too short focal lengths they are unsuitable for bird photography.

Both compact digital cameras and smartphone cameras are great travel cameras, for photos of people and places, because of their size. The quality of the smartphone cameras are continuously improving, replacing the need for compact digital cameras and thus killing that market. Neither compact digital cameras nor smartphone cameras will, however, meet the quality that DSLR cameras can produce.

 ISAK'S TIPS

The best camera is the one that you have with you! I often use my smartphone when I'm doing a bird photography shoot to photograph the setting, people in action or even portraits of birds when you can get close enough to them. The quality of the photos is excellent and it's compact enough to carry with you all the time, providing you with opportunities to capture photos or videos when it's just too much effort to get the big DSLR camera out.

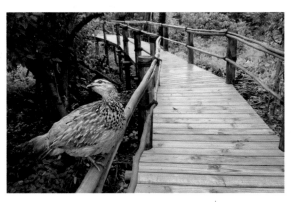

Crested Francolin, Okavango Delta in Botswana | *1/250 sec at f/2.2, ISO 32*
iPhone 5s + 4.12mmf/2.2 lens back camera

Digital sensor pixels

The sensor in a digital camera performs the same function as the film or slide in the old analog cameras. It captures light, creating the image. The sensor is located at the back of the camera, in line with the lens. Digital sensors work with a grid of light buckets, also known as pixels. Thus, the photo is projected onto the sensor by the lens and the light buckets (or pixels) captures the intensity of the light and converts it into a digital photo. The more pixels there are to capture the image, the better the resolution of the photo. In other words, more pixels mean you can print your photo bigger. More pixels also mean you can crop your photo more in post-processing and still have enough pixels left for a good quality image. That is only partly true though and I never encourage people to crop too much.

The pixel count on DSLR cameras today typically varies from around 8 megapixels (8,000,000 pixels) to 36 megapixels (36,000,000 pixels). Although it forms part of the criteria for choosing a DSLR, it is by no means the most important one. An 8 MP file can be printed to A3 size (297mm x 420mm) at 220 dots per inch resolution, which is the best printing resolution – so for books or posters you do not really need to have more than a 16 MP file at best. Since larger files take more space and typically make the burst rate of the camera slower, it has its drawbacks and so you have to find a camera that offers a good balance between the two. With the current technology, the 18 MP cameras offer stunning resolution while still maintaining good all round specs.

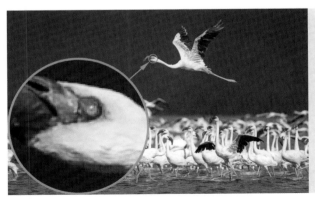

The digital image is a grid of small, coloured, square blocks called pixels that you see when you zoom in on the image.

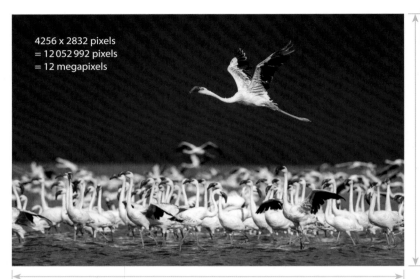

4256 x 2832 pixels
= 12 052 992 pixels
= 12 megapixels

2832 pixels

4256 pixels

The resolution of a camera's digital sensor is the product of the quantity of pixels on the horizontal and vertical axis. The more pixels there are on the surface of the sensor, the higher the resolution of the camera. Nikon's D3S DSLR camera has a resolution of 12 megapixels.

Lesser Flamingos, Lake Bogoria in Kenya | *1/2000 sec at f/7.1, ISO 400*
Nikon D3S + 200-400mmf/4 lens | *Manual Mode*

Digital sensor size

Full frame and crop factor refer to the physical size of the sensor. A full-frame sensor is physically the same size as a slide film, 36mm x 24mm. Crop-factor sensors are categorised as 1.3, 1.5 or 1.6 times. This refers to how much smaller they are physically compared to the size of a full-frame sensor. A 1.5 crop factor 10 MP sensor, for example, is 1.5 times smaller than a full-frame 10 MP sensor. They have equal resolution, but since the surface area of the 1.5 crop-factor sensor is smaller than that of the full-frame sensor, the pixels are physically distributed closer together – referred to as 'pixel density'. Full-frame sensors with their lower pixel density as a general rule of thumb offer better quality images with better contrast, smoother gradation and lower noise or grain.

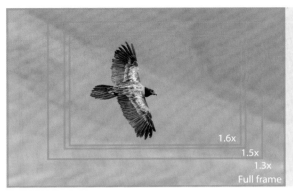

A camera with a crop factor sensor artificially zooms into the frame for a cropped field of view, creating the sense that you are using a longer lens and making the birds appear larger in your images.

Bearded Vulture, Drakensberg in South Africa | *1/2000 sec at f/7.1, ISO 400*
Canon 1D Mark II N + 600mmf/4 lens | *Manual Mode*

The biggest difference between full frame and crop factor, however, is that the smaller sensor artificially zooms into the photo. It has the same effect as taking a photo with a full-frame sensor and then cropping two-thirds into the middle of the frame during your post-processing. Through the viewfinder, you also see a cropped view making it seem like the lens has a longer focal length. Should you put a 100mm lens on a full-frame sensor camera, your view will be that of a 100mm focal-length lens, whereas when you put that same lens onto a 1.5 crop-factor camera, your view will be that of a 150mm focal-length lens. For bird photographers the artificial focal length gained is a great advantage as birds are small and you are always trying to get close to them. When you turn your 600mm lens into a 960mm lens with a 1.6 crop-factor body, your chances of getting a full-size bird in your viewfinder is much better as you don't need to be as close to the bird to achieve the same effect with the same lens and a full-frame camera.

Another advantage of crop-factor sensors is that they only utilise the best part of the lens. The rule of optics tells us that the middle part of a lens renders the best sharpness and contrast. As you move away from the middle to the side of the lens, the quality degrades, and the edge of the lens renders the worst quality. Crop-factor sensors crop the image projected by the lens, the middle part of the image, and they therefore utilise the best part.

15

Canon's camera and lens systems have lenses designed for either the full-frame or crop-factor systems. It is therefore important to note that not all lenses will fit onto any camera body. Full-frame lenses will fit onto both full-frame and crop-factor camera bodies, and crop-factor lenses are designed to fit onto crop-factor bodies.

All Canon DSLR cameras are compatible with their EF (electofocus) lenses. You can recognise an EF lens by its red dot – you line up this red dot on the lens to a similar looking dot on the camera body. Every camera regardless of sensor size has a red dot. The EF-S (short back focus) lenses are designed for the 1.6x crop-factor camera bodies where the lens sits deeper in the camera body when connected. This system is indicated by a white square that should be lined up on the lens to the similar looking white square on the camera body.

To simplify:

- Canon EF lenses (red dot) will fit onto all camera Canon DSLR bodies, including full frame, 1.3x crop-sensor bodies and 1.6x crop-sensor bodies.
- Canon EF-S lenses (white square) will only fit onto a Canon 1.6x crop-sensor camera body.
- Full-frame and 1.3x crop-sensor Canon DSLR camera bodies can only be used with EF lenses (red dot). On the camera itself there is only a red dot mount mark.
- 1.6x crop-sensor Canon DSLR camera bodies can be used with both EF (red dot) and EF-S (white square) lenses. On the camera itself there is both a red dot and a white square mount mark.

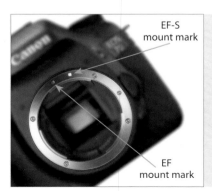

EF-S
mount mark

EF
mount mark

In the Canon system, the EF and EF-S lenses have different markings. This is indicated on both the lens and camera body where the lens is connected to the camera body (also called the lens mount).

The Nikon system has only 1.5x crop-sensor DSLR camera bodies called **DX format,** and full-frame sensor bodies called **FX format.** All the Nikon lenses work on both camera formats where the lens mounts are indicated by a white dot on the camera and lens.

 ISAK'S TIPS

> Since most full-frame lenses fit onto crop-factor bodies and probably no crop-factor lenses will fit a full-frame body, before you buy a camera and lens, I suggest you consult a camera shop to make sure the lens will work on the camera body.

Buffer memory and writing speed

When you take a lot of photos in rapid succession, for example a bird in flight, the camera stores the photos in its buffer memory first, before downloading the photo files to the memory card. The first few photos can be taken in rapid succession because there is no bottleneck for their storage, but when the buffer is full, you can only take new photos at the same rate that the camera starts clearing these photos onto the memory card – this is usually quite slow. When the buffer memory is small, it gets full quickly. This means that while the bird is flying in to land and you've already released the shutter ten times before the bird is even close to you, the camera will stop releasing the shutter. It may also just release it every now and again as soon as it's opened space in the buffer memory for a new photo to be taken as it slowly clears the buffer memory onto the memory card. Each camera has a buffer size as part of its specification, measured in number of photos, and the bigger the buffer, the better your chance of taking lots of photos in rapid succession.

The speed at which the camera can clear the photos from the buffer memory onto the memory is called the writing speed. Thus, the faster the writing speed, the more photos you would be able to take in rapid succession.

For bird photography I recommend getting a camera with a buffer of at least 12 RAW photos and a writing speed of at least 100 megabits per second (MBPS).

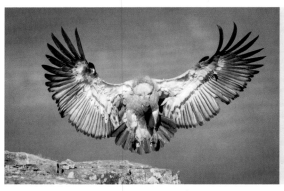

Taking a sequence of shots will guarantee that you catch the bird in its best posture. For that you'll need a camera that will allow for a large number of shots to be taken before the internal memory is full.

Cape Vulture, Drakensberg in South Africa | *1/2500 sec at f/5.6, ISO 320* | *Canon 1D Mark II N + 600mmf/4 lens* | *Manual Mode*

Frame rate

With any action photography, including photographing birds in flight, the action happens so fast that it is impossible to anticipate that perfect frame and take only one photo at that exact moment. The advantage of digital photography is that you can take many photos, delete most and only keep the best. It does not cost you anything extra to take more photos. Having this in mind, your best chance of capturing that perfect frame in an action sequence is to take lots of photos in rapid succession and then afterwards choose the best frame from the sequence. The faster the rate over a short period of action, the better chance of capturing the perfect frame. You don't just photograph blindly in the hope of capturing something – it is still a calculated decision. Instead of just taking one photo, you improve your chances by utilising the features of the equipment.

One of the most important considerations when purchasing a new camera is the speed at which it can take photos in rapid succession. When you take a photo, the camera flips the mirror up to expose the sensor to the light through the lens, to 'take the shot'. It then flips the mirror back into place so that you can see through the lens to make sure that it is still aimed at the bird and to continue to track the focus.

This flipping of the mirror is also the sound that you hear when you take a photo – the 'click'. When you keep pressing the shutter button down, the camera keeps taking photos in rapid succession, repeating this cycle of flipping the mirror up and then down again continuously. The mirror is a relatively large component and flipping it up and down is a mechanically straining task. If a camera is designed to do this flipping fast and continuously, it enables you to keep taking photos in rapid succession. The faster you can take photos, the better chance you have of capturing that perfect moment – this happens so fast that it's impossible for you to anticipate the shot and to get it by taking one only. One of the advances in camera technology is specifically to improve this frame rate. The higher the frame rate, the faster the rate of taking photos. This feature is measured in 'frames per second' (FPS).

For bird photography I recommend getting a camera that can take at least 8 frames per second in rapid succession.

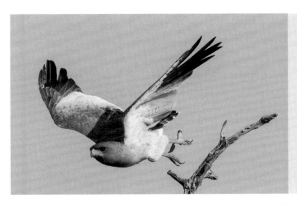

To capture the best posture you need a camera with a good frame rate that can take photos in rapid succession without too much of a delay between the shots.

Pale Chanting Goshawk, Kgalagadi Transfrontier Park in South Africa
1/2000 sec at f/7.1, ISO 500 │ *Canon 1D Mark II N + 600mmf/4 lens* │ *Manual Mode*

Focus system

An autofocus system is a combination of camera and lens functions. The camera communicates with the lens, instructing the motor drive to move the elements inside the lens to focus on the subject. This system is complicated, but is probably the most significant aspect in camera

evolution. The camera with the best autofocus system will yield the best results. This forces the engineers at the major camera manufacturers to constantly improve these systems, often scrapping existing technology and designing from scratch again.

The camera uses a series of algorithms to determine what and where the correct focus should be. The faster the camera can do these calculations, the faster it can instruct the lens to focus.

All photographers require cameras that can focus accurately. Accurate focus ensures that the image is sharp at the correct place and where you want it to be. Difficult lighting conditions such as low light, little contrast or backlighting can 'confuse' the camera or make it difficult to achieve accurate focus at the correct place. Good technique of the photographer can definitely help in difficult conditions, but the photographer still relies on the camera to do the actual focusing.

Focus tracking requires the camera to not only focus accurately on the subject, but to keep making minor adjustments in focusing while the lens is pointed at a moving subject. The faster the subject moves, the faster the camera needs to react and re-adjust when the focus changes. Birds in flight are some of the fastest and most erratic moving subjects that photographers can ever photograph. Keeping the bird perfectly in the middle of the frame when following it as it flies across the sky is almost impossible. Even with the best hand–eye coordination and reactions, a bird photographer would struggle to keep the focus point on the bird the whole time. The camera needs to be intelligent enough to not re-adjust focus to the background during those moments when the focus point is not on the bird. Most camera autofocus systems can be tweaked on the menu to accommodate for various scenarios, for example fast-moving subjects, erratic movements or where the bird is temporarily obstructed by other objects. Cameras with good focus tracking systems are a crucial requirement for photographers who want to take photos of birds in flight.

But how do you know what is a good focus and tracking system when looking at camera specifications? Unfortunately there is no easy way to tell, except for the rule of thumb that every new camera model will have an improved focus and tracking system. Typically all cameras have good enough focus system for accurate focusing of static subjects. Only

the 'advanced amateur' and 'professional' bodies would, however, have adequate focus tracking systems for photographing birds in flight. The 'professional' bodies would of course have the best focus tracking system.

A good focus system in a camera can keep a bird in focus for extended periods – even where there is little contrast and where the bird is small in the frame.

Hottentot Teal, Marievale Bird Sanctuary in South Africa | *1/2500 sec at f/5.6, ISO 500*
Canon 1D Mark II N + 600mmf/4 lens | *Manual Mode*

Rugged build

Outdoor photography opens the photographic equipment up to the risk of getting wet, bumped, dented or any other damage. Operating outdoors, even if you try to take good care of your equipment, means that you often bump your equipment or expose it to severe temperatures. In the Kalahari Desert in South Africa your lens might be in the sun on the seat next to you in the vehicle when temperatures soar past 40 degrees outside. Then, in Japan in the winter when the Japanese Cranes perform in the snow you might find yourself outside in a blizzard trying to capture that magical scene when temperatures plummet to minus 20 degrees. If you like to rough it, you might splash water onto it or snow that falls on the camera might melt, making it wet.

For these reasons the camera manufacturers have built the camera bodies out of solid aluminum casts, strong enough to handle these bumps. Most of the exposed areas are also covered with rubber strips to help with shock absorption when you bump them. They also take care with the buttons and seal them with rubber to waterproof them.

You never know where the bird photography will take you. Initially you might think that you'll only go to the local bird hide on sunny Saturday mornings. But, this hobby is so addictive that the next moment you find yourself on a boat on the Okavango River, with water splashing around you, trying to capture a Southern Carmine Bee-eater diving into its nest.

It's always worth getting a camera body that can withstand some abuse and there is not often much information about this in the brochure when you're about to purchase a new camera. Most manufacturers might say if it's weather sealed, but there is not a standard measure for this. Typically, professional camera bodies are rugged, while advanced amateur bodies can withstand some abuse and bad weather, and entry-level cameras should be handled carefully. You don't want to go on your dream trip to the Antarctica to photograph penguins and then have the equipment fail on you because it can't withstand the great temperature differences.

Your bird photography hopefully takes you to places that are dusty, muddy, rainy, humid, extremely hot or extremely cold. You need equipment that is weather sealed and that can withstand a few knocks and bumps. I photographed flamingoes on the volcanic and muddy shores of Lake Bogoria in Kenya where my photographic equipment was exposed to the sun, extreme heat and mud.

Lenses

Have you ever walked into a bird hide and seen a row of long lenses all lined up next to one another, all aimed at the same small bird? Long lenses are the envy of every bird photographer, except of course if you own the longest one.

A lens is the mechanism that projects the image of the bird onto the sensor of the camera to capture as a photo. It is therefore just as important as the camera body itself. Lenses come in all shapes and sizes and it's important to understand the function of each one and what image it can create for you. The general rule of thumb used to be that you should invest in a good lens rather than in a good camera. It is true to some degree. The rule of optics means that a sharp lens will be sharp forever, but the advances in digital cameras means that with every new model released you can get images previously impossible to get with the earlier model and that cannot be ignored. Advances in lens technology have much longer intervals and the upgrades usually involve lighter lenses because of lighter material and improved image stabilisers.

Looking at all the different lens options it can be daunting to decide which one is the best or which one is right for you. Here are some criteria for a good lens:

- **Focal length:** a long focal length makes a small bird large in the frame.
- **Bokeh:** this is the soft background that it creates. Look for the widest aperture of the lens. A 400mmf/2.8 lens has a widest aperture of f/2.8 that creates a much softer background than a 400mmf/5.6 lens with its widest aperture of f/5.6.
- **Weight:** the photographer's ability to manoeuvre a lens with ease is a big consideration. The lighter the lens, the easier it is to manoeuvre and get the shots. A lightweight lens is also easier to travel with, especially with airline's weight restrictions.

- **Sharpness:** creating crisp, clear and sharp images.

- **Contrast:** the ability of the lens to deliver a clear distinction between the dark and bright parts of the image instead of a murky or washed-out look.

- **Vignetting:** this is a typical quality issue on a lens where it creates dark corners in the edges of the frame. This can best be seen when you photograph the sky.

Camera and lens manufacturers make lenses to fit their own cameras. In other words, a Canon lens will only fit a Canon camera body, and the same with Nikon. There are a few lens manufacturers that make lenses to fit a specific brand of camera. Sigma, Tamron and Tokina, for example, makes lenses to fit Canon or Nikon bodies specifically.

A good quality lens can last you a long time. If a lens is sharp and you look after it, it will last for many years and will remain sharp. It is therefore good value for money to buy a good second-hand lens at a reduced rate that will perform just as well as a new lens. Even if the outside of the lens looks scruffy, it's the quality of the glass that counts. If you test it and it performs perfectly, then it is perfect.

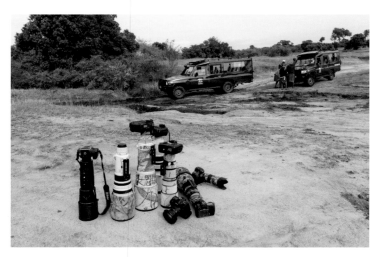

Although long lenses are the workhorse lenses for bird photography, the other shorter lenses offer different shots. Choosing what lenses to take on safari depends on the opportunities that you'll get, although you can almost never go wrong if you take along your longest lens.

Focal length

"The bigger the better!" This is not necessarily true in photography in general, but for bird photography it does help getting the bird large in your frame while still being a distance away from it.

Lenses come in different lengths, referred to as focal lengths, which are the physical measurements of the length of the barrel. This varies from 800mm down to about 8mm for most consumer lenses. They are categorised by size, where the longest lenses are called 'super telephoto' followed by 'telephoto', then 'normal', 'wide-angle' for the short lenses, and the very short ones are called 'super-wide angle'. Zoom lenses are where the focal lengths can be adjusted by twisting the barrel of the lens to zoom in or out. Prime lenses only have one focal length that cannot be adjusted.

The longer the lens, the larger the subject will be in the frame and the narrower your field of view will be. Super telephoto lenses, such as the 600mmf/4, are the workhorse lenses for bird photographers and are used for bird portraits, birds in flight and tight portraits of large animals.

Telephoto lenses, e.g. 200mm, are used to show a bird in its environment or a full body portrait of a large mammal. Wide-angle lenses, e.g. 24mm, are used for landscape photographs.

As a rule of thumb, the longer the lens, the more lens elements there are in the barrel of the lens and thus the heavier and more expensive the lens becomes. A new professional super telephoto lens costs roughly the same as a new small vehicle, while a new professional wide-angle lens costs only 15% of that. Bird photography requires mostly super telephoto lenses and is therefore one of the most expensive genres of photography. But you don't have to break the bank to do bird photography. There are plenty of good quality super telephoto lenses on the market that do not cost an arm and a leg. It might just mean that you have to work a little harder and get a little closer to your subject than those who have expensive lenses. Buying second-hand lenses is a cheaper alternative, as long as you buy from a reputable source.

ISAK'S TIPS

Buying second-hand equipment from an internet photographic community is a safe option that could save you a lot of money. As with electronic equipment, you should beware of fraudsters and just apply common sense. The best would be to meet in a camera shop where the experts can tell you if the equipment is in good condition. There are a few photo communities on the Internet, such as BirdPhotographers.net, Naturescapes.net and OutdoorPhoto, who each have a classified section. When you see a lens advertised that interests you, you can have a look at the profile of the user selling it. When the user is active on the site, making regular posts and engaging with other users on the site, I would consider it a safe bet and reputable person to buy from.

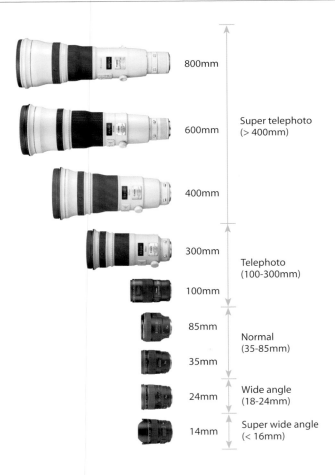

800mm	
600mm	Super telephoto (> 400mm)
400mm	
300mm	Telephoto (100-300mm)
100mm	
85mm	Normal (35-85mm)
35mm	
24mm	Wide angle (18-24mm)
14mm	Super wide angle (< 16mm)

Zoom lenses vs prime lenses

One of the challenges of bird photography is to get as close to your subject as possible. Birds are small and skittish and to have the bird large in your frame, and not just as large as one pixel on your sensor, means that you have to make a real effort to get close to it. There are various ways to achieve this, but using a super telephoto lens helps. Through experience you learn how close you should be to your subject for the photograph that you have in mind with the lens that you are using. To get to within that perfect distance is usually impossible. Every so often it happens that you get too close to your subject, or a bird lands closer than expected right in front of you, or you think of a different way to compose the photo to go wider and include the environment. When this happens and you use a prime lens you are stuck. You cannot zoom in or out, making the envisaged composition impossible except if you move yourself backwards, further away from the subject. If you have a zoom lens, you can stay where you are and simply zoom out to get the shot.

200-400mmf/4
Zoom lens

200mmf/2
Prime lens

400mmf/2.8
Prime lens

Prime lenses, e.g. 600mm, cannot zoom in and out and only project the image of a fixed focal length. This is often seen as a negative because the ability to compose your photo by zooming in and out is one of the most important requirements. Although the ability to zoom in and out is handy, the same effect can be achieved by physically moving yourself closer to or away from your subject. In fact, the ability to zoom in and out often makes you take the cliché photos where you subconsciously

zoom to compose the subject in a way that you've seen in other photos before. Being 'stuck' with a fixed focal length and struggling to compose a subject that is too big in your frame forces you to try different compositions, ones that you have not tried before that are not clichéd, resulting in creative angles on the common photos.

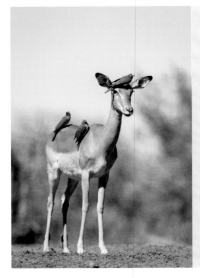

Cliché shot with a zoom lens

Red-billed Oxpecker on impala,
Mashatu Game Reserve in Botswana
1/3200 sec at f/5.6, ISO 560
Nikon D4 + 200-400mmf/4 lens
Aperture Priority, 0 ev

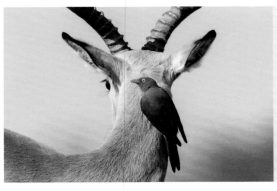

Creative composition
with a prime lens

Red-billed Oxpecker on impala, Mashatu Game Reserve in Botswana | *1/1000 sec at f/8, ISO 400*
Canon 1D Mark IV + 600mmf/4 lens + 1.4x | *Aperture Priority, 0 ev*

The other advantages of prime lenses are that they usually offer sharper quality images with better contrast. With fewer lens elements, light has to travel through fewer pieces of glass reducing refraction and resulting in better quality. They often have larger front lens elements than zoom lenses, which produce the soft background, referred to as bokeh, that all wildlife photographers love. The view through the lens is so clear and sharp that one gets addicted to it. As a rule of thumb these lenses also focus faster and more accurately, especially in low-light conditions.

A zoom lens like the 200-400mmf/4, for example, is a lens that makes your field of view narrower or wider by bringing your subject closer or further away in your viewfinder by twisting the barrel of the lens clockwise or anti-clockwise to zoom in or out. The ability to zoom offers great versatility to the photographer. This advantage often overshadows the drawback of slower focusing and poorer bokeh (the more in-focused backgrounds where your subject is not separated from the background as clearly). This makes you get the shot that you would have missed because of being unable to zoom out with a prime lens. Zoom lenses are optically complicated and use a lot of lens elements to keep a subject in focus with different focal lengths. This added number of lens elements causes light to refract more than in prime lenses and compromises sharpness, contrast and vignetting. A rule of thumb is that the larger the zoom range is, the poorer the quality of the lens.

Zoom lenses in shorter focal lengths, such as the wide-angle 16-35mm and telephoto 70-200mm lenses, are very popular and still render good quality when compared with their prime lens counterparts. There are fewer super telephoto zoom lenses available with the 80-400mm, 100-400mm and 200-400mm lenses being very popular. Apart from them there are not many other options, and if you want to photograph at 600mm you'll have limited options other than using a prime lens.

The decision between buying a prime lens or a zoom lens is usually a question of budget and versatility vs quality. The sharpness and bokeh of fixed lenses might be better than a zoom lens and comes with a high price tag, but if you have to change focal lengths quickly, the versatility of the zoom lens will get you the shot, whereas changing lenses or even just picking up another camera often makes you miss the shot. The space you have around you when photographing might also influence your

decision. If you only photograph from your own vehicle where you have the seat next to you empty, having many lenses is not a problem. If your family is travelling with you, then space is limited and having fewer lenses is an advantage. If you have to travel by air and your carry-on luggage weight is restricted, having fewer lenses to travel with might be your only choice.

 ISAK'S TIPS

When you're starting out and you are not sure which lens to buy, buy second-hand first to try it out. Keep buying and selling until you've found the lens that works the best for you. Bird photographers should buy a good prime super telephoto lens first and the other shorter lenses only later.

List of lenses for bird photography

Manufacturer	Focal Length	Classification	Full Frame or Crop Factor	Fit for Bird Photography	Price
Prime lenses in Canon system					
Canon	EF 800mm f/5.6 L IS USM	Super Telephoto	Both	Excellent	R 140 000
Canon	EF 600mm f/4 L IS USM MK II	Super Telephoto	Both	Excellent	R 150 000
Canon	EF 500mm f/4 L IS USM MK II	Super Telephoto	Both	Excellent	R 120 000
Canon	EF 400mm f/2.8 L IS USM MK II	Super Telephoto	Both	Excellent	R 130 000
Canon	EF 400mm f/5.6 L USM	Super Telephoto	Both	Excellent	R 18 000
Canon	EF 300mm f/2.8 L IS USM MK II	Telephoto	Both	Good	R 80 000
Canon	EF 300mm f/4 L IS USM	Telephoto	Both	Good	R 20 000
Canon	EF 200mm f/2.8 L USM MK II	Telephoto	Both	Medium	R 10 000
Zoom lenses in Canon system					
Sigma	50-500mm f/4.5-6.3 APO DG OS HSM	Super Telephoto	Both	Good	R 20 000
Canon	EF 200-400mm f/4 L IS USM Extender 1.4x	Super Telephoto	Both	Excellent	R 145 000
Canon	EF 100-400mm f/4.5-5.6 L IS USM	Super Telephoto	Both	Good	R 20 000
Sigma	120-300mm f/2.8 EX DG OS HSM	Telephoto	Both	Good	R 50 000
Canon	EF 28-300mm f/3.5-5.6 L IS USM	Telephoto	Both	Medium	R 35 000

Manufacturer	Focal Length	Classification	Full Frame or Crop Factor	Fit for Bird Photography	Price
Canon	EF 70-200mm f/2.8 L IS USM MK II	Telephoto	Both	Medium	R 32 000
Sigma	70-200mm f/2.8 APO II EX DG OS HSM	Telephoto	Both	Medium	R 15 000
Canon	EF 70-200 mm f/2.8 L USM	Telephoto	Both	Medium	R 16 000
Canon	EF 70-200mm f/ 4.0 L IS USM	Telephoto	Both	Medium	R 16 000
Canon	EF 70-200mm f/4.0 L USM	Telephoto	Both	Medium	R 8 000
Canon	EF 24-70mm f/4 L IS USM	Normal	Both	Medium	R 20 000
Canon	EF 24-70mm f/2.8 L USM MK II	Normal	Both	Medium	R 30 000
Canon	EF 16-35mm f/2.8 L II USM	Wide Angle	Both	Medium	R 18 000
Canon	EF 8-15mm f/4 L Fisheye	Fisheye	Both	Medium	R 19 000
Prime lenses in Nikon system					
Nikon	800mm f/5.6E AF-S VR FL ED	Super Telephoto	Both	Excellent	R 240 000
Nikon	600mm f/4G AF-S VR IF-ED	Super Telephoto	Both	Excellent	R 145 000
Nikon	500mm f/4G AF-S VR IF-ED	Super Telephoto	Both	Excellent	R 120 000
Nikon	400mm f/2.8G AF-S VR IF-ED	Super Telephoto	Both	Excellent	R 130 000
Nikon	300mm f/2.8G AF-S VR II IF-ED	Telephoto	Both	Good	R 92 000
Nikon	300mm f/4D AF-S IF-ED	Telephoto	Both	Good	R 20 000
Nikon	200mm f/2G AF-S VR II IF-ED	Telephoto	Both	Medium	R 95 000
Zoom lenses in Nikon system					
Sigma	50-500mm f/4.5-6.3 APO DG OS HSM	Super Telephoto	Both	Good	R 20 000
Nikon	200-400mm f/4G AF-S VR II IF-ED	Super Telephoto	Both	Excellent	R 115 000
Nikon	80-400mm f/4.5-5.6G AF-S ED VR	Super Telephoto	Both	Good	R 39 000
Sigma	120-300mm f/2.8 EX DG OS HSM	Super Telephoto	Both	Good	R 49 000
Nikon	28-300mm f/3.5-5.6G ED VR	Telephoto	Both	Medium	R 16 000
Nikon	18-300mm f/3.5-5.6G VR ED DX	Telephoto	Crop Factor	Medium	R 16 000
Nikon	70-200mm f/2.8G AF-S VR II	Telephoto	Both	Medium	R 35 000
Nikon	70-200mm f/4G ED AF-S VR	Telephoto	Both	Medium	R 22 000
Nikon	24-70mm f/2.8G AF-S ED	Normal	Both	Medium	R 24 000
Nikon	16-35mm f/4G IF-ED AF-S	Wide Angle	Both	Medium	R 20 000
Nikon	14-24mm f/2.8G AF-S ED	Super Wide Angle	Both	Medium	R 26 000

Lens aperture

Each lens has a widest aperture, for example, a 600mmf/4 lens's widest aperture is f/4 and a 800mmf/5.6 is f/5.6. This is a measurement shown in the description of the lens and relates to the size of the front lens element. Generally speaking, the wider the widest aperture of the lens, the larger the front lens element is. A larger front element means a heavier lens, softer bokeh, faster focusing lens and a more expensive lens.

Zoom lenses might have a different widest aperture at different zoom positions. A Sigma 50-500f/4.5-f/6.3 lens, for example, has a widest aperture of f/4.5 at 50mm and a widest aperture of f/6.3 at 500mm. If you compare that to a Canon prime 500mmf/4 lens, then you'll know that the Canon's f/4 widest aperture will create a better bokeh and softer background than the Sigma lens zoomed to 500mm with its widest aperture of f/6.3 at the same focal length.

Difference in the diameter of the front elements

Canon EF 400mm f/5.6L USM lens Canon EF 400mm f/2.8L IS II USM lens

The front element is an indication of its widest aperture. The Canon 400mmf/2.8 lens has a much larger front element than the Canon 400mmf/5.6 lens, although they share the same fixed focal length.

Converters

Converters are a great way to increase magnification on a lens. The effect is almost like zooming in to make the subject appear larger in your frame. Converters are small lens elements that can attach to the back of the lens and they use the same attachment mechanism as those used to connect a lens to the camera body. The converter is designed to attach to the back of the lens and also to attach the camera to the converter, so that the converter is positioned between the camera and lens. Two or more converters can even be stacked on top of one another when using extension tubes.

Converters are available in various magnifications, including 1.25x, 1.4x, 1.7x or 2x. These numbers refer to the magnification that the converter offers. When you connect a converter to a lens, the new focal length of the lens and converter combination is the result of the converter magnification number multiplied by the lens focal length. For example, a 1.4x converter attached to a 100mm lens will make it a 140mm lens combination.

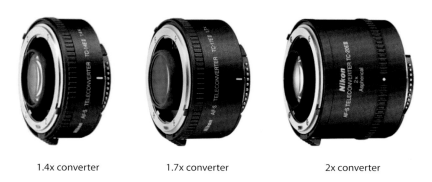

| 1.4x converter | 1.7x converter | 2x converter |

The converters that are the most popular are the 1.4x, 1.7x and 2x.

The added focal length is a great advantage for bird photographers who constantly try to get closer to their subjects, and the 1.4x converter is commonly used. Note, however, that converters change the widest aperture of a lens. A 1.4x converter adds 1 f-stop, while a 2x converter

adds 2 f-stops to a lens. For example, a 1.4x converter on a 600mmf/4 lens will make it an 840mmf/5.6 lens; and a 2x converter on a 400mmf/5.6 lens will make it an 800mmf/11 lens. Not only do they change the widest aperture, they also degrade the quality of the image, often making them slightly softer. This is most noticeable when photographing with the aperture wide open, for example at f/5.6 with the 600mm + 1.4x combo in the earlier example. When you close the aperture and photograph at f/11, for example, you'll notice a great improvement in sharpness, although it's not quite at the same levels as without the converter.

Another drawback of converters is that they make the focusing of a lens slower, and depending on the camera, converter and lens combination, it could even disable autofocus completely. Some lenses lose the ability to autofocus with focus points other than the single one in the middle of the frame, while others lose the ability to autofocus altogether. Consult the manufacturers to find out exactly how your system's focusing will be affected with the different converters, but here follows a general guideline for the autofocus effect of converters:

- Professional camera bodies' autofocus systems are less affected than advanced amateur camera bodies, and they in turn are less affected than entry-level camera bodies when using converters.

- The performance of large aperture lenses like f/2.8 lenses are less affected than smaller aperture lenses like f/5.6 lenses when using converters.

- Converters with higher magnification like 2x converters affect autofocus systems more than converters with lower magnification like 1.4x converters.

 ISAK'S TIPS

Converters are made for specific camera brands, so you cannot fit a Nikon converter onto a Canon camera for example. It's best to use the same brand converter for the lens.

Support systems

I can clearly remember the day when I got my first long lens. I attached the 500mm lens and 2x converter to my camera and ran into the garden to photograph the first bird I could see. A Crested Barbet sat on the neighbour's fence – it was miles away – but I aimed my camera in its direction and had the bird just fitting into my frame as I looked through the viewfinder. I was so happy because I'd wanted to get full-frame photographs of birds and finally I had the equipment to do it. I took a few shots and excitedly ran back to my computer to download the images. But the disappointment I felt at that moment was something I'll never forget. The images were fuzzy and blurry – not sharp and clear like I'd expected. I couldn't understand what was wrong and took a few more photos of other birds, but kept getting the same result. I couldn't believe it and didn't know how to fix it. After almost giving up someone then told me about using support systems when using long lenses. With my 1.6x crop-factor camera and effective focal length of 1600mm of course I can now understand that hand-holding such a long lens will accentuate your slightest movement and result in blurry images if you don't use good support. My next purchase, needless to say was a good tripod!

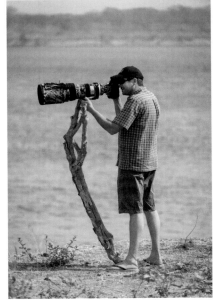

Good support systems are essential to keep long lenses from moving and creating blurry and soft images. Long lenses are heavy and difficult to hand-hold anyway, so you need to rest the lens on something – even a tree or log will do!

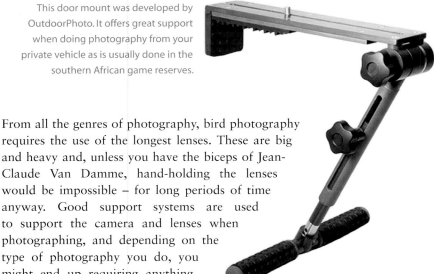

This door mount was developed by OutdoorPhoto. It offers great support when doing photography from your private vehicle as is usually done in the southern African game reserves.

From all the genres of photography, bird photography requires the use of the longest lenses. These are big and heavy and, unless you have the biceps of Jean-Claude Van Damme, hand-holding the lenses would be impossible – for long periods of time anyway. Good support systems are used to support the camera and lenses when photographing, and depending on the type of photography you do, you might end up requiring anything from a beanbag to a gimbal system. Support systems are not only useful to support the lens when your arms are not strong enough, they also help to keep the lens from moving, even just slightly, as you take portrait photos of static birds. Movement with any lens results in blurry and soft images especially when you use slow shutter speeds. The longer the lens, the more effect even a small movement has on the image when you look through the viewfinder. That is why good support systems are crucial when you use long lenses – you have to keep the lens from moving.

When you photograph birds in flight, you have to keep the lens pointed at the bird as it flies across the sky. For that you need a mechanism that offers support for the weight of the lens, but also for the ability to effortlessly move the lens up and down and left and right. Moving the lens to keep it pointed at a bird as it flies is called 'panning'. There are different supports systems that offer both support and panning, and depending on your preference and how you go about your photography, different systems will appeal to you.

Tripod

Tripods are often associated with portrait photography of people or landscape photography, but tripods form part of the essential equipment that bird photographers require. They not only support the weight of the lens, but tripod legs can be adjusted so that your lens is at the height you require, whether you stand or sit behind it.

Tripods have three legs with adjustable lengths that are joined at one point. The tripod head is the part at the top of the tripod onto which you connect your camera, and it has a mechanism that can be loosened or tightened to allow your camera to be moved up and down, and left and right. Some tripods and tripod heads are manufactured as one unit, and some are manufactured separately, allowing you to fix different tripod heads onto the legs. There are a variety of different types of tripod heads available, all designed for different applications and with different mechanisms.

The single-unit tripod legs and head are usually designed for small cameras and lenses – this small and lightweight tripod can be used to photograph anything from landscapes to people portraits to birds in flight.

Bird photographers require both a sturdy solution to support the heaviest of cameras and lenses, and a system that accommodates interchangeable tripod heads. The tripod systems that meet this requirement are the ones where the legs and heads are sold as separate units. Not only are the legs thick to support heavy weight, but the tripod legs are also long enough to support a camera and lens elevated high enough for you to stand behind it when the legs are extended. The legs are usually made up of three individual pieces that fit into one another and they are tightened on the ends where the pieces meet. When you set up your tripod, it is very important to test the tightness of these mechanisms. Once extended, apply some extra weight to each leg to make sure they don't collapse, before setting up your expensive lens on top.

Manufacturers do indicate the weight that a tripod can support and it is advised to use a conservative estimate for your camera and lens weight when you go tripod shopping. Bird photographers should get tripod legs that can support a minimum of 8kg. Manufacturers offer tripod legs in various materials, including steel, aluminum, graphite and carbon fibre which make a significant difference in weight. Carbon fibre is the lightest material but also the most expensive, and if you consider that you will be carrying the tripod, lens and camera around the lake, from the car to the bird hide and even across airports, weight could be more important than cost.

Tripods for bird photographers are long and bulky, so if the tripod does not fit onto your camera bag, it is handy to carry it in a tripod bag that you can throw over your shoulder, especially when travelling by air.

Tripod heads are designed for one of two applications.

- The first is to offer fixed angle and position. The **ball head** is the most popular solution for this application and is preferred by landscape photographers who need to aim their lens in a certain direction and then lock it in that position. It is not recommended for bird photography.

- The second application is one that offers smooth movability of the lens. **Gimbal** and **fluid heads** are popular solutions for this application.

Birds fly in a three-dimensional space, so in order to photograph them you need to point your lens at them, which is a two-dimensional exercise: up, down, left or right. How close you are to the bird is the task of the autofocus system as focusing is a function of the distance of the subject away from you. In order to point your lens at a bird in flight you require a system to support your lens and make the moving of the lens smooth and effortless. Your only other alternative is to have a large bicep. The ability to swing the lens quickly in the direction of an approaching bird is crucial to getting that shot and that is what gimbal and fluid heads are designed to do.

My suggestion is to invest in sturdy tripod legs that can support some of the heaviest cameras and lenses on the market because you never know what equipment you might end up getting in future. Sturdy tripod legs can be expensive, but if you spend the money now, you'll have the benefit of it forever.

ISAK'S TIPS

When you have your camera and lens on your tripod, never leave it unattended. In fact, always keep your hand on your camera because you never know when a dog may run past you through the tripod legs or an unexpected burst of wind decides to blow your tripod over.

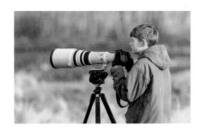

Gimbal head

A gimbal head is a tripod head mechanism with swinging arms that allows effortless movement in all directions. A lens is attached through the lens collar onto the swinging arm of the mechanism at the lens's centre of mass. The lens will then be horizontal when hanging free. The whole mechanism can turn sideways on the tripod which allows the photographer to effortlessly move the lens left, right, up and down by applying very little force.

Gimbal heads are some of the most popular tripod heads for bird photographers and allow for smooth panning when taking photos of birds in flight as well as sturdy support when doing portrait shots of static or slow-moving subjects. They allow you to point your lens effortlessly in any direction whether you sit or stand behind your lens. Gimbal heads offer the widest shooting angles, 360 degrees horizontally and almost the same vertically. They have two knobs to fix the lens vertically and/or horizontally. When you photograph normally, you would have the knobs open, but you can lock the lens into position when, for example, aiming at a perch where a bird is going to land. You would also lock it if you carry the lens around on the tripod.

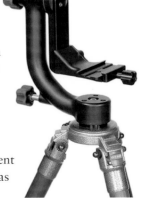

The gimbal head is designed to offer effortless movement of the lens. The drawback is that the mechanism has

very little resistance and does not absorb any vibrations from the camera when you take photos. These vibrations are then absorbed into the lens, making it vibrate ever so slightly. This becomes noticeable when you take photos with the lens in a fixed position and is problematic when you shoot at slow shutter speeds as the slight movement could cause blurry photos.

It is, however, a heavy and bulky piece of precision-made equipment, adding a lot of weight to your camera kit.

Fluid head

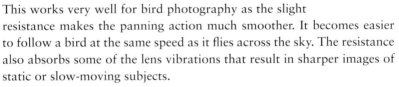

Fluid heads are designed with the same objective as a gimbal head. They offer smooth panning for a lens with the ability to lock it into a specific position. A fluid head has, like the name suggests, a fluid resistance in its mechanism that offers adjustable resistance to the moving elements. This works very well for bird photography as the slight resistance makes the panning action much smoother. It becomes easier to follow a bird at the same speed as it flies across the sky. The resistance also absorbs some of the lens vibrations that result in sharper images of static or slow-moving subjects.

The fluid head also offers a very wide shooting angle, 360 degrees horizontally, but probably a few degrees less on the vertical axis compared to the gimbal heads.

Beanbag

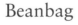

The beanbag is the original camera support system. It is the simplest, and cheapest support system and it works very well. Whether it is filled with rice, plastic beads or beans it takes shape around your lens when you rest on it, absorbing vibrations to keep it perfectly still when releasing the shutter. This renders sharp images! To get the most from your beanbag, it is important to dig the lens barrel into the bag slightly so that the fit is snug.

- Beanbags offer the flexibility to move them around quickly especially if your shooting position changes considerably.
- They fit onto any surface.
- You can stack a number of beanbags on top of one another to gain height or offer more support.
- You also have the flexibility to adjust the position of your lens without much effort.

Beanbags can be made with pieces of rectangular cloths, sewn together and filled with rice or beans. There are many different shapes and sizes that can be bought and, depending on the application, there will be various ones that work well. The U-shaped beanbag is good on the round bars on safari vehicles as well as over the door of your own vehicle. Normal rectangular beanbags work well on flat surfaces, and having more than one bag gives you the option of assembling your own structures.

There are two drawbacks to beanbags that you need to be aware of.

- Firstly, when the lens is resting on the beanbag and you move it to follow a bird in flight, it will also twist the focus ring, compromising the focusing of the lens and resulting in out-of-focus images. So for taking photos of birds in flight it's important to keep the focus ring from touching anything. You can still use the beanbag if you have no other support, but rest the collar of the lens on the beanbag.
- Secondly, when a bean- or rice-filled beanbag gets wet, it will start to smell – you may even have to throw the bag away.

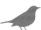 ISAK'S TIPS

To offer even more sturdy support, rest your lens on a beanbag while putting another beanbag on top of the lens. This will add some weight and make the lens steadier, resulting in sharper photos, even at slow shutter speeds.

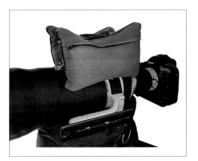

Panning plate

A panning plate is small and flat with a
turning head where you slot and tighten
the lens collar onto the head, allowing
for a smooth and effortless sideways
panning motion of your lens. It is handy to
use in a bird hide where there is no space to
set up a tripod or when you photograph from a
vehicle. It is important to use it with a beanbag by placing it flat on top
of the beanbag. That allows for up and down movement by tilting the
plate forward or backwards on the beanbag.

ISAK'S TIPS

A panning plate offers you a lot of freedom when you use it on a safari vehicle.
It can stay permanently attached to the lens collar, allowing you to pick the lens
up for hand-held shots. Then when
you place it back on top of a beanbag,
it allows for smooth left and right
panning, especially when you do slow-
motion panning blur shots.

Ground pod

A ground pod is very similar to a panning plate, but
does not have a turning head. It merely has a thread
on the top of the plate to allow for screwing any type
of tripod head on top of it. This is very handy as you
can screw either a gimbal or fluid head onto it. These heads
allow for up, down, left and right movement so you can operate your
camera and lens in the same way as on your tripod. The ground pod is
useful in a hide where there is no space for a tripod, as well as when you
photograph with a long lens from a vehicle. Put a beanbag over the door
of your vehicle and rest the ground pod on the beanbag.

ISAK'S TIPS

An added advantage of the ground pods is to use it when laying flat on the ground for those low-angle shots. With a gimbal on top of the ground pod you can move a heavy lens effortlessly in any direction.

Monopod

A monopod is basically a tripod on one leg. It is used for supporting the weight of a camera system when the photographer is in a standing position. Bird photographers would typically use it when needing a long lens while walking in the field, quickly taking a couple of photos and then carrying on walking. It does not offer the sturdy support of a tripod or smooth-panning motion of a fluid or gimbal head, but it does offer some degree of movability. With its convenient size and weight, it makes it easy to carry and much faster to setup compared with a tripod when you want to just quickly take a few shots. It's not a permanent substitute for a tripod, but if you don't have both a tripod and monopod it still offers valuable support, which is better than hand-holding a lens. Just like tripods they are also manufactured using different materials where the carbon fibre versions are lightweight and strong, but expensive.

Using a monopod requires the photographer to hold onto it with one hand for support and then with the same hand move the whole system in an attempt to point the lens in the direction of a subject. The other hand is on the camera ready to press the shutter. Any type of tripod head can be used on the monopod, but that head would normally be locked to stop any additional movement of the lens relative to the monopod. To move the lens, you have to move the monopod with it as a whole.

ISAK'S TIPS

A monopod can be used on a safari vehicle to take low-angle photographs when you're not allowed off the vehicle. Simply attach your camera and lens to the monopod, extend the legs, lower it slowly to the ground with your hand next to the side of the vehicle, while you release the shutter with a remote release with your other hand. You will have to photograph blindly, aiming the lens with the hand that holds the tripod, but with some practice and lots of photos, your success rate will improve.

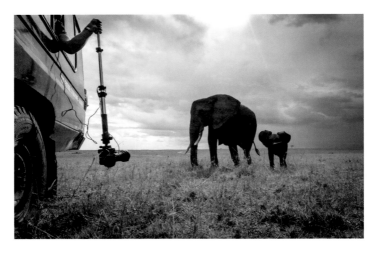

Other accessories

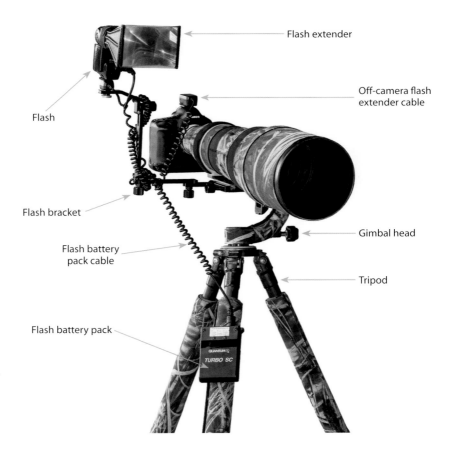

Flash extender

Off-camera flash extender cable

Flash

Flash bracket

Flash battery pack cable

Gimbal head

Tripod

Flash battery pack

Flash

Contrary to popular belief a flash is designed to balance light, and not to be used as the main source of light. This means that photographing a bird in the middle of the day with harsh sunlight conditions, dark shadows will fall unevenly across the bird's face, making it an ideal situation to fill in those shadows with a little application of flash light. But, as mentioned before, since it's difficult to get close to birds it means that you're probably far away with a big lens. The flash needs to be bright and strong, much stronger than if you're photographing people close-up under the same conditions. Distance and the aperture you use have the biggest effect on flash, requiring it to be stronger for the same effect if you're further away from your subject. This means that strong flashes are needed.

Entry-level and advanced amateur camera bodies have on-camera, pop-up flashes, while professional bodies come standard without on-camera flashes. But since you require a strong flash, I recommend that you invest in a good external one even if you have an on-camera flash. The on-camera flash is simply not strong enough for bird photography applications. Other disadvantages of the on-camera, pop-up flashes are that they are powered by the camera itself, thus draining the camera's battery and compromising the number of photos you can take. Another disadvantage is that it can't recycle fast, meaning that if you take photos in rapid succession, the flash would only fire every now and again and not keep up with the camera.

External flashes fit onto the top of the camera, on the hotshoe. Flash brands are not interchangeable, so you can't use your Canon flash on a Nikon camera body or the other way around. Some other companies like Nissan, for example, make flashes for most camera brands and often cost less than the camera's brand with the same features.

The professional series of flashes from the camera manufactures have a lot of features that might be unnecessary unless you want to do sophisticated flashwork with multiple flashes or strobes. I would suggest you look for a flash that is strong, with good recycling time and where you can set the exposure compensation on the flash itself.

Flash accessories

There are some flash accessories, other than a flash battery pack, that would make sense for a bird photographer to own.

- The first is a flash extender. This is a cheap but effective accessory that extends the range of your external flash. A normal flash has a short range, usually shorter than the distance you need to reach birds. The flash extender will add those few extra metres of reach to your flashlight. It should be permanently fitted to your flash when you photograph with your long lens.

- Another useful accessory is an off-camera flash extender cable used in combination with a flash bracket. The bracket will hold the flash in place, off camera, while the off-camera flash extender cable will connect the camera to the flash. When the angle between the flash and the lens is too close, you often get the green reflected eye of a bird from the flash. By moving the flash away from the camera, increasing the angle between the flash and the camera, the effect becomes less or is illuminated. Remember to buy the off-camera flash extender cable for your specific brand of flash.

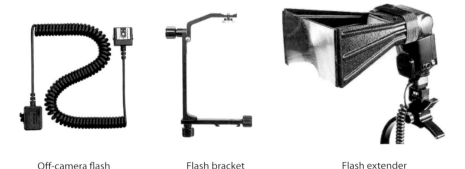

Off-camera flash Flash bracket Flash extender
extender cable

Memory cards

The photos taken by a photographer on a DSLR camera are stored in digital format on a memory card that slots into the camera. This card has a limited capacity and can store only so many photos. Before the card is full, the images should be cleared from the card by copying them onto a computer.

Compact Flash (CF) and Secure Digital (SD) cards are the most commonly used in DSLR cameras. Different camera models use different card types, with some models even having slots for both. There is no practical advantage of one type over the other, and the camera model you own will dictate your choice of card type.

Your choice in memory cards is limited to the brand, size and speed. Like with most electronics, it is advisable to stick with leading brands. For memory cards I suggest Lexar or Sandisk. That leaves you to choose the size and speed. For bird photographers both options are equally important. Size refers to the data capacity of the card. It is measured in gigabytes (GBs). The larger the card, the more gigabytes it is and the more photos you can fit onto the card. As the size increases, so does the price, so what size is good enough? A good criterion would be to have enough capacity for one full day of photography based on an elaborate estimate. Then, double that capacity. If you consider how much money you spend on cameras, lenses and photographic trips, and how important it is not to run out of space with your cards, then it makes sense to have more than adequate capacity. Bird photographers tend to take a lot of photos, and you want to make sure that on that day when you have an exceptional sighting where there is non-stop action and photographic opportunities, you can carry on taking photos without worrying about filling all your cards to capacity, running out of space and missing great photos. The newer DSLR cameras create higher resolution images that take up more space on your cards, reducing the number of images that can fit onto a card. I typically use a 128GB card that offers more than enough capacity.

As you take photos, the images are stored digitally on the camera's buffer memory and then downloaded onto the memory card. This happens automatically. Each camera has a specific transfer speed at which it downloads the images to the card, referred to as the **write speed** of the

camera. The card itself has a separate write speed at which data can be written to it. Thus, to utilise the full potential transfer speed of the camera to the cards, you should get a card that has a faster or equal write speed to that of the camera. Alternatively, the camera would only be able to write data to the card at the slower write speed of the card.

Read speed of the card is the rate at which data can be read from the card when you download your images from the card onto your computer. Since this does not influence the performance of the camera or potentially limit you when you take photos, the read speed of cards is not a serious consideration when choosing a card.

Both read and write speeds are measured in megabits per second (MB/s). A good benchmark currently is a card with a write speed of over 100 MB/s. Some manufacturers do not specify the speed in these units but rather something like '100x' which cannot be used as a measurement to compare speeds with other cards. Buy the fastest cards that you can get because, as technology improves, the slower cards get obsolete or redundant quickly.

Speed

Size

Secure Digital (SD)
memory card

Compact Flash (CF)
memory card

 ISAK'S TIPS

I've often heard people give the advice that it's better to have a lot of small cards than one large card. The argument is that if the data on any card corrupts, then at least you don't lose all your data. I disagree. I think there is a much better chance that you will lose small cards by misplacing them than one big card that gets corrupted. Corrupted cards can happen, but very seldom, and even if it does happen, you'll have an excellent chance of retrieving most images with data recovery software. The convenience of having a few large cards as opposed to having lots of smaller ones definitely outweighs the disadvantages.

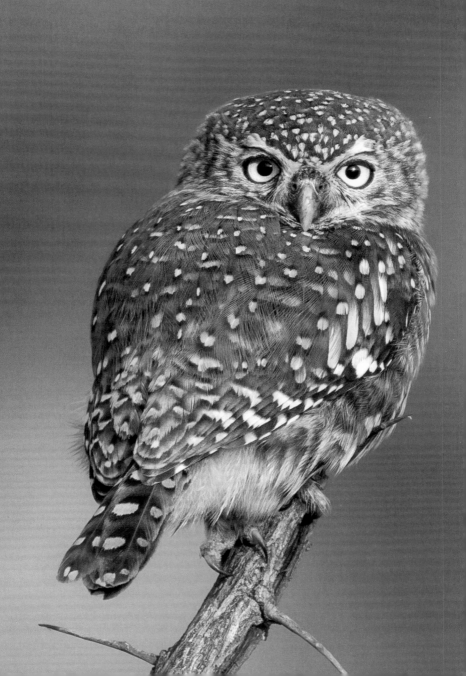

Different modes for different applications

Introduction

All DSLR cameras have different modes for using while photographing. Depending on the model it might have an Auto, P, Av (A), Tv (S), M, Bulb, Sport, Landscape or Portrait mode. What do they all mean and which one is the best for bird photography? To answer these questions you have to first understand the fundamentals of digital photography: aperture, shutter speed and ISO. These three controls create the exposure – in essence they create the photo. The mode that you choose to photograph in, whether it is P or Av (A) or Sport mode is just a different way in which the photographer and the camera together adjust the aperture, shutter speed and ISO in order to create an exposure. But, before things get too confusing, let's start at the beginning.

Digital photography has made photography easy enough that anyone can take a good photo, even if you don't know the basic fundamentals of photography. Photography can be categorised as part technical and part creative. Good photographs of birds are the ones that draw the viewers' attention, typically a creative vision that was captured in a technically perfect fashion. But there is no point in having wonderful creative ideas without the technical skill to pull them off. These creative ideas will only allow you to improve your photographs to a point, but you need to understand the basic mechanics of photography, what effect this has on your photos, and how to use this to your creative advantage.

Digital cameras might have revolutionised photography, but the principles remain the same. The creative part follows the same rules of art in digital photography as it did in analog photography. The technical part also follows the same rules in digital photography as in analog photography – with the exception of the digital sensor that has replaced film. Digital photography has just made it easier for the photographer to achieve technical perfection by displaying the results at the back of the camera and changing some of the settings on the photographer's behalf.

Photographs are defined as the capture of light and that is what cameras are designed to do – to capture light. To do this, you need the following:

• You need the light to fall onto a surface where you can record it, and to be able to **control the intensity level** of the recording.

• You need to **control the amount of light** that falls onto this surface.

• You also need to **control how long the light will remain** on this surface.

These three variables create an exposure – the recording level, amount of light and length of time. In digital cameras the **recording level** of light is the ISO, the **amount** is the aperture and the **time** is the shutter speed. These three mechanisms work together and not only affect the exposure but each one controls its own effect.

It is important for a bird photographer not only to understand how aperture, shutter speed and ISO affect the exposure of a photograph, but also what other unique effects they each have. They are all linked by the way they change exposure. This means that if one is changed, one of the others (or both) must be changed to compensate for the change in exposure. For example, if the shutter speed is slowed down, it adds more light and then the ISO can be set to be less sensitive to compensate and keep the exposure the same. This means that in addition to the changes in value of shutter speed and ISO, each one's own effects are changed. The slower shutter speed creates more blur when there is motion present and the lower ISO creates a less grainy image.

 KEY POINTS

• **Aperture is the size of the opening** in the lens through which light travels. A **wide aperture, such as f/4**, is a large opening and lets in a lot of light. A **narrow aperture, such as f/22**, is a small opening and lets in little light.

• **Aperture affects depth of field**. A wide aperture, such as f/4, creates a **shallow depth of field**. This is where the subject is in focus and the background is soft, making the subject stand out from the background. A narrow aperture, such as f/22, creates a **deep depth of field**. This puts everything in the photo in focus.

- **Shutter speed is the duration** that the shutter stays open. A **slow shutter speed, such as 1/10 of a second,** exposes the sensor to light for a long time. A **fast shutter speed, such as 1/2500 of a second,** exposes the sensor to light for a short time.

- **Shutter speed affects sharpness.** A slow shutter speed, such as 1/10 of a second, will be sensitive to the lens or subject movement and could create **blurred images.** A fast shutter speed, such as 1/2500 of a second will **freeze any fast-moving subjects.** The faster the subject moves, the faster shutter speed you require to freeze the motion.

- **ISO is the sensitivity of the sensor. High ISO values, such as ISO 1600,** create **low quality** images with noise but allow for faster shutter speeds to be used. **Low ISO values, such as ISO 100,** create the **best quality** 'clean' images but require slower shutter speeds to be used.

- In **aperture priority mode** (Av or A) **you choose both the aperture and ISO** and the **camera chooses the shutter speed.** This is the most popular mode for bird photographers to photograph in as you need to be in control of the depth of field.

- In **shutter priority mode** (Tv or S) **you choose both the shutter speed and ISO** and the **camera chooses the aperture.** The only application for this mode is if you want to photograph at a specific slow shutter speed.

- In **manual mode** you choose all the exposure control settings: **aperture, shutter speed and ISO.** This mode is useful when you have a consistent light source, like a sunny day, and you photograph in a single general direction.

- With **auto-ISO enabled the camera will choose an ISO.** In aperture priority and shutter priority this mode leaves too little control to the photographer and the camera might sacrifice shutter speed for quality, which is typically the decision that the photographer should make. **Only use auto-ISO in manual mode** – this means you choose aperture and shutter speed and the camera will choose the ISO.

- **RAW files** store images at the **highest possible resolution and quality,** and this is the recommended file type for bird photographers. The alternative **JPEG file type is smaller** and you can fit more photos onto a memory card, but you have less room to make changes during post-processing.

- **White balance is the temperature and tint** of a photo. You can either make the camera choose the white balance with auto white balance enabled or choose a specific white balance. In **RAW files the white balance is not embedded** and can be changed during post-processing, making **auto white balance an ideal way to photograph** with one less setting to think about when photographing.

Aperture

An aperture is the lens opening and physical diaphragm inside a lens that can open and close to control the amount of light that comes through the lens. The size of the opening is measured in f-stops where a small lens opening (or narrow aperture) is indicated by a large f-number, e.g. f/22. A large lens opening (or wide aperture) is indicated by a small f-number, e.g. f/4. This becomes rather confusing because when you refer to a narrow aperture, you are talking about the size of the hole – and this is directly opposite to the f-number which is large.

For reference: narrow aperture = f/16; wide aperture = f/4

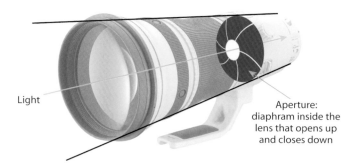

Light

Aperture:
diaphram inside the
lens that opens up
and closes down

The function of the aperture is to control the amount of light that falls onto the sensor to create even exposures, but the effect of the aperture is that it modifies the depth of field in the image. Photographers love the effect of depth of field, and love being in control of it. Have you ever seen a portrait photograph of a bird where the background is perfectly soft and out of focus, making the bird stand out from the background? You could say the bird 'pops' out of the background. It is a wonderful effect

to accentuate the bird and create a clean, simple, but striking image. That effect is called shallow depth of field. It means that only a small area or plane within the photograph is in focus, and everything else is out of focus. Landscape photographers love to use the opposite – they want everything in the photo to be in focus: the foreground, mountains in the background and clouds in the sky all need to be sharp and in focus since all the elements carry equal weight in the image.

Changes in aperture can be expressed as changes in stops of light. The reference to 'stops of light' is so that you can compare apples to apples when you compare the effect on exposure by the aperture, shutter speed and ISO. That will be discussed later, but first let's talk about how a change in aperture is expressed as changes in stops of light. This means f/8 is a standard aperture, from there f/11 is one stop narrower and f/5.6 is one stop wider. These values might not make much sense, but in time you will get more familiar with them. You can set your camera to make adjustments in exposures in full stops, 1/2 stops or 1/3 stops. This means that if you've set the camera for 1/3 stop intervals, every turn of the aperture dial would only change the aperture 1/3 of a stop. The f-numbers are then also displayed differently. From f/8 it would go to f/9, then f/10 and then f/11 if you turn the dial three times.

Depth of field is a function of the focal length of the lens, the lens aperture and the chosen aperture. A shallow depth of field means your subject is in focus and the background is out of focus. A deep depth of field means that both subject and background are in focus. The effect of a shallow depth of field is by default more easily created by a long lens. Aiming a wide-angle lens at a tree in the distance, for example at f/8, will put everything in the image in focus (the tree and the mountain behind it), while aiming at the same tree at f/8 with a 600mm lens will have a shallow depth of field effect – the tree will be in focus and the mountain behind out of focus. To think of depth of field is to think of levels of distances away from you. To get all the subjects on the different distance levels in focus, you need to have a deep depth of field, like f/16. The further the distance levels are from one another, the deeper the depth of field you need to keep them all in focus, such as f/22. The opposite is also true. If the subjects are on distance levels that are close to one another, it

will be difficult to keep one subject in focus and the others out of focus, so you should use the widest aperture you have, e.g. f/2.8. If you keep using f/2.8, then the subjects will be more out of focus when the distance levels are further away from one another.

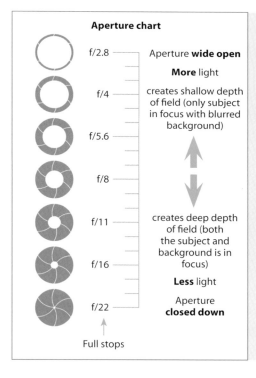

Aperture chart

f/2.8 —— Aperture **wide open**

More light

f/4 —— creates shallow depth of field (only subject in focus with blurred background)

f/5.6 ——

f/8 ——

f/11 —— creates deep depth of field (both the subject and background is in focus)

f/16 ——

Less light

f/22 —— Aperture **closed down**

Full stops

Aperture Chart: Aperture is measured in f-stops where f/2.8 refers to a large opening that lets a lot of light through. From f/2.8 to f/4, then f/5.6 and so on decreases the light by one full stop each time.

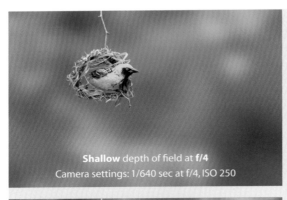

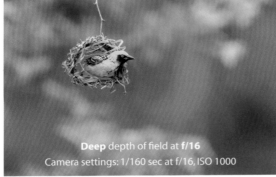

Shallow depth of field at **f/4**
Camera settings: 1/640 sec at f/4, ISO 250

Aperture affects the depth of field. With a wide aperture the subject is in focus and the background blurred for a shallow depth of field. With a narrow aperture both subject and background are in focus for a deep depth of field.

Deep depth of field at **f/16**
Camera settings: 1/160 sec at f/16, ISO 1000

Through the viewfinder the aperture value is expressed as the number of the f-stop only. In this case, 5.6 which means f/5.6.

Aperture: this indicates an aperture of f/5.6

58

Bird photographers love the shallow depth of field effect as it makes the birds stand out from the background. So you should always shoot at widest apertures such as f/4 or f/5.6

I mentioned earlier that depth of field is also a function of the lens aperture. The degree to which a lens can separate the background from the subject is referred to as the bokeh (the term comes from the Japanese word *boke*, meaning 'blur' or 'haze'). Wide aperture lenses like f/2.8 lenses naturally have a better bokeh, meaning they create a soft out-of-focus background. If you take a photo of a bird against a uniform background with a 400mmf/5.6 lens at f/5.6, the background would be more in focus than the same photo taken with a 400mmf/2.8 lens at f/2.8.

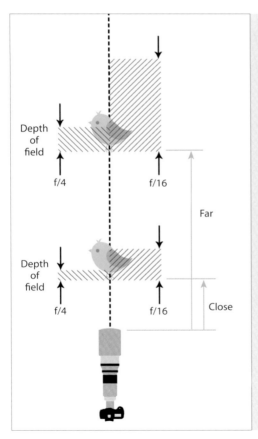

When you focus on a bird, only a part of the bird is in sharp focus – from a little in front of the focus point to a little behind the bird. This is the depth of field. The closer the bird is to you the narrower this area becomes when using the same aperture. If you have focus on the front leg of a Malachite Kingfisher for example that sits sideways 6 metres away from you, the back leg would be out of focus if you use a 600mm lens at f/4. That is how shallow the depth of field becomes with a long lens at a wide aperture at it's minimum focus distance.

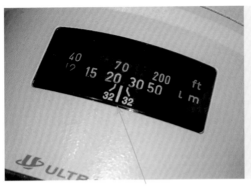

Most lenses have a focus distance measure at the top of the lens. As the lens focuses you will see the numbers change until it stops when focus is achieved. The number across the white line is the focus distance.

Focus distance = 24m

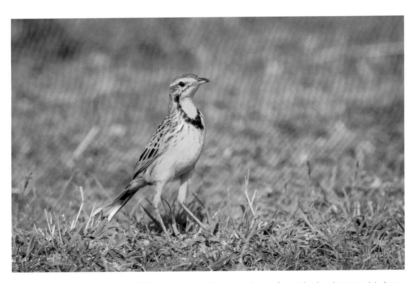

To create a shallow depth of field where the bird stands out from the background, I chose a wide aperture of f/5.6.

Yellow-throated Longclaw, Maasai Mara National Reserve in Kenya | *1/2000 sec at f/5.6, ISO 400*
Canon 1D Mark IV + 600mmf/4 lens | *Aperture Priority, 0 ev*

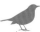 ISAK'S TIPS

For the best shallow depth of field effect you should try to get as close to the bird you're photographing as possible. This means trying to make the distance between the bird and its background as large as possible relative to the distance between you and the bird.

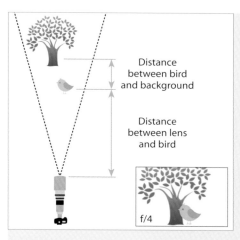

Distance between bird and background

Distance between lens and bird

f/4

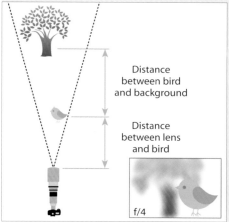

Distance between bird and background

Distance between lens and bird

f/4

Bird photographers are always concerned about backgrounds. An out of focus background makes the subject stand out from the background and is one way to accentuate the subject and simplify a composition. Even when using the widest aperture you will notice that the further the background is behind the bird, relative to the distance to the lens, the more out of focus the background will become. Getting closer to the birds is thus one way of getting those nice out of focus backgrounds even if you don't own a lens with a wide aperture.

Shutter speed

Shutter speed is the length of time that the camera sensor is exposed to the light coming through the lens when you take a photo. This is measured in seconds, and a typical shutter speed is only a fraction of a second, like 1/50th of a second for example. Depending on the mode you photograph in, the shutter speed will either be something that you specifically choose or that the camera automatically chooses. The slower the shutter speed, the longer the amount of time that the sensor is exposed to the light. This will therefore create a brighter exposure if the other settings on the camera do not compensate for it. The opposite is also true where a faster shutter speed will expose the sensor for a shorter duration resulting in a darker exposure.

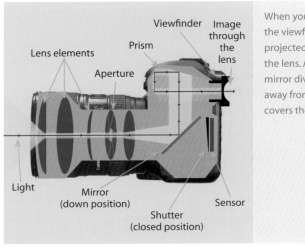

When you look through the viewfinder you see a projected image through the lens. At this stage the mirror diverts the light away from the shutter that covers the sensor.

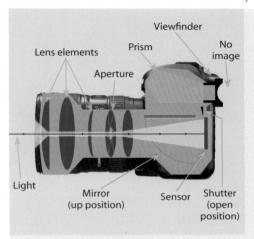

Viewfinder

Lens elements

Prism

No image

Aperture

Light

Mirror (up position)

Sensor

Shutter (open position)

When pressing the shutter button:

- The mirror flips up to make the light travel to the sensor, making the view through the viewfinder dark for that moment. This is the sound you hear when you take a photo.
- Light travels to the shutter and for the duration of the selected shutter speed the shutter curtain opens up to expose the sensor to the light (usually only a fraction of a second).
- After the sensor captures the light, the shutter curtain closes back into position and the mirror flips down again to direct the light away from the sensor and through the viewfinder.

Shutter speed chart

1/2000 — **Faster** shutter speed

Less light

creates **sharp** images (freeze action)

1/1000

1/500

1/250

1/125

creates **blurred** images (movement blur)

1/60

More light

1/30 — **Slower** shutter speed

Full stops

Inside the camera body of a DSLR camera is a shutter box with a mirror. When you press the shutter button to take a photo, the camera flips the mirror up to expose the sensor to the light coming through the lens. The shutter speed is the length of time that the mirror stays up, before flipping back down to divert the light coming through the lens upwards to the viewfinder, and blocking it from the sensor. The force at which the mirror flips up and hits the top of the mirror box is quite significant – that is the sound you hear and vibration you feel when you 'take the photo'.

Shutter speeds of today's DSLR cameras can be set from 30 seconds to 1/8000th of a second in **shutter priority** and **manual mode**, while in **bulb mode** the shutter will stay open for as long as you hold the shutter button down (or until the camera battery goes flat). Shutter speed is displayed as the fraction of a second on the LCD screen and through the viewfinder if it's less than a second. For example, 1/200th of a second is displayed as 200, and 1/50th of a second is displayed as 50. When the shutter speed is close to a second, it gets tricky. 4 means it's 1/4 of a second (0.25 seconds), then 0"3 means it's 0.3 seconds, 0"8 means it's 0.8 seconds and 1" means the shutter speed is 1 second long. From there it's easy again, with 2" meaning 2 seconds and 2"5 meaning 2.5 seconds shutter speed, etc. So just take note that 5 means 1/5th of a second and 5" means 5 seconds.

Shutter speeds can also be referred to as 'exposure'. When people say 'a 30-second exposure', they mean using a shutter speed of 30 seconds.

Similar to the changes in aperture, the changes in shutter speeds can also be expressed as changes in **stops of light**. Every doubling or halving of a shutter speed changes it by one stop. Doubling 1/100 sec to 1/200 sec can be referred to as reducing by a stop of light (or darkening it by one stop), while halving it to 1/50 sec will be adding a stop of light (or brightening it by one stop).

Luckily you don't have to worry about the exposure effect of shutter speeds since the camera will calculate exposure for you. So even if you choose a specific shutter speed, the camera can adjust the other controls to compensate for it. Shutter speed does, however, have an effect on the sharpness of photos and this is why shutter speed is the most important control that every bird photographer should take note of.

Either the movement of the lens or movement of the subject causes images to be blurry and soft even while perfectly in focus. Consider that if the shutter is open for x amount of time, in that time, while the sensor is capturing the image, if the subject moves, the image of the subject will appear blurred in the photograph. Thus, the faster the subject moves, the faster your shutter speed should be to freeze the motion.

In bird photography your subjects can move very fast especially when a small bird flies across the sky. When it sits still you can get away with slower shutter speeds for capturing a portrait shot, but as soon as it takes-off, you require a fast shutter speed to freeze that motion. You don't always necessarily want to freeze the motion, sometimes you can aim to capture a sense of motion, blurring the wing tips, for example, in a bird-in-flight photograph. It can even go further and blur the whole picture of a bird flying across the sky with only its head sharp in the photo. For that effect you need to use a slow shutter speed to blur the movement while at the same time panning with the subject, keeping the head of the bird in the same position in the viewfinder for the duration that the shutter remains open. In other words, when you want to create a blurred effect, then you should use a slow shutter speed. If you want to freeze the motion, then you need to use a fast shutter speed. The faster the subject moves, the faster shutter speed you require.

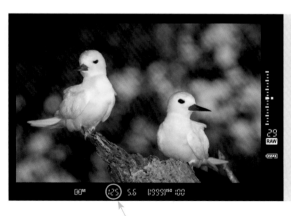

Through the viewfinder the shutter speed value is expressed as a number only and not a fraction. In this case the 125 refers to 1/125th of a second shutter speed.

Shutter speed:
this indicates a shutter speed
of 1/125th of a second

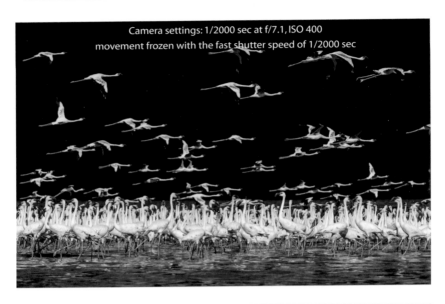

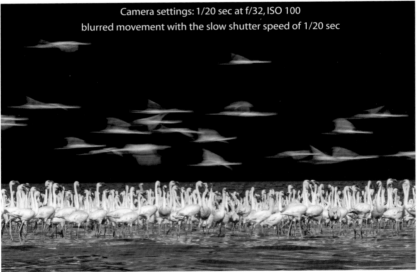

Shutter speed affects the 'freezing' of action or blur of motion. With a fast shutter speed, any action will freeze the action in a sharp image. With a slow shutter speed, any motion of the subject or motion because of lens movement will be captured as a blur.

ISO

ISO refers to the sensitivity of the camera's sensor. It controls the time required to create an exposure and affects the quality of the image. The higher the ISO number, such as ISO 1600 for example, the more sensitive it is to light and the poorer the image quality will be with lots of noise (grain). At a high ISO the sensor needs very little time to create the exposure (or capture the image on the sensor). The lower the ISO number, such as ISO 100 for example, the less sensitive the sensor is to light and the better the image quality will be with little or no grain (noise). At a low ISO the sensor needs a long time to create the exposure (or capture the image on the sensor). ISO is measured by numerical values. Typically ISO 100 is the lowest ISO value and can then be set higher to ISO 200, then 400, 800, and upwards to ISO 12800 or even more on the latest cameras. These values can be expressed as stops of light, doubling or halving the values. ISO 400 is one stop less than ISO 800 for example, while ISO 1600 is one stop more than ISO 800. You can set your camera to make adjustments in exposures in full stops, 1/2 stops or 1/3

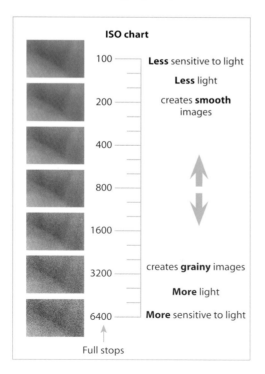

ISO chart

100 — **Less** sensitive to light

Less light

200 — creates **smooth** images

400 —

800 —

1600 —

3200 — creates **grainy** images

More light

6400 — **More** sensitive to light

Full stops

stops. This means that if you've set the camera for 1/3 stop intervals, every adjustment of ISO would only change the value by 1/3 of a stop. From ISO 100 it would go to ISO 125, then ISO 160 and then ISO 200 if you adjust the values three times.

ISO affects the quality of the image. At a high ISO-sensitivity level the sensor will capture light quickly but will create a grainy poor-quality image. At a low ISO-sensitivity level the sensor will take long to capture light but the image will be smooth and of good quality.

Camera settings: 1/50 sec at f/5.6, ISO 200
smooth surface with the low ISO of 200

Camera settings: 1/320 sec at f/8, ISO 3200
grainy surface with the high ISO of 3200

Through the viewfinder the ISO sensitivity is expressed as a number. In this case 100 means ISO 100.

ISO: this indicates an ISO sensitivity of 100

'Noise' refers to the grain on the image. It is the small specs you see that are most noticeable when you zoom into an area of the image. Noise can be seen best in the darker tones, usually on the areas of the photo where you have a soft, uniform and out-of-focus background. This grain might be a nice effect for a black-and-white photograph, but bird photographers should try to avoid it. Less noise means better quality, making the images look better and allowing you to print your images bigger and at a better resolution.

Portrait photos are usually taken at low ISO values.

Southern Yellow-billed Hornbill, Kruger National Park in South Africa | *1/200 sec at f/8, ISO 400*
Canon 1D Mark IV + 600mmf/4 lens | *Aperture Priority, -1 ev*

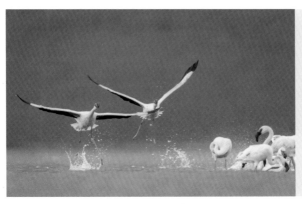

Sometimes the only way to get fast enough shutter speeds to freeze the bird in flight is to set the ISO high, even if it creates grainy images.

Lesser Flamingos, Lake Bogoria in Kenya | *1/2000 sec at f/6.3, ISO 4000*
Canon 1D Mark IV + 600mmf/4 lens + 1.4x | *Aperture Priority, -1/3 ev*

ISO works in the same way as the ASA did with film where low ISO values means good quality 'clean' images, and high ISO values results in noisy (or grainy) images. But if low ISO values mean better quality, why would you ever choose to use a high ISO value? The answer is that ISO forms part of the **exposure triangle** and affects your aperture and shutter speed. If you choose to use an aperture of f/4 for a shallow depth of field and a shutter speed of 1/2000 of a second, then the ISO needs to be adjusted to create an even exposure. That might result in you having to use ISO 1600, for example, that is high and will result in a noisy image. If you want to halve that, to ISO 800 for better quality, then one of the other values must also be adjusted to keep the same exposure. The shutter speed will have to compensate for that by changing it to 1/1000 of the second, for example, which could potentially influence the ability to 'freeze' the motion.

Photography is a game of compromise. In the scenario described above, would you want to adjust the ISO lower for better image quality but risk not being able to freeze the action in the image, or do you want to be sure to freeze the action in the photo but have a grainy image? The train of thought should be to use the lowest possible ISO while still maintaining your chosen aperture and having a shutter speed to give you a sharp image where required.

Good noise performance is one of the major advancements of the latest technology. The ability to get good-quality images at high ISOs means that you can photograph at much faster shutter speeds. Consider that ten years ago when you tried to photograph a bird in flight, just before sunrise when the light was low, you could only use ISO 800 as that was the highest ISO that offered acceptable quality. Under those conditions and with those settings it would only allow for a shutter speed of a 1/50 sec, which is so slow that it is impossible to get a sharp image. Today, the highest ISO with acceptable quality is probably ten times that, resulting in a 1/500 sec shutter speed under those same conditions, which gives you a much better chance of getting a sharp image.

What is the highest ISO you can use? That is an impossible question to answer and will be a personal choice. Bird photographers are always looking to use fast shutter speeds and thus tend to push the ISO as high as they can. Different camera models have different noise performances,

but the latest model will always have an improved noise performance over its predecessor. These days the advances in high ISO performance are so great that you can hardly see a difference between ISO 100 and ISO 800, and even ISO 8000 produces acceptable results. Professional camera bodies perform better than advanced amateur camera bodies, and they in turn perform better than entry-level camera bodies at high ISO.

Personally, I do not mind a little bit of noise and would comfortably push my ISO up to ISO 2000 or even ISO 8000 if it's a special moment that I would otherwise not get. In good sunlight conditions ISO 400 is a good choice as it produces perfectly 'clean' and good quality images while still allowing for fast shutter speeds. My advice would be that images that are soft because of slow shutter speeds get thrown away, but a sharp image with lots of noise can be recovered and saved. So rather use slightly higher ISO values, but make sure you get a sharp image.

In sunlight conditions, keep your camera on ISO 400 by default, but when the light is low such as overcast conditions, push it up to ISO 800 (or even higher).

 ISAK'S TIPS

In RAW mode you can recover exposure to a large degree in post-processing. When you have an under- (dark) or overexposed (bright) image, you can adjust the exposure back to normal levels. Noise, however, tends to show up badly when you have an underexposed image that you recover, and an overexposed image hardly shows any noise when you recover it back to normal levels. Thus, making sure you get the exposure correct in camera is a great way to reduce noise on your images (even if you shoot at high ISOs). A great tip is to have your images 1/3 of a stop overexposed in camera as that will reduce the noise when you correct the exposure in post-processing. But beware, your margin of error becomes much less so you have to be more conscious of exposure when you photograph. (This tip is only applicable to Canon users. The Nikon users should rather underexpose than overexpose in camera. Recovering an underexposed Nikon RAW image does not show more noise.)

Triangle of exposure: aperture vs shutter speed vs ISO

The word photography means the capture of light. The creating of an exposure is the technical core of photography and is controlled by the aperture, shutter speed and ISO. I'm talking only about the 'brightness' of the photograph and not the secondary effect of these controls (aperture influence depth of field, shutter speed influence sharpness, and ISO influence noise). These three mechanisms work together to create an exposure. Each one on its own manipulates the level of brightness of a photograph and thus the combination effect of these three controls is the exposure that gets created. Whether you set the values of aperture, shutter speed and ISO manually yourself, or whether the camera chooses them for you, if they are the same they will create the exact same exposure. Metering, exposure compensation, aperture priority, shutter priority and auto-ISO are just fancy ways in which the camera either chooses some of the values automatically or helps you to choose them yourself, but all they do is to set the aperture value, shutter speed value, and ISO value, which in turn create the exposure.

To explain how they affect one another (in terms of brightness), consider the following example. Pretend that 1/800 sec at f/8 and ISO 400 render an even exposure (this means the photo looks just right, it's not too dark or too bright). If you change the shutter speed to 1/1600, which is faster and allows for less time to capture the light, then the image would be darker (and be underexposed). If you change the shutter speed to 1/400 sec, which is slower and allows for more time to capture the light, then the image would go brighter (and be overexposed). The same effect will happen when you change the ISO. If you set it to ISO 200 (making it less sensitive to light), the image will be darker; and if you change it to ISO 800, it will make the image brighter (making it more sensitive to

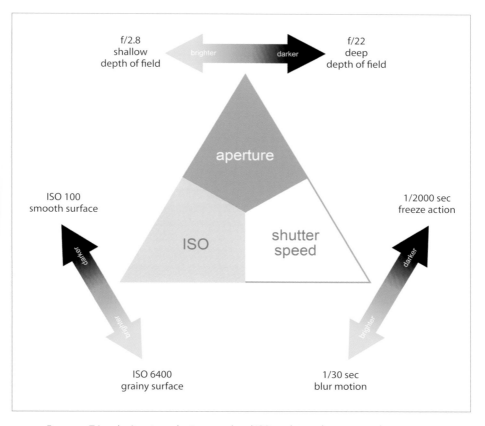

Exposure Triangle: Aperture, shutter speed and ISO work together to control exposure. Aperture affects depth of field, shutter speed affects sharpness and ISO affects image quality. When one value changes, it also changes the exposure and so another one must also change to compensate for it.

light). Changing the aperture will have the same effect. If you change it to f/5.6, it widens the aperture and allows more light through which makes the image brighter, and if you set it to f/11, it makes the aperture narrower and allows less light through, making the image darker. Therefore, each of these three mechanisms on their own manipulate the level of brightness of the image. But if you modify a combination of them, you will be able to keep the same exposure (i.e. keep the exposure as even exposure).

Aperture	Shutter speed	ISO		
f/8	1/800	800	Normal exposure	
f/8	1/1600	800	Under exposure Freeze action better	
f/8	1/400	800	Over exposured Blur motion more	
f/5.6	1/1600	800	Shallower depth of field Freeze action better	
f/5.6	1/800	400	Shallower depth of field Less grainy images	
f/8	1/400	400	Blur motion more Less grainy images	

As you now know, each of these three controls affects exposure, but they also have a secondary effect. Aperture influences depth of field, shutter speed influences sharpness, and ISO influences image quality. Using the example above, if you now know that you'd like to have a shallow depth of field effect, you have to change the aperture from f/8 to f/5.6. This is considered a one stop change in exposure. This will make the photo one stop brighter (or one stop overexposed). So, now you have to compensate for that change in aperture by changing one of the other two controls in the other direction to make their effect darker. You can either change the shutter speed one stop faster (darker) or change the ISO one stop down (darker). Pretend that you're happy with the original shutter speed and you decide to change the ISO one stop down to ISO 400. Now your settings are 1/800 sec at f/5.6 and ISO 400 compare to 1/800 sec at f/8 and ISO 800, but the exposure of the image remains the same. When you change one setting to one stop brighter, you have to change one of the other settings to one stop darker to compensate for it. When you change one setting to three stops brighter, you have to change the combination of the other settings to three stops darker.

Of course you never have to set these values manually like in the example, the camera chooses them for you, but it is important to know that if one of them goes up, the other(s) go down. This could, for example, mean that if you choose to have a shallower depth of field, you gain extra shutter speed, or if you want to use a slow shutter speed you should choose a narrower aperture. The most common compromise is that of image quality and shutter speed: a faster shutter speed to freeze the motion better means using a higher ISO resulting in a grainier image (poorer quality).

◄ If a normal exposure is created (e.g. f/8 at 1/400 sec, ISO 800), then a change in one of the values without any compensation for the change by the other values will change the exposure of the image. This can be seen in (1) and (2) above where the shutter speed was changed. In (3), (4) and (5), however, a change in one value is compensated for by a change in the opposite direction by another. This can be mixed and matched to create various effects while keeping the exposure the same.

Creative modes

A DSLR camera has different modes that you can photograph in. These modes might vary depending on which camera you have. All of them have at least a P, Av (A), Tv (S) and an M mode. Some might also have Auto, Sport, Landscape and Portrait modes. These different modes control what decisions you should make and which decisions the camera will make. In auto mode, for example, the camera makes all the decisions, even whether the flash should be used or not.

In Av (A) mode the photographer has to choose the aperture, the ISO, the exposure and whether the flash should be used, while the camera will only choose the shutter speed. Bird photographers need to be in control of most of the settings, so the only modes relevant to use are aperture priority (Av or A), shutter priority (Tv or S), and manual mode. Each mode has its own application for specific conditions and types of photographs.

Aperture priority (Av or A)

Aperture priority is the mode that bird photographers most often use. I use this mode probably for 90% of my photographs. In this mode you select both the aperture (also known as the f-stop) and the ISO for the shot, while the camera automatically selects the shutter speed to create the desired exposure.

DSLR cameras have built-in light meters that measure the light in a scene that then calculates what to set the shutter speed value at when you have chosen an aperture and ISO in this mode. If you point the lens in a different direction, the aperture and ISO values will remain unchanged,

but the light in the scene might be different, in which case the camera will select a different shutter speed. This makes photography easy as you can concentrate on the bird in the viewfinder while the camera will take care of exposing the photo correctly. Because you are now in control of the apertures and ISO, you know that regardless of the shutter speed chosen your image will have a fixed depth of field and image quality.

Being in control of the depth of field is crucial for bird photographers. You mostly photograph at a wide aperture, such as f/5.6, to make your subject stand out from the background. Using this wider aperture (that lets in a lot of light through the lens) has the added benefit that the camera selects a fast shutter speed to compensate for this wider aperture and the extra light it lets in, making it ideal for freezing action photos.

Aperture priority is indicated as 'Av' (aperture value) on Canon and 'A' on Nikon cameras. This mode is one of the options on the large dial located at the top of the camera. On some models you have to press the 'mode' button and toggle between the different modes.

When you are in aperture priority mode, the camera's main adjustment wheel adjusts the aperture values. This wheel is usually located at the top of the camera where your forefinger reaches when you hold the camera normally. As you turn the wheel you'll see how the aperture value changes. It changes on the LCD screen located at the top of the screen, and on the LCD screen at the back of the camera if you have that display on, or when you look through the viewfinder. The values are displayed as numbers only, so if you select f/8, for example, the LCD would display an '8'. F/2.8 will be displayed as '2.8' and f/22 as '22'.

Aperture priority is the best mode to work in when taking the following photos:

- Bird portraits
- Close-up bird portraits
- Wide-angle bird portraits that show the environment
- Action and behaviour
- Birds in flight

ISAK'S TIPS

When you work in aperture priority you should still be concerned about the shutter speed that the camera assigns. The shutter speed has an effect on sharpness. As you look through the viewfinder, you can see the shutter speed value that the camera assigns. When you want a slower or faster shutter speed, you control it by selecting a different ISO value where the camera will in turn then assign a different shutter speed.

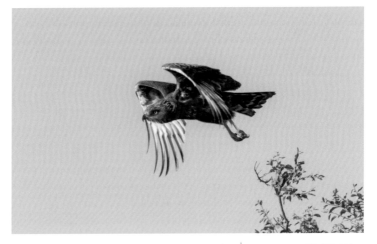

Brown Snake Eagle, Etosha National Park in Namibia | *1/2000 sec at f/8, ISO 800*
Canon 1D Mark IV + 600mmf/4 lens | *Aperture Priority, +2/3 ev*

Shutter priority (Tv or S)

Shutter priority is rarely used in bird photography. In fact the only time I use it is for slow-motion panning photos where I deliberately try to blur motion with a slow shutter speed while panning with the subject to make part of the subject sharp. In this mode you select both the shutter speed and the ISO for the shot, while the camera automatically selects the aperture to create the desired exposure.

DSLR cameras have built-in light meters that measure the light in a scene to then calculate what to set the aperture value to when you have chosen

a shutter speed and ISO in this mode. If you point the lens in a different direction, the shutter speed and ISO values will remain unchanged, but the light in the scene might be different, in which case the camera will select a different aperture.

Since shutter speed controls the sharpness of a photo, you would think that this mode would make sense. Bird photographers want to be in control of shutter speed, but not at the cost of the wrong depth of field. Consider the following example: if you are in aperture priority mode where you choose the aperture for a specific depth of field, it does not matter if the shutter speed that the camera selects changes from 1/500 sec to a 1/2000 sec for example as the light changes. The effect of a shallow depth of field is still achieved in both photos. If the same photos were taken in shutter-speed priority where 1/500 sec shutter speed was selected, the camera would choose a wide aperture initially, creating the same shallow depth of field effect, but then when the light increases it would select a narrow aperture to compensate for the light, ruining the effect.

The only scenario where I use shutter speed priority is if I deliberately try to blur motion to capture a sense of movement. It creates a great artistic effect that works well on overcast days when there is little light and little contrast on your subjects. You typically choose very slow shutter speeds, anything from 1/2 sec to 1/50 sec. The technique is explained later in the book.

Shutter priority is indicated as 'Tv' (timer value) on Canon and 'S' on Nikon cameras. This mode is one of the options on the large dial located at the top of the camera. On some models you have to press the 'mode' button and toggle between the different modes.

When you are in shutter priority mode, the camera's main adjustment wheel adjusts the shutter-speed values. That wheel is usually located at the top of the camera where your forefinger reaches when you hold the camera normally. As you turn the wheel you'll see how the shutter-speed value changes. It changes on both on the LCD screen located at the top of the screen, on the LCD screen at the back on the camera if you have that display on, or when you look through the viewfinder. The values are displayed without a 'fraction' sign, so 1/200 of a second, for example, will be displayed as 200. 1/50 of a second will be displayed as 50, 1/2 a second shutter speed will be displayed as 0"5, and one second and

slower will have the " sign. Thus, a 1-second shutter speed is displayed as 1" a 2-second shutter speed as 2" and so on. It is important not to get confused. 4" means a four-second shutter speed and 4 means 1/4 of a second shutter speed. Shutter priority is the best mode to work in when taking slow-motion panning photos.

ISAK'S TIPS

Always choose a low ISO value when you photograph at slow shutter speeds. Beware that when you select very slow shutter speeds in this mode it could overexpose your photo. When you choose very slow shutter speeds, like 1/20 sec, and especially in bright conditions, the camera will compensate for the light by closing down the aperture. Each lens has a different narrowest aperture and once that is reached, the camera can't compensate anymore and would therefore overexpose the photo. One way to correct this is to choose the lowest ISO value possible, but in bright conditions that might not even be enough. Some cameras have a setting called 'safety shift' where you instruct it to select either of the ISO, aperture or shutter speed values to compensate for exposure once that 'limit' is reached.

Red-billed Queleas, South Luangwa National Park in Zambia | *1/25 sec at f/22,* *ISO 100* | *Canon 1D Mark IV + 600mmf/4 lens* | *Shutter Priority, 0 ev*

Manual

Manual mode can be very useful for bird photography. I am using it more and more these days and, under the right conditions, it can take care of your exposure dilemmas. In this mode you choose the values of all three of the camera's exposure controls – the aperture, shutter speed and the ISO. That means that you are totally in control of the photo's exposure and it is your task to keep checking the exposure to make sure you've chosen the correct settings.

When you photograph birds in flight at a wetland, for example in aperture priority mode, and in the first photo the bird is against the clear sky, the photo will be slightly underexposed (dark) because the camera evaluates the bright scene. The next photo might have the bird against dark reeds resulting in an overexposed photo because the camera evaluates the dark scene. The photographer can compensate for this by using the exposure compensation function, but when you photograph birds in flight, the scene changes too quickly and too often during a sequence of photos, that it does not allow enough time to continuously adjust the exposure compensation.

The problem is that different backgrounds require different exposure compensations, but if the light source remains, then the light on the subject will remain constant too, regardless of the background. In manual mode you can set the exposure by adjusting the three exposure controls for the subject and then you will be sure that you'll always have the correct exposure.

The advantage of using this mode is that you are guaranteed to have good exposure on the subject regardless of whether it is in the sky or close to the water with a dark background. Bird photographers are always concerned about shutter speed, wondering whether it will be fast enough to freeze the action. In manual mode you choose the shutter speed and can therefore be assured that it is good enough for the photo you are trying to get and that it will not automatically be changed by the camera.

There are two pitfalls when using this mode:

- The first is when you **choose the exposure for the scene in front of you,** especially in sunlight conditions, the chosen exposure would only be correct for a narrow field of view, from 45 degrees to the left of you to 45 degrees to the right of you. If you photograph a bird that is 90 degrees either to the left or right, the light could potentially be so different that the photo will be over- or underexposed.

- The second pitfall is that **this mode only works well when the light remains constant,** typically in either clear sky or overcast conditions. When the light keep changing intermittently from sunshine to cloudy and then sunshine again, your photos might end up being severely over- or underexposed. You can only choose exposure for one condition at a time.

To setup the camera for manual mode photography of birds you start by choosing a random (or best guess) aperture, shutter speed and ISO. Next, you take a photo of any object that might more or less resemble what you'll be photographing, judging the exposure from the histogram review on the LCD screen at the back of your camera. If the photo is over- or underexposed, you adjust the settings and re-take the same photo. Then you judge the exposure again and repeat this cycle of testing and adjusting until you get the exposure spot on. It will help to choose a subject with both white and dark tones since they are a great reference for adjusting exposure, and then to keep taking photos of the same object during your test until you're done.

In manual mode you should be aware that the main adjustment dial of the camera will be adjusting either aperture values or shutter speed values. If it is the one, then the other value can be adjusted with the secondary adjustment dial. The secondary adjustment dial is different for all camera models. Sometimes it's a wheel at the back of the camera, sometimes a dial at the top of the camera close to the main adjustment dial, and sometimes you have to hold the exposure compensation button in while adjusting the main adjustment dial. Choosing ISO is still done in the normal way and it does not change in manual mode.

Manual mode is the best mode when taking bird portraits or birds in flight for long periods of time, from one position while the lighting conditions remain constant. This is normally when taking photos from a hide when the sky is clear.

When you use manual mode in the early mornings or late afternoons, remember to keep checking and adjusting your exposure, at least once every five minutes, since the intensity of the light changes slowly.

ISAK'S TIPS

A great tip for choosing the exposure initially is to aim the lens at a scene where half of the frame is taken up by sky and half is a neutral colour, such as reeds. Next, adjust the aperture, shutter speed or ISO while keeping your eye on the exposure compensation scale in the viewfinder. You might see values change on the scale while you're making the adjustments. Keep adjusting until the exposure compensation scale is in the middle on '0', which indicates an even exposure.

Auto-ISO

In aperture priority mode you choose the aperture and the ISO and the camera selects the shutter speed. In shutter priority you choose the shutter speed and ISO and the camera selects the aperture. In manual mode you have to choose all three values. So would it not make sense to have a mode where you choose the aperture and shutter speed and the camera selects the ISO? In fact, that would be the ideal for bird photographers since bird photography relies more on the correct aperture and shutter speed than the correct ISO. Today there is a mode like that – manual mode and activating auto-ISO.

Auto-ISO, as the name suggests, is a setting on a DSLR camera that can be activated in all modes: aperture priority mode, shutter priority mode and manual mode. When it is activated the camera will select the ISO in addition to the other values. When you photograph in aperture priority mode, for example, you choose the aperture and ISO, and with auto-ISO enabled the camera would set both shutter speed and ISO. The problem is, however, that the camera might choose to improve the image quality by lowering the ISO instead of increasing the shutter speed for which it was set up to do. The same will happen in shutter priority where you could control the aperture by manipulating the ISO values. In manual mode the auto-ISO function works well. You choose the aperture and shutter speed, while the camera will select the ISO to create an even exposure.

I would recommend you use auto-ISO only in manual mode, and not in aperture priority or shutter priority modes.

The advances of high ISO performance in DSLR cameras have given ISO a much lower priority during the decision-making process. Today, whether the photo was taken at ISO 100 or ISO 400 almost becomes irrelevant since the quality looks the same. A few years ago those differences were significant. The chosen ISO could 'make or break' a photo, but today that is not the case any longer. The correct aperture and shutter speeds have a much greater effect on the photo than ISO, so camera manufactures decided to add the option of auto-ISO to make the camera select an ISO.

Unfortunately with some cameras it's not as straightforward as I explained. Although auto-ISO can be used in manual mode, the camera then does not allow for exposure compensation. This means that the camera will select an ISO automatically, but always for an even exposure. So in the scenarios where you have to underexpose, like photographing a small white bird against a dark background for example, you cannot change the exposure compensation which would result in an overexposed image with blown highlights on the bird.

Most Nikon cameras now offer you two ways to utilise auto-ISO:

- The first is the way I described above where you **photograph in manual mode and activate auto-ISO.** The Nikon cameras then still allow exposure compensation.

- The second is to photograph in aperture priority mode and then **select ISO sensitivity settings** from the menu. Here you enable an auto-ISO with a minimum shutter speed and a maximum ISO sensitivity. In aperture priority you select the aperture. The camera will then select the lowest ISO while keeping the shutter speed within your selected limit. When the light gets low, the ISO value will shoot up until it reaches its set limit and then lower the shutter speed again.

 ISAK'S TIPS

Just as you keep an eye on the shutter speed that the camera selects when you photograph in aperture priority mode, so you must also keep an eye on the ISO that the camera selects. Maybe the difference between ISO 100 and ISO 400 is negligible but when the camera starts to choose very high ISO values, like ISO 4000, you should compensate for that by widening the aperture or slowing down the shutter speed to maintain good quality images. Remember, the rule is to use the lowest ISO possible while still having enough shutter speed to get a sharp image, given the chosen aperture.

RAW vs JPEG

There is a saying 'friends never let friends shoot JPEGs' which is jokingly shared among photographers. A DSLR camera can be set to either record images in RAW format or in JPEG format. Both formats have advantages and disadvantages, but the RAW format resembles the unmanipulated capture of the image the way slide film did in analog cameras, making it the purist's choice.

My suggestion is to always shoot in RAW mode, but to understand why I say this I have to explain how the camera captures the images. A sensor is made up of millions of photo buckets (pixels) that capture the light that falls onto it when you take a photo. These photo buckets can only capture the intensity of light that falls onto it, almost like capturing different shades of grey. To make it even more complicated, a filter is placed on top of each photo bucket forcing it to only capture the intensity of one of three colours: green, blue or red. When a photo is taken by a 10 megapixel sensor for example, the camera stores the levels of light intensity for 10 million individual pixels, each either for a green, blue or red colour. This is called the RAW data and is a far cry from the beautiful photograph that was taken. In order for the camera to display this data as an image, it needs to apply a RAW conversion. This means that by applying a specific algorithm the differently shaded green, blue and red pixels are transformed into an image. The camera then still applies some sharpness, contrast and saturation to the image to make it look the same as you saw through the viewfinder.

The advantage of RAW files is that they capture the images in the original format that the camera captured. This allows you to tweak the image to a much larger degree than a JPEG file. This is because these tweaks are done to the original RAW data, and through tweaking, you are in effect manipulating the algorithm that converts the data into an image.

The camera sensor is made up of pixels or buckets that capture the intensity of light that falls into each bucket. But to complicate it further, each pixel or bucket only captures the intensity of green, blue or red filtered light into its bucket. These filters are organised in a matrix across the sensor, known as a Bayer pattern.

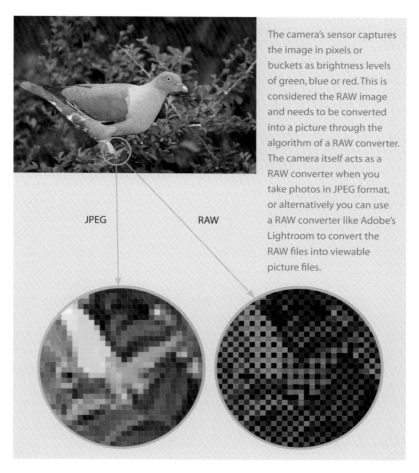

JPEG RAW

The camera's sensor captures the image in pixels or buckets as brightness levels of green, blue or red. This is considered the RAW image and needs to be converted into a picture through the algorithm of a RAW converter. The camera itself acts as a RAW converter when you take photos in JPEG format, or alternatively you can use a RAW converter like Adobe's Lightroom to convert the RAW files into viewable picture files.

JPEG images are created with alterations of sharpness, contrast and saturation already embedded in the image and offer much less tolerance to tweak these settings. The disadvantage of RAW files is that they're large files, and so you can only fit fewer images onto a memory card as compared to JPEG files. The quality and size of the JPEG images can be set in the camera's menu.

Bird photographers enjoy making their photos look as good as possible to get the most out of them, so you should photograph in RAW mode. Sports journalists, on the other hand, need to get their images out quickly to the media and so they photograph in JPEG mode, but should pay more attention to capturing the images correctly in camera with the correct sharpness, exposure and white balance.

	RAW mode	JPEG format
Size of the files	Large – can fit fewer images onto a card	Small – can fit many images onto a card
Quality	Large tolerance for editing	Limited degree of editing
Number of shots in burst mode	Few	More than RAW files
Require special software to process?	Yes	No
View files on a Mac	Yes	Yes
View files in Windows	No	Yes
Room for mistakes in camera	Yes	No

Processing a RAW file can recover up to 1-stop of light on both ends of the histogram, recovering details in both the brights and the darks that would otherwise be lost. In addition, it also allows you to choose any white balance (the temperature and tint of the colours) in post-processing, allowing you the freedom not to have to choose the correct one in camera.

White balance

Have you ever seen a photo of a fish eagle where the whites on his chest appear to be blue, making the image look 'cold'? This is the result of an incorrect white balance. White should be white in an image. Nature photographers constantly struggle to keep colours looking natural. In a studio photographers use grey cards as a reference to measure what the correct white balance for their studio lights should be. The objective is that the images display the correct colours, having the grey card appear grey in the image and not with a blue or yellow cast.

In nature you don't have grey cards. If you ask someone to hold a grey card next to the kingfisher on the perch in front of you so that you can take some test shots to calculate the correct white balance, the bird would obviously fly away. Not all the birds have patches of neutral colours to use as a reference, and even if they did it would still be difficult to calculate the correct white balance – some scenes should look 'warm', such as that golden light in the morning, or 'cold' when you photograph a bird in the shade.

You rely on your own visual judgment of the photo in post-processing, tweaking the white balance until the colours of the image on the screen match the colours you saw in the scene when you looked through the viewfinder to take the shot. There is no right or wrong recipe you can follow.

White balance is the temperature and tint of an image captured by a camera. The temperature refers to the warmth of the image, cold or warm, appearing either slightly blue or slightly yellow. The tint refers to the image appearing either slightly purple or slightly green. Both temperature and tint are indicated as numerical values and are applied by the camera to the photo as it is taken.

DSLR camera bodies allow you to choose the white balance for a photo, by choosing a pre-set for white balance – on some cameras you can even type in your own custom white balance values. Some camera bodies have specific buttons assigned for this task, while on others you have to change it in the menu. One of the options is **auto white balance**, where the camera chooses the temperature and tint that will be applied based on an algorithm applied to the scene that it reads through the viewfinder. Other options include:

- Daylight
- Shade
- Cloudy
- Tungsten
- White florescent light
- Flash

When you take photos in JPEG mode, the white balance applied to the image is embedded in it, leaving you with little room to modify it afterwards in post-processing. Therefore, you need to make sure you use the correct white balance, either by trusting the camera's auto white balance setting or by manually choosing the white balance that matches the lighting conditions when you take the photo. In RAW mode, the white balance is only applied during the RAW conversion of the image, leaving you with the freedom to choose or change it afterwards in post-processing. This is a great advantage of using RAW mode – it means you never have to worry about setting the white balance in camera. One less thing to think about when taking photos!

When you choose one of the white balance pre-sets other than **auto white balance**, the effect can be quite strong, making the images appear very warm or cold. If you select a white balance pre-set that matches the lighting conditions you're photographing in, it will make the images look more natural. But if you choose the wrong pre-set, the effect can potentially ruin the image. In nature photography you mostly photograph outdoors, so your only considerations are whether it is cloudy, shady or sunny. Conditions change quickly. You might be photographing a bird that was sitting in the shade and then suddenly jumps to a spot of sunlight. If you don't trust the camera to choose the correct white

balance for you, you should remember to continuously look out for changing lighting conditions to that you select the correct white balance. This is of course, if you don't photograph in RAW mode or plan to correct the white balance in post-processing.

I suggest leaving the camera setting on **auto white balance** since the camera does a good enough job in choosing the white balance on your behalf. That leaves you with one less thing to think about when you take photos. In the few instances where white balance needs to be altered, you can easily do that in post-processing.

The white balance refers to the temperature and tint of an image that can make it look cold with a blue tint, warm with a yellow tint or normal. The white balance can be changed during post-processing when the photo is in RAW format. The white balance of a photo in JPEG format can be changed slightly but not to the same degree.

European Bee-eater,
Etosha National Park in Namibia
1/2500 sec at f/8, ISO 640
Canon 1D Mark IV + 600mmf/4 lens + 1.4x
Aperture Priority, 0 ev

Making good exposures

*Malachite Kingfisher, Marievale Bird Sanctuary
in South Africa* | *1/2000 sec at f/6.3, ISO 640
Canon 1D Mark III + 600mmf/4 lens + 1.4x
Aperture Priority, +1/3 ev*

Introduction

Photography means 'the capture of light' and therefore exposure is the essence of photography. Making good exposures in camera creates great quality images and that's the objective of every photographer.

The word 'exposure' refers to the brightness of the image, where a **good exposure** means the brightness of the image is not too dark and not too bright – it is just right (also called 'even exposure'). An underexposed image is one that is too dark, and to 'underexpose' a photo means to make it darker. An over-exposed image is one that is too bright, and to 'over-expose' a photo means you make it brighter.

Photographers often refer to 'stops of light'. These are measurements that apply to the aperture, shutter speed and ISO. You may say, 'make the image one stop darker' and that means closing the aperture down from f/8 to f/11 for example. You can also change shutter speed and ISO by different 'stops'. Typically, when you have an even-exposure and you change the aperture by one stop, you'll have to change the shutter speed or ISO by one stop in the opposite direction to compensate for the adjustment.

There are only three controls in a camera and lens that affect exposure:

- Aperture
- Shutter speed
- Sensor sensitivity (ISO)

In the days of film there was little room to 'fix' the exposure of a slide in post-production, which made it critical to take a photo at the correct settings for a good exposure. Without the help of instant feedback from the LCD screen, it was an achievement on its own if your slides were well-exposed, even if the photos themselves were 'boring' by today's standards. In the digital era we have much more room to 'fix' the exposure in post-

processing, so photographers don't pay too much attention to it – as long as it's more-or-less correct. With instant feedback from the camera, histograms, highlight alerts, better light meters and algorithms, today's DSLR cameras make it possible for us to concentrate on the creative part of photography without worrying about the technical part. Let's explore the functions of the camera that helps us make good exposures!

 KEY POINTS

- Your camera can be setup to read the light in the scene in various ways from where it will calculate the correct exposure. I recommend **always using evaluative (matrix) metering** where the **whole scene carries equal weight** and then using exposure compensation to tweak the exposure.

- **In strong backlit scenes, sunsets and photography at night with a spotlight** it might merit switching to **spot metering**.

- **Exposure compensation** is the photographer's tool to **control the exposure** of the photo. If the photo is **too dark,** then **increase** the exposure compensation. If the photo is **too bright,** then **decrease** the exposure compensation.

- **Judge the exposure** of a photo by looking at the **histogram.** Make sure the graph is between the left and right limits and there is **no build-up of pixels on either end.** To move the graph to the right, you have to increase the exposure. To move the graph to the left, you have to decrease the exposure.

- Always set your **flash to high-speed sync** (on Canon) or **FP** (on Nikon) and use it in **ETTL mode.**

- **Fill-in flash** is typically used in the daylight when you want to **add light to the shaded areas** on a bird. Use aperture priority and switch the flash to -1/3 flash exposure compensation. Control the power of the flash with the flash-exposure compensation.

- **Full flash** is used at night when there are **no other light sources.** Set the camera to manual mode, to f/5.6 at 1/200 of a second and ISO 400. Control the power of the flash with the flash-exposure compensation.

- **Balancing flash** is a technique used where you **capture beautiful colours in the background behind a bird that is in turn exposed with flash,** such as an orange sunset. Set the camera to manual mode and control the exposure of the background with the settings on the camera. The exposure on the bird is controlled separately with the flash-exposure compensation.

Metering

Metering refers to the way in which the camera reads the light in the scene, and it needs to read the light so that it can understand what the exposure of the scene should be. This is important because the camera will set the shutter speed, aperture or ISO automatically based on its findings. It will create what it thinks is the correct exposure.

There are four (Nikon = 3) different metering modes that can be selected on your DSLR camera. There is a button located at the top of the camera for you to toggle between the different metering modes. If your camera does not have one, you can either change it in the menu or on the LCD screen display at the back of the camera. The different options could be indicated as icons only, so it's important to learn what they mean.

Each metering mode reads the light in a scene differently and that will force you to use different exposure compensations. It is important to know how each mode works so that you can choose the correct exposure compensation. If you use spot metering on a white bird, the camera will underexpose the photo, but if you apply evaluative metering to the same frame, it could result in an overexposed image.

What the camera does is to break the whole scene up into little blocks. It then assigns a brightness level to each block (disregarding colour), almost like recording what shade of grey each block is. Then it will take the average of all the brightness levels of the blocks and compare this to neutral grey (50% grey). If the average is darker than neutral grey, it will indicate it as underexposed, like -1 for example, and if the average is brighter than neutral grey, then it will be indicated as overexposed, +1 for example. But the camera does not always consider each of these blocks to have equal importance when it calculates the average exposure – depending on the metering mode you select it might make the blocks in the centre of the frame carry more weight than the others or it might

use the blocks in the very centre of the frame (or where your focus point was) for the calculation. If this sounds complicated, here is a description of each metering mode:

1. This Greater Kestrel is against a bright background.

2. The camera breaks the photo up into small blocks and measures the brightness levels of each block.

Average tone of the photo

Neutral gray

3. The camera calculates the average brightness levels of the blocks and then compares them to neutral grey. In this case the photo is brighter than neutral grey.

4. The camera has to make the photo darker so that the average brightness matches neutral grey. Here the photo is too dark but correctly exposed based on the way the camera metered the exposure (it doesn't know the bright background should be bright).

This is the process that the camera follows to adjust the exposure based on the way it measures the light.

Greater Kestrel, Kgalagadi Transfrontier Park in South Africa | *1/1600 sec at f/8, ISO 1000 Canon 1D Mark III + 600mmf/4 lens + 1.4x* | *Aperture Priority, +1 ev*

- **Evaluative metering** 🔘 (**Nikon = matrix metering** 🔳): The camera evaluates the scene as a whole, giving every part of the scene equal importance. This mode works well for all scenes.

- **Partial metering** 🔘 (**No Nikon equivalent**): In this metering mode the camera only considers the middle 6.5% of the viewfinder area to calculate the exposure. This mode works well when the background is much brighter than the subject due to backlighting.

- **Spot metering** 🔘 (**Nikon = spot** 🔘): This mode works the same way as partial metering, but considers an even smaller area of the viewfinder, 2.5%. It works well when you want the camera to ignore the exposure of the entire frame, except for where your focus point is. Photographing owls at night with a spotlight is a good example of where spot metering can be used successfully.

- **Centre-weighted average metering** ⬜ (**Nikon = centre-weighted** 🔘): In this mode the brightness is metered at the centre and then averaged for the entire scene – the whole scene is considered, but more weight attributed to the area where your focus point is.

My recommendation is that you keep your camera on one mode only, evaluative metering, and learn how one metering mode interprets light in a scene. Regardless of whether you keep changing metering modes, you might still have to use exposure compensation anyway to adjust exposure for the specific scene.

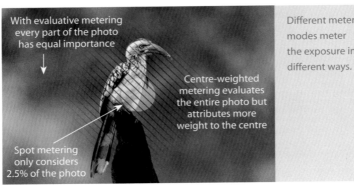

Red-billed Hornbill, Khwai River in Botswana | *1/500 sec at f/4, ISO 400*
Canon 1D Mark IV + 600mmf/4 lens | *Aperture Priority, 0 ev*

Evaluative metering: the whole scene has even tones so that any metering mode will result in an even exposure.

Centre-weighted metering: the whole scene has even tones so that any metering mode will result in an even exposure.

Spot metering: the whole scene has even tones so that any metering mode will result in an even exposure.

Three-banded Plover, Mashatu Game Reserve in Botswana | *1/2000 sec at f/5.6, ISO 400*
Canon 1D Mark III + 500mmf/4 lens + 1.4x | *Aperture Priority, 0 ev*

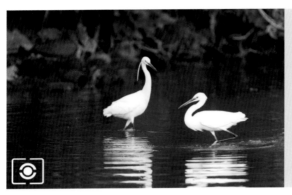

Evaluative metering: the bulk of this photo has dark tones making the camera overexpose the scene.

Centre-weighted metering: the camera considers equal amounts of dark and bright tones and this creates the even exposure.

Spot metering: the camera considers only the white on the bird and wants to adjust it to a neutral grey, resulting in an underexposed photo.

Little Egrets, Mashatu Game Reserve in Botswana | *1/1250 sec at f/4, ISO 800*
Nikon D3X + 200-400mmf/4 lens | *Aperture Priority, -1 ev*

Evaluative metering: the bulk of this photo has bright tones making the camera underexpose the scene.

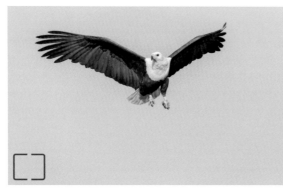

Centre-weighted metering: the camera considers equal amounts of dark and bright tones and this creates the even exposure.

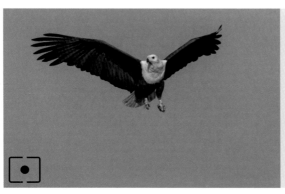

Spot metering: the camera considers only the white on the bird and wants to adjust it to a neutral grey, resulting in an underexposed photo.

African Fish Eagle, Chobe River in Namibia | *1/2000 sec at f/5.6, ISO 500*
Canon 1D Mark III + 600mmf/4 lens | *Aperture Priority, +1 ev*

Exposure compensation

The advances in DSLR camera technology are improving to such a degree that the exposure usually corrects automatically. But when it doesn't, it allows you to evaluate the exposure when you look at the photos on the LCD screen at the back of the camera. You can do this instantly in the field while you still have a chance to correct it for the next sequence of shots.

When you take a photo, the camera reads the light in the scene and then adjusts the aperture, shutter speed or ISO automatically to create an even exposure (or what it 'thinks' is an even exposure). You can, however, instruct the camera to create a brighter image by adding exposure, or to create a darker image by reducing exposure. This 'instruction' is called exposure compensation.

Exposure compensation is measured in number values, ranging from -2 to -1, 0, +1 and up to +2 (the range on some cameras might be wider). If your camera is set up to use 1/3 intervals, then each adjustment would make the exposure compensation change in thirds, meaning it will change from 0 to +1/3, then +2/3, +1, +1 1/3 and so on if you add exposure, or similarly to -1/3 and so on if you reduce exposure.

Most DSLR cameras display the exposure compensation value on a scale with a dot, where the dot indicates the chosen exposure compensation. On Canon cameras if the dot moves to the right it means it's adding exposure (+), and when the dot moves to the left it means it's reducing exposure (-). The dot in the middle indicates even exposure (0). You can see this scale on the LCD screen at the top of the camera, on the LCD screen at the back of the camera if you have that display on, or through the viewfinder. I recommend familiarising yourself with the display in the

viewfinder as you should be able to adjust the exposure compensation while keeping your eye on the scene in front of you by looking through the viewfinder.

The way in which you adjust exposure compensation is different on every camera. I've set up my camera for adjusting it with the large wheel at the back, but on some camera models you have to press and hold the exposure compensation button in while turning a dial. The direction in which you turn the dial controls whether exposure compensation changes up or down, but this you will be able to see on the scale.

Most scenes do not require any exposure compensation. It is only scenes with large areas of very bright or very dark light in your frame that you need to pay attention to. A small bird against a dark background is a good example of where you need to correct the exposure. The camera reads the light in the scene as dark, wanting to brighten it to a neutral grey, resulting in an overexposed bird to the extent that it becomes pure white with no detail. To expose that scene correctly you need to instruct the camera to keep the image dark by setting the exposure compensation to something in the region of -1.

Exposure compensation scale

Exposure compensation set to 0 creates an even exposed photo.

Exposure compensation set to -1 creates an underexposed photo.

Exposure compensation set to +1 creates an overexposed photo.

Another typical example where exposure compensation is required is when you photograph a bird flying against a bright sky. The camera reads the light in the scene as bright, wanting to darken it to a neutral grey, and turning the bird into a silhouette against a mid-tone background. You need the bird to be correctly exposed – so you need to instruct the camera to add exposure by setting the exposure compensation to something in the region of +1.

When a scene is even in tone, then exposure compensation set to 0 should create a correctly exposed photo (when evaluative metering is used).

When a scene is dark in tone, like small bright birds against a dark background, then exposure compensation should be set to underexpose (e.g. -1) to create a correctly exposed photo (when evaluative metering is used).

When a scene is bright in tone, like birds against a bright sky, then exposure compensation should be set to overexpose (e.g. +1) to create a correctly exposed photo (when evaluative metering is used).

Through experience you'll learn by looking at a scene to instinctively recognise what a good initial guess for exposure compensation would be. You can then set the compensation before you take your first photo. It might not be spot on, but it will be close enough to still get the shot. In bird photography those extra few seconds you can save by having a first good guess will often make you get the shot that others miss.

Different metering modes will read the light in the same scene differently, requiring you to use different exposure compensations. A small white bird against a dark background for example, metered with evaluative metering, will require you to reduce exposure (-) since the camera's evaluation of the entire scene is that it's dark. The same scene metered with spot metering on the bird will require you to add exposure (+) since the camera's evaluation of the bird is that it's bright.

Exposure compensation only works in program mode, aperture priority, shutter priority and in manual mode with auto-ISO enabled. In these modes, the camera always manipulates one of the exposure controls to compensate for exposure. For example, in aperture priority mode where you choose the aperture and the ISO, the camera selects the shutter speed. The selected shutter speed would create an even exposure – but if you now set the camera to underexpose by one stop, the camera will use a shutter speed that is one stop faster. In the same way it will adjust the mechanical exposure controls when you photograph in the other modes. Consider the following example: If you're photographing in aperture priority mode and you choose f/8 and ISO 400 and the camera selects 1/800 sec shutter speed for an even exposure, when you choose an exposure compensation of -1 to make the photo one stop darker, the camera will select 1/1600 instead (one stop darker).

In manual mode, without having auto-ISO enabled, the camera does not select any of the exposure controls and thus cannot change the exposure. It will still indicate on the exposure scale what it 'thinks' is normal exposure, but it is up to you to change one of the mechanical exposure controls to make the photo darker or lighter.

 ISAK'S TIPS

When you set the exposure compensation for a scene and you are finished with photographing that scene, remember to set it back to 0 (or the default value that you use). Sometimes a photographic opportunity arrives unexpectedly and catches you off guard, which does not allow you the time to first check to see what exposure compensation you're on, before knowing how much to adjust from that value to get the shot. It is valuable to know the settings the camera is on when you're not behind the lens.

Histogram

Getting the correct exposure in camera while you take photos is one of the main technical challenges of photography – and with the latest technology cameras have made it much easier for us. They can adjust settings automatically to get exposure perfect almost every time. But sometimes we still need to tweak the exposure slightly, especially when lighting conditions are tricky. DSLR cameras have made it possible to instantly see the photo you had just taken on the LCD screen at the back of the camera. This is a great way to see if you have the correct exposure and then to adjust it if it needs to be tweaked in the camera for the next photo.

A histogram plots the distribution of the tones in an image on a graph. The left side of the graph is in the dark tones and the right side in the bright tones.

The difficulty is that you cannot judge the exposure by just looking at the photo and how bright the elements in the photo appear to be, because LCD screen brightness varies between camera models. You can even set the brightness of the screen and that creates another variable – this brightness competes with the brightness of the conditions you find yourself in, making it hard sometimes to even see the image clearly. Bird photographers typically photograph outdoors – usually in sunny or, at least, bright conditions which makes the evaluation of the image on the screen impossible.

The histogram is designed as a scientific way to evaluate exposure. You can set your camera to show a histogram of an image on the LCD screen alongside the image. A histogram is a graphical representation of the distribution of the tones captured in your image and helps you to evaluate the image to see if your exposure is correct. You can choose to see a graph with the average tones of all the colours combined or, alternatively, to see graphs of the prime colours (red, green, blue) individually – but the grey histogram for the average tones is adequate to use. This is a great tool to use especially when you're photographing in the field and you have the chance to 'fix' your exposure for the next sequence of photos. Poorly exposed photos can only be 'saved' to a certain extent, and correcting the exposure in post-processing often leads to poor image quality, so it's better to get the exposure right in camera.

A histogram is also displayed in post-processing and guides you to process the image exposure correctly.

The histogram plots the tones of the image on a graph, where the left side indicates the dark tones, the middle the mid-tones, and the right side indicates the bright tones. Vertically it shows how much of each tone has been captured. There is not an ideal shape for a histogram as it is a representation of an image and every image will be different. An evenly spread histogram, from the left all the way to the right side with a bulge in the middle is usually a good one. If the bulge is to the left of the middle, it could indicate an underexposed image with too many dark tones; and a bulge to the right might indicate an overexposed image with the too many bright tones. However, you need to take note that images with tricky lighting conditions, such as a small white bird against a dark background, might have the bulge of tones on the left side of the histogram which is the correct exposure. What you should look out for is a histogram with a gap on either end or a build-up of tones on the very left or right side of the histogram.

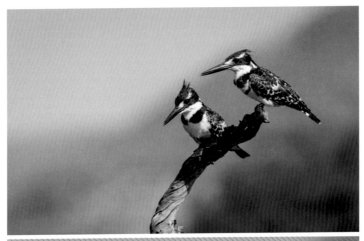

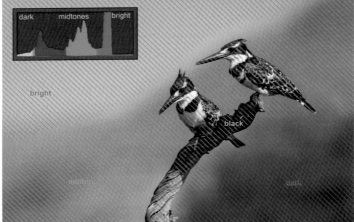

In this image of Pied Kingfishers it is clear how the three prominent tones are indicated by the three spikes in the histogram. Red indicates the bright tones at the top left of the image and the spike on the right side of the histogram. Green indicates the midtones across the middle of the image and the spike in the middle of the histogram. Blue indicates the dark tones at the bottom right of the image and the spike on the left side of the histogram. Yellow indicates the very dark tones as the black on the kingfishers and the shadow on the perch in the image and the small bulge on the very left of the histogram.

Pied Kingfishers, Pilanesberg National Park in South Africa | *1/2000 sec at f/11, ISO 1250*
Canon 1D Mark III + 600mmf/4 lens | *Shutter Priority, 0 ev*

A build-up of tones on the very left side of the graph indicates an underexposure and you might lose detail in the dark tones. A gap on the left side means the dark tones in the image are too bright and you should underexpose in the camera to stretch the dark tones to just touch the left side.

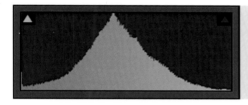

A build-up of pixels on the left means you are you losing detail in the dark tones.

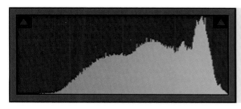

A gap on the left is a sign of the image potentially being overexposed.

A build-up of tones on the very right side of the graph indicates an overexposure and you will lose detail in the bright tones. A gap on the right side means the bright tones in the image are too dark and you should increase exposure in the camera to stretch the histogram to touch the right side.

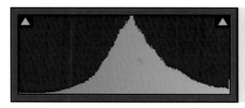

A build-up of pixels on the right means you are losing detail in the bright tones.

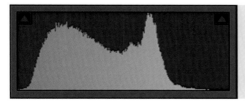

A gap on the right is a sign of the image potentially being underexposed.

A great way to indicate blown highlights or lost detail in the blacks is to have the 'highlight alert / warning' turned on in your camera. If any part of the image is blown out or has lost detail, those areas would flicker on the screen, making you aware of the exposure problems and where they are.

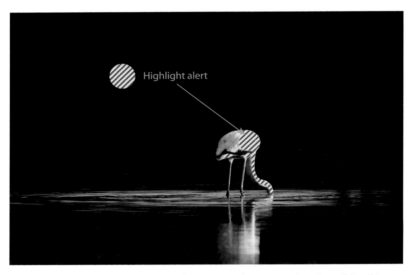

The 'highlight alert / warning' feature of the camera shows you where loss of detail in over- or underexposed areas occurs.

Greater Flamingo, Marievale Bird Sanctuary in South Africa | *1/1250 sec at f/5.6, ISO 640*
Canon 1D Mark II N + 600mmf/4 lens + 1.4x | *Aperture Priority, 0 ev*

It is understood that the bright tones in an image store more detail. Therefore, 'fixing' an underexposed image by adding exposure in post-processing is less effective than the other way around where you bring the exposure down with an overexposed image. This means it is better to take your images in camera so that they look slightly overexposed. The exposure can be corrected in post-processing but you'll end up with more detail in the image. Bringing detail back from the underexposed dark tones in an image is limited and you usually end up with little detail and lots of noise.

A photo with relatively even tones will have an evenly distributed histogram.

A photo with plenty of bright tones will have a bulge to the right in the histogram.

A photo with plenty of dark tones will have a bulge to the left in the histogram.

Looking at histograms becomes very technical, so for bird photographers I recommend you make sure that when you take a photo your histogram is at least within the left and right limits and without a build-up on either end. Don't get concerned about the tiny details, just know where it stems from and look out for the major warning signs.

 ISAK'S TIPS

In my experience when you use Canon cameras it's good to overexpose slightly. You can bring the detail back beautifully from the bright tones. On the Nikon system you should be very careful with overexposure. When a part of an image appears to be overexposed on the histogram, you cannot retrieve any detail. The detail from dark tones, however, can be recovered very well, so for Nikon users I recommend you underexpose slightly if you're worried about clipping the bright parts.

Flash

Most people think that a flash should be used at night. The opposite is true. A flash helps to balance light, and is most effective in the middle of the day in harsh sunlight conditions. When you photograph a bird in the sunlight in the middle of the day, most of it would be in strong light and some parts would be covered by a strong shadow that creates a harsh contrast and a very unappealing image. In order to balance the light to reduce the contrast, you need to fill in those shaded areas with a flash. I'm sure that a lot of people have had this bad experience where the intention was to use fill-flash only to find a terrible overexposed result. When this happens it can be very off-putting and often makes you 'afraid' of using the flash. But in this section I will show how to make sense of the flash by dividing it into three categories for three different applications. Flash is such a powerful tool for creative effects that it's worth mastering.

The entry-level and advanced amateur DSLR cameras usually have an on-camera flash. This flash pops up from the camera body (manually or automatically, depending on the mode you're in) and is sometimes referred to as a 'pop-up' flash. It's powerful enough for most of the creative effects you will ever need, but an external flash will be much more powerful, allowing you to get a few shots that you would otherwise not have got with an on-camera flash. Professional cameras do not have on-camera flashes, but have a hot-shoe at the top of the camera body into which an external flash can slot. In fact, all cameras have a hot-shoe for an external flash, even the ones that have an on-camera flash. In that case you can choose which one to use – although when an external flash is connected it makes it mechanically impossible for the on-camera flash to pop up.

One feature of flash is that you can set its exposure compensation to control the power of the flash. This can be set independently (not all

on-board flashes can do this) from the camera's exposure compensation providing you with the power for creative effects.

The reason for most people's bad experience with the use of flash is when they get the dreaded overexposed flash look after their good intentions of using fill-flash. This is caused by the camera slowing the shutter speed down to the flash synchronisation speed of the camera. It is usually 1/200 sec on most cameras. This is a default shutter speed that the camera uses to capture the full power of the flash. If you were photographing in aperture priority mode before you switched the flash on, for example, and with your choice of settings the camera was on 1/1000 sec and you were getting an even exposure at that time, then when you switch the flash on, the camera will turn the shutter speed down to 1/200 sec while keeping the other settings unchanged. This will result in an overexposed image. To fix this, you have two options.

- If your camera and flash allow, you can **set the flash to high-speed sync (on Canon) or FP (on Nikon)** where the camera will ignore the flash synchronisation speed and won't change the shutter speed. In the example the shutter speed will remain unchanged at 1/1000 sec and the flash will fire, although the camera might only capture a portion of the flash for a weaker flash effect.

- The second alternative is to **make sure you photograph with a shutter speed equal to, or slower than, the flash synchronisation speed.** You can do this by lowering the ISO or perhaps using shutter priority mode instead.

For a start I recommend setting up your flash as follows:

- **ETTL (exposure through the lens):** This will enable the camera to set the exposure of the flash based on the exposure that it reads in the scene, through the lens

- **High-speed sync (on Canon) or FP (on Nikon):** This will prevent the camera from lowering the shutter speed to the flash synchronisation speed and creating overexposed images. Just note that on some cameras this cannot be set for on-camera flashes.

- **Flash-exposure compensation:** Set this to -1/3 by default as this is always a good starting point. The flash-exposure compensation can be set separately from the camera's exposure compensation. On

external flashes you have the choice of setting it on the flash unit itself or with the button allocated for flash exposure compensation on the camera itself.

Fill-in flash

This is the most common application for flash and is used in the daylight with the bird in the harsh sunlight or perhaps in the shade, but where you want to fill in the shadow covered areas on the bird with some light. On a cloudy day with dull light it would also help to 'lift' the image slightly.

- Photograph normally, using aperture priority or the mode that suits the situation and set the camera's exposure compensation until the photo is correctly exposed.
- Switch the flash on and start by setting it to -1/3 on the flash-exposure compensation.
- Take a photo and look at the results. If the flash effect is too strong, then decrease the flash-exposure compensation. If the flash effect is too weak, then increase the flash-exposure compensation.
- If the whole photo seems to be too bright, then decrease the camera's exposure compensation.

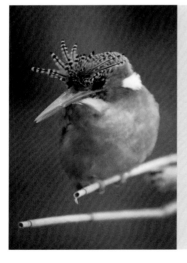

Use fill-in flash to lift an image in dull light.

Malachite Kingfisher,
Rietvlei Dam Nature Reserve in South Africa
1/30 sec at f/5.6, ISO 200
Canon 20D + 600mmf/4 lens + 1.4x
Aperture Priority, -1/3 ev

Full flash

When you photograph at night and you have no other light source, then the flash could become your main and only light source. This is typical when you want to photograph owls at night. The effect of full flash is not great for bird photography as the photos often have that harsh 'flashed look'. To improve the look of the photo you can either try to soften the flash by putting a plastic diffuser over it or perhaps use the flash off-camera by holding it away from the camera (you might need an assistant for this). The different angle of the flash will create the effect of side lighting and reveal some of the textures on the bird.

- Switch your camera to manual mode.
- Set the camera to f/5.6, 1/200 of a second and ISO 400 for a start.
- Focus on the bird (have someone shine a torch light on the bird if possible) and switch the flash on.
- Start by setting the flash to -1/3 on the flash-exposure compensation.
- Take a photo and look at the results. If the flash effect is too strong, then decrease the flash-exposure compensation. If the flash effect is too weak, then increase the flash-exposure compensation.
- If you've increased the flash exposure compensation but you can't see the effect in the photo, it means that the flash is firing at full power. To increase the exposure in your photo you have to increase the ISO or choose a wider aperture.

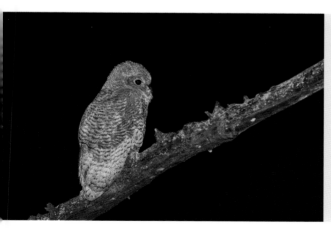

Use full flash when there is no other light source and flash is the last resort.

Pel's Fishing Owl,
Okavango Delta in Botswana
1/100 sec at f/4, ISO 400
Nikon D4 + 200-400mmf/4 lens
Manual Mode

Balancing flash

This type of flash is my personal favourite and the most fun to try. It involves balancing the light of the background and that of the flash on the bird. A typical application would be if you have an orange sunset and you want to capture the colours in the sky behind the bird, but you also want to add some flash light on the bird to show it as more than a silhouette.

The easiest way to execute this is to use manual mode on your camera. The camera settings will control the exposure of the background and the flash will control the exposure on the bird, with flash-exposure compensation.

- Switch your camera to manual mode.

- Set the camera to f/5.6, 1/200 of a second and ISO 400 for a start.

- Take a photo without the flash and look at the result – only look at the exposure of the background. If you want the background to be darker, then lower the ISO or choose a narrower aperture. If you want the background to be lighter, then increase the ISO or choose a wider aperture. Keep taking photos and adjusting the settings until you have the desired exposure in the background.

- Focus on the bird and switch the flash on.

- Start by setting it to -1/3 on the flash-exposure compensation.

- Take a photo and look at the results. Now only look at the exposure on the bird and ignore the exposure on the background. If the flash effect is too strong, then decrease the flash-exposure compensation. If the flash effect is too weak, then increase the flash-exposure compensation.

- If you've increased the flash-exposure compensation but you can't see the effect in the photo, it means that the flash is firing at full power. This means that the light in the background is too strong and the flash can't provide enough light to expose the bird correctly. The only thing you can do to improve this is to get closer to the bird so that you put it within better reach of the flash light.

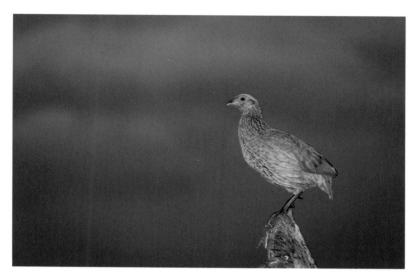

Use balancing flash to control both the brightness of background as well as the light on the bird.

Swainson's Spurfowl, Okavango Delta in Botswana | *1/640 sec at f/4, ISO 1250*
Canon 1D X + 70-200mmf/4 lens | *Manual Mode*

 ISAK'S TIPS

Always carry an extra set of fully charged batteries for your flash. You never know when the perfect opportunity to use your flash will arise and you don't want to run out of battery power and miss out on great photos!

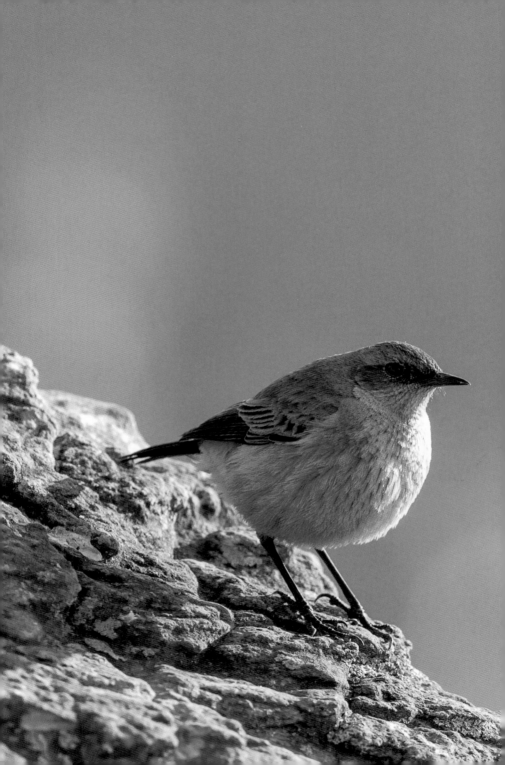

How light affects photography

Buff-streaked Chat, Drakensberg in South Africa
1/500 sec at f/5.6, ISO 800 | Nikon D3S +
600mmf/4 lens | Manual Mode

Introduction

There is a joke that wildlife photographers have the longest lunch hour than any profession. This stems from the general knowledge that the best light in the day is in the early morning and late afternoon. Photos with mood are the result of the photographer's careful consideration for the light's colour, quality and direction – so it is accepted that bird photographers only get up to photograph early in the morning and then again late in the afternoon when the light is good. This leaves them with an extended lunch hour to relax when the quality of light is not good enough to take photographs. This is only partly true, however, and although light is by far the biggest consideration when you photograph, I will explain in this chapter why I often photograph at other times of the day.

The phonetics of 'photography' are derived from the Greek words *photos*, meaning 'light', and *grahphein* meaning 'to draw'. This term was first used in the 1830s when the first photographs were produced. The word 'photography' therefore means 'painting of light', which makes it no surprise that this 'capturing of light' that we do with our cameras is the most important element of photography.

Wildlife photographers are governed by light, more so than any other genres of photography. The environment changes and you have little control over it. If a big cloud moves in front of the sun, there is little you can do about it. You don't photograph in a studio where lighting conditions are controlled with flash lights, studio lights and reflectors. Bird photographers want to portray their subjects as naturally as possible and are thus governed by the lighting conditions presented. You want to capture your subjects in specific conditions to make them look as good as possible and so you go out to photograph when you know you'll have the best chance of having those conditions. It is often said that

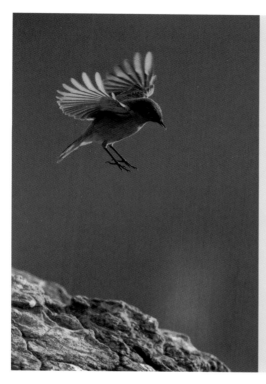

The Familiar Chat would be considered a dull-looking bird or 'little brown job' by most people. I used backlighting just before sunset when the light was golden to accentuate the bird's shape, wings and posture to create an image with mood in golden soft light.

Familiar Chat,
Drakensberg in South Africa
1/2000 sec at f/5.6, ISO 3200
Nikon D3S + 600mmf/4 lens
Aperture Priority, 0 ev

bird photographers 'chase the light' which means you get up at the early hours of the morning to be in the bird hide just before sunrise, so that you can capture your subjects in the best quality light.

Birds are beautiful creatures with stunning colours, profiles and postures when they're active. Different lighting conditions and the direction in which you photograph them relative to your light source offers different opportunities to showcase different elements of their beauty.

- **Low light** is best to show the movement of birds with a slow-motion panning shot.

- The profile of roosting birds in a dead tree will be the most striking as a silhouette during **twilight**.

- To capture the feather detail of a black-and-white bird will be done best with **golden front light**.

121

ISAK'S TIPS

Most people think you should only photograph when the light is soft and golden, but even if it's heavily overcast and the light is dull you can still create good images. I believe there is a good photo in every situation. Photographing birds in the rain with streaks of rain in front of a dark backdrop for example is a great way to get unique images when everyone else has packed their cameras away. Slow-motion panning shots is a great way to utilise low light to make the camera drop the shutter speed down. When you have flying birds you simply pan with them at their speed, keeping them in the same place in your frame as you pan with them, creating a blurry image with parts of the birds sharp in the image.

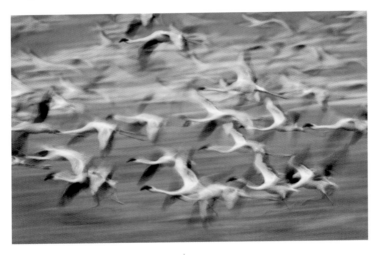

Lesser Flamingos, Lake Bogoria in Kenya | *1/10 sec at f/16, ISO 100*
Canon 1D Mark IV + 600mmf/4 lens + 1.4x | *Shutter Priority, 0 ev*

KEY POINTS

- The **golden light** of the first and last hour of the day is the **best** to photograph in, although you are not restricted to only photograph during those times.

- Always consider where the sun is relative to you when you face the bird that you want to photograph. Position yourself to have the **sun behind you**, making your shadow on the ground point towards the bird to see as much light on your subject as possible. This is called **front light**.

- **Side light** is when you position yourself to have the **sun 90 degrees to your left or right** when you face the subject. This reveals the textures on a bird and should only be attempted during golden light when the sun is low on the horizon.

- **Back light** is when you position yourself to be **photographing into the sun**. This accentuates the shape of a bird with the rim light around it or soft light through its feathers when it lifts a wing. Try this only during golden light when the sun is low on the horizon. Try to find a dark background to enhance the effect of back light.

- Atmospheric conditions such as **dust, mist or rain** show the best in a photograph when using **back light with a dark background**. Using a wider lens often creates a better mood in the image.

- When the **light is diffused** by clouds or light inside a forest, for example, it is considered to be soft light and this allows you to **photograph the whole day**.

- **Heavily overcast** and dark conditions create low light which results in flat or dull light. The little contrast makes ideal conditions to try **slow-motion panning shots** if you can find flying birds to photograph.

- Consider using **flash during hard light conditions** when the sun is strong and high to fill in those shaded areas on the bird, or when the light is dull in **low-light conditions** to lift the image and put a catchlight in the eye of the bird.

- **Twilight colours** in the sky peak before sunrise or after sunset. This is best captured with the **silhouettes** of birds to show their clear profiles against the colourful sky, usually using a wider lens.

Colour and quality of light

In southern Africa we are blessed with good light. The weather varies between the seasons: in summer the days are longer but you might experience rain; in winter the days are short but the light remains good all day long and it's rare to see a cloud in the sky. Of course there are some places, like Cape Town, that have their own special weather, but in general we are blessed with variable weather. Each season has its own special light that offers the bird photographer enough variety to capture the same bird in many different ways.

The sun is our natural source of light. It rises in the east, but creates beautiful soft twilight colours in the sky even before it pops up above the horizon. This light is low but soft and the sky acts as a giant reflector. This is usually a great time for landscape photographers to be out with their wide lenses and tripods, capturing this light with low ISOs and shutters speeds – bird photographers are still drinking coffee at this time. After twilight, the sun appears on the horizon, first casting golden light on the earth at a low angle. The golden light is a result of the dust and smoke particles in the sky where the rays from the sun have to travel through more atmosphere at a low angle. The impurities in the sky filter out all the colours except for the one with the longest wave length – red. The filtered light is also weaker and thus softer, making this hour a favourite for bird photographers to work in. As the sun gets higher in the sky the angle changes, shortening the shadows on the ground, and getting stronger as the rays travel through less atmosphere. At this stage the light is still good because the angle is low. From mid-morning to noon the light becomes really strong and at an angle that is from the top down. This light is considered hard and not recommended for photography. This cycle continues in reverse from noon forward, where the light gets better towards sunset, turning golden just before the sun disappears and then an hour of twilight follows.

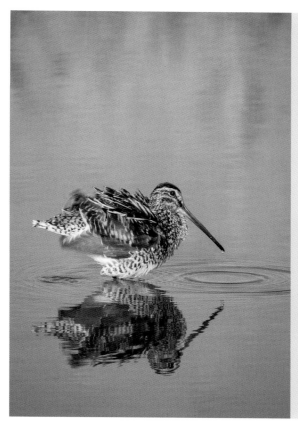

I photographed this snipe just before sunset when the light was low and golden, revealing all the detail on the bird in rich and saturated colours.

African Snipe,
Marievale Bird Sanctuary
in South Africa
1/500 sec at f/8, ISO 200
Canon 20D + Sigma
50-500mmf/5.6 lens
Aperture Priority, 0 ev

In summer the skies are clear of dust and smoke and you get strong light, provided that the sun doesn't disappear behind clouds in the rainy season. Winter is the dry season where dust and smoke from veld fires fill the skies. This is not bad for photography. Thin layers of clouds, dust and smoke create soft light that is good to photograph in for the whole day. When the clouds are thick and dark or you find yourself inside a dense forest, the light is low, making it difficult to photograph with fast shutter speeds but offering other possibilities.

The colour and the quality of light are influenced by both the seasons and the time of the day. These photographic opportunities will be explained in this chapter.

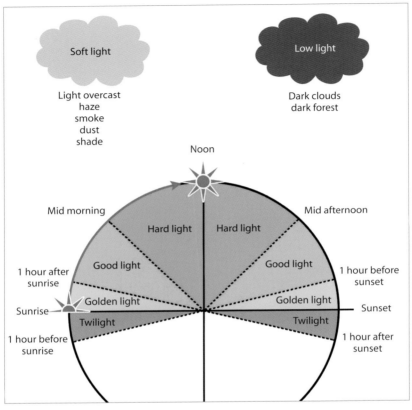

The colour and quality of light is affected by both the position of the sun in the sky as well as the atmospheric conditions such as clouds, dust and smoke in the sky.

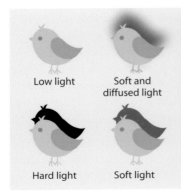

Low light

Soft and diffused light

Hard light

Soft light

The quality of the light can be judged by observing your own shadow or that of your subject. No visible shadow means the light is low. When you can see the detail of the surface within the shadow, it means the light is soft. When the edge of the shadow is not well defined, it is not only soft but also diffused. In hard light the edge of the shadow is well defined and dark, making it difficult to see any detail on the surface within the shadow.

ISAK'S TIPS

From all the colours and qualities of light, golden light remains a favourite with bird photographers. This light elevates a photo regardless of whether the angle is used as front light, back light or side light. This Red-backed Shrike posed beautifully in the golden light that I used as back light where a dark background was necessary.

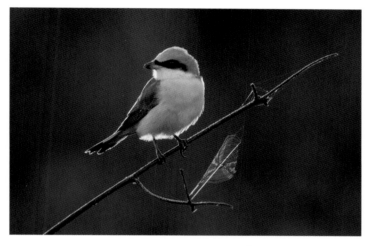

Red-backed Shrike, Kruger National Park in South Africa | *1/160 sec at f/5.6, ISO 400*
Canon 1D Mark III + 600mmf/4 lens | *Aperture Priority, -1 2/3 ev*

Golden light

Golden light, like the name suggests, is when the light has a golden colour. This light is created by the dust and smoke in the air and does not last long – up to one hour after sunrise and from one hour before sunset. The beautiful colour and soft quality of this light makes it a favourite for bird photographers. You can of course only have this light when there are no clouds to obstruct the sun. The quality of light creates a soft contrast between sunlit and shaded areas on a bird to reveal the detail of both. There are surprisingly many birds that have parts of white and parts of black on the body. The golden light is ideal to reveal the detail of both, which is impossible to achieve under any other lighting condition.

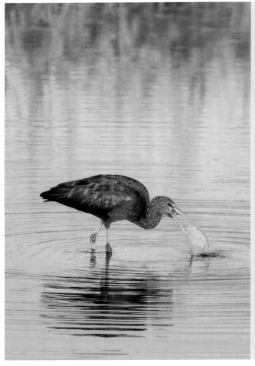

Golden light on this ibis is not only great in colour but is also soft, revealing detail in both bright and dark areas on the bird. The soft light also accentuates the iridescence of the feathers that makes them appear to change colour as the angle of view or the angle of illumination changes.

Glossy Ibis, Marievale Bird Sanctuary in South Africa | *1/500 sec at f/8, ISO 400*
Canon 20D + Sigma 50-500mmf/5.6 lens | *Aperture Priority, 0 ev*

ISAK'S TIPS

To make the most of this light, photograph birds against a natural toned background (top). Against the clear sky (bottom), the golden colour loses its impact.

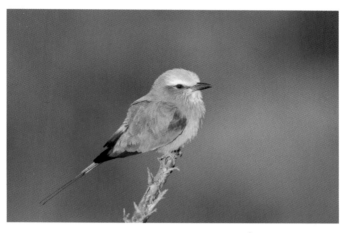

Lilac-breasted Roller, Mashatu Game Reserve in Botswana | *1/2000 sec at f/4, ISO 400* | *Canon 1D Mark III + 600mmf/4 lens* | *Aperture Priority, -1/3 ev*

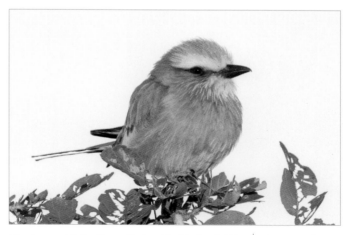

Lilac-breasted Roller, Kruger National Park in South Africa | *1/100 sec at f/10, ISO 200 Canon 20D + 600mmf/4 lens* | *Aperture Priority, +1/3 ev*

Good light

Good light is defined as the light that you get just after golden light but before hard light. It is strong light that still falls at a low angle and does not create a harsh contrast. Although not as dramatic or beautiful in colour as golden light, this is still good light to photograph in. You still see detail in both sunlit and shaded areas on a bird, although the contrast is much more noticeable. During the peak of the winter months, the sun stays lower on the horizon and at noon is only about 45 degrees up in the sky. These are great conditions for bird photographers as you have good light the whole day.

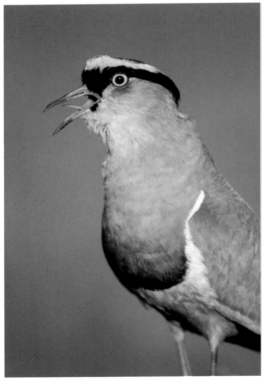

This lapwing was photographed two hours before sunset. The low angle of the sun will cast the shadow of the bird away from the photographer to reveal all the colours and detail of the bird in strong light.

Crowned Lapwing, Rietvlei Dam Nature Reserve in South Africa | *1/1250 sec at f/5.6, ISO 200*
Canon 1D Mark II N + 600mmf/4 lens + 1.4x | *Aperture Priority, -1/3 ev*

ISAK'S TIPS

The good light itself is not special. Although good enough to photograph in, so you have to work harder and 'play' with the light to make an image special. This Verreaux's Eagle-Owl image is only special because of the play of light of the sunlit bird against the dark background that created the contrast.

Verreaux's Eagle-Owl, Okavango Delta in Botswana │ 1/320 sec at f/5.6, ISO 800 Canon 1D Mark IV + 600mmf/4 lens │ Aperture Priority, -2 ev

Hard light

In the middle of the day, usually from mid-morning to mid-afternoon, the sun is high in the sky and strong, creating shadows that fall straight down to the ground. This makes a big contrast between these shaded areas and the sunlit areas which is not visually pleasing. They cast a shadow over the eye of most birds and animals, and because that is where the viewer of an image's attention goes, such photos fall flat and lose their impact. This is considered the worst kind of light for bird photographers. It does not mean that you have to pack the camera away. One way to still take decent photos is to get close to your subject and use fill-flash to balance the light by adding light to the shaded areas.

This Martial Eagle was photographed in the middle of a sunny day, casting an undesirable shadow over the eye of the bird.

Martial Eagle, Kruger National in South Africa | 1/500 sec at f/8, ISO 100 | Canon 20D + 100-400mmf/5.6 lens Aperture Priority, 0 ev

ISAK'S TIPS

When you do photograph in hard light, try to get as much of the light behind you so that from your angle you see the largest area of the bird exposed to the sunlight. In South Luangwa National Park in Zambia you can photograph Southern Carmine Bee-eaters from the top of a bank above their nests. At noon the sun is almost completely behind you as you photograph down onto the birds flying below you.

Southern Carmine Bee-eater, South Luangwa National Park in Zambia | 1/2500 sec at f/5.6, ISO 400 | Canon 1D Mark III + 70-200mmf/2.8 lens | Manual Mode

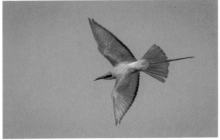

Diffused light

Some call it 'diffused light', while others call it 'ambient light'. What it refers to is the soft light that you get during bright overcast or cloudy conditions when the clouds act like a large filter, or in the shaded areas under trees when there is lots of light but it comes from all angles and is soft. You can see this by looking at your own shadow on the ground. When the light source in not a single point but is a large area, then the border of your shadow is not a defined line but rather a soft transition between light and dark.

Bird photographers often prefer this type of light, especially if they plan to photograph the whole day. These are the light overcast conditions they would choose. It is great for close-ups of birds and reveals the details and texture without strong contrast. The colours are also much more saturated. Beware, however, that it works only when you get close and have the bird large in the frame. Wide shots or long shots lack contrast and colour, looking flat and boring.

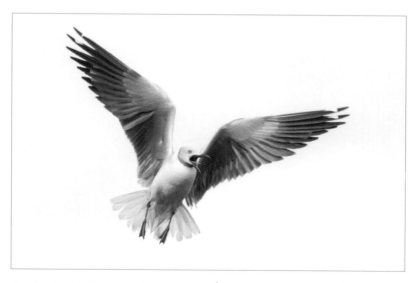

Grey-headed Gull, Bonearo Park in South Africa | *1/1250 sec at f/8, ISO 1000* | *Canon 1D Mark III + 600mmf/4 lens* | *Aperture Priority, +1 2/3 ev*

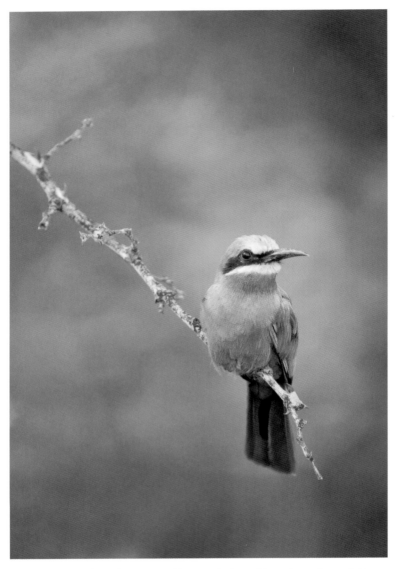

The diffused light from the overcast skies reveals the striking prime colours of this very colourful White-fronted Bee-eater.

White-fronted Bee-eater, Kruger National Park in South Africa | *1/320 sec at f/5.6, ISO 800* | *Canon 5D Mark II + 600mmf/4 lens + 1.4x* | *Aperture Priority, 0 ev*

Low light

Photographers often say "there is no light". What they mean is that there are low-light conditions – the kind of light that you often get when it is dark, overcast or raining, or when you are inside a dark forest. It is difficult to photograph birds under these conditions as there is almost no contrast or colour and the images not only look flat and dull but you struggle to get a good shutter speed and therefore nice sharp photos. When a bird is flying against the sky or you photograph it against a body of water that is brighter than the bird, then these are the worst conditions you can get.

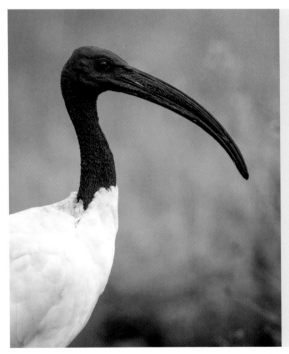

The low light created by heavy overcast conditions is not ideal for photographing bird portraits or bird behaviour. The only way this portrait of an African Sacred Ibis was saved was by getting close enough to fill the frame and accentuate the detail on the bird.

African Sacred Ibis, Marievale Bird Sanctuary in South Africa | *1/800 sec at f/8, ISO 400*
Canon 20D + 600mmf/4 lens + 1.4x | *Aperture Priority, 0 ev*

ISAK'S TIPS

The low contrast and slow shutter speeds you get in low light are ideal for trying your hand at slow-motion panning shots. Look for birds that fly parallel past you like this pelican did and then pan at the same speed as the bird by following it through your viewfinder.

Great White Pelican, Lake Nakuru National Park in Kenya | *1/25 sec at f/11, ISO 100* | *Canon 1D Mark IV + 600mmf/4 lens* | *Shutter Priority, 0 ev*

Flash

Apart from the sun and a spotlight, a flash is the only other light source in photography. Flash light is handy when you want to put a catchlight in the eye of a bird, lift the image with some colour and contrast in low light, balance light to fill in shaded areas during hard light, or when you want to photograph an owl at night and you don't have a spotlight. Like a woman with makeup, the rule of flash is to apply it without the viewer realising it. The wrong application will give you that ugly 'flashed' look. The colour of the flash light is blue, giving the image a cold look. This can be changed during post-processing by warming the image up with the temperature slider.

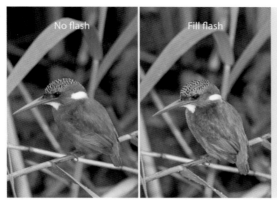

The dull light in the dark shade of a bridge made this kingfisher portrait look flat and lose impact. The addition of a little fill flash created stronger contrast in the image as well as a catchlight in the eye.

Malachite Kingfisher, Rietvlei Dam Nature Reserve in South Africa | *1/125 sec at f/8, ISO 400*
Canon 20D + 100-400mmf/5.6 lens | *Aperture Priority, -1/3 ev*

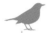 ISAK'S TIPS

To avoid the dreaded 'overexposed flash look', make sure you use shutter speeds slower than your flash synchronisation speed. This is normally 1/200 sec, so use that or any speed slower than 1/200 sec by choosing a lower ISO like I did here with the Cape Rock Thrush.

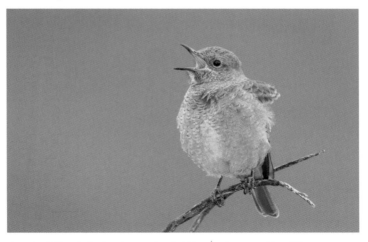

Cape Rock Thrush, Drakensberg in South Africa | *1/60 sec at f/5.6, ISO 400*
Canon 1D Mark III + 600mmf/4 lens | *Aperture Priority, 0 ev*

Twilight

The light during the twilight hours is considered low, but refers to the striking colours you see in the sky instead of the low light that falls on your subject. Before sunrise and after sunset there is a short window period where the sky turns into amazing hues of orange, blue and purple. The clearer the sky, the more intense the colours become. This is no time to pack the camera away, in fact this is one of my favourite times for bird photography. This light is great for getting clear silhouettes of birds. You need to find a bird, or group of birds, where their profiles are clearly defined and then photograph against the intense colours as a backdrop. The birds will be black, with no detail, but the shape and colours captured will create a striking image. In addition to the silhouettes, you can also use the flash to add light and detail to the birds while the background remains the same bright colour.

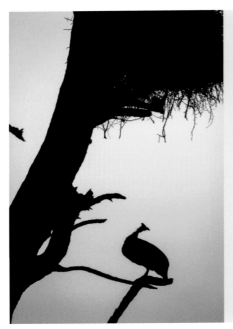

Helmeted Guineafowl can't see at night so they find a roosting spot in trees just as the sun sets. When they choose a dead tree, the clear branches create an ideal opportunity to photograph them with their clear profiles against the twilight colours that appear just after sunset.

Helmeted Guineafowl, Kruger National Park in South Africa | *1/15 sec at f/5.6, ISO 400* | *Canon 20D + 600mmf/4 lens* | *Aperture Priority, 0 ev*

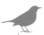

ISAK'S TIPS

Twilight is the ideal light to try the 'flash and motion' effect where you capture the bird as part blurry, but then add flash to freeze the other part behind the twilight colours in the background. During a photo workshop in the South Luangwa National Park in Zambia I saw these guineafowl standing on the edge of the river bank and one by one they flew up past us into a tree to roost for the night. With the twilight colours just after sunset, this was the ideal opportunity to use the flash and a slow shutter speed to get the 'flash and motion' effect.

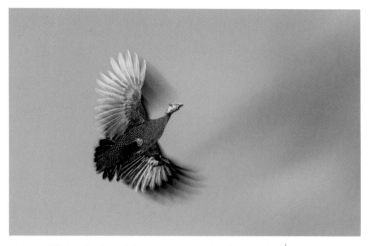

Helmeted Guineafowl, South Luangwa National Park in Zambia | *1/50 sec at f/4, ISO 800* | *Canon 1D X + 70-200mmf/4 lens* | *Aperture Priority, 0 ev*

Direction of light

You often see photographers position themselves relative to the light. This is no coincidence as the direction of the light plays just as important a role as the quality of the light. Front light with the sun directly behind you, side light with the light coming from 90 degrees away from you, and back light when you photograph into the sun are the most common directions and each creates its own effect in a photograph. Let's explore these effects in the section below.

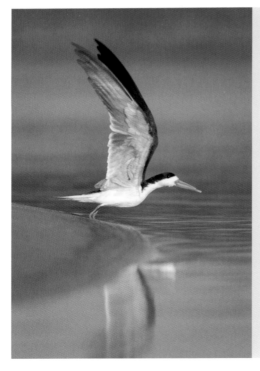

The sun from behind me illuminated every part of this skimmer as it lifted its slender wings to take to flight.

African Skimmer, Okavango River in Botswana
1/2000 sec at f/5.6, ISO 400
Canon 1D Mark III +
600mmf/4 lens
Manual Mode

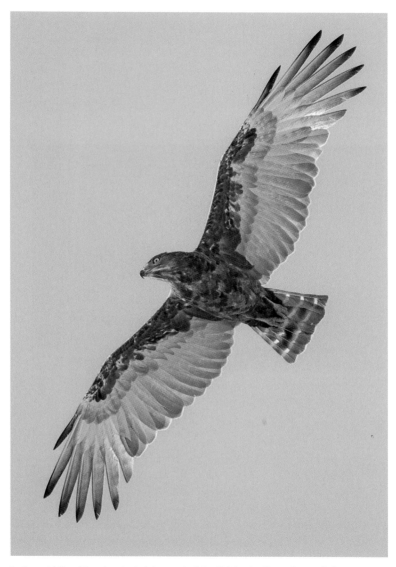

In the middle of the day the bright sand of the Kalahari reflects the sunlight upwards, like a giant reflector, to reveal the detail under the wings of soaring raptors.

Brown Snake Eagle, Kgalagadi Transfrontier Park in South Africa | *1/2000 sec at f/5.6, ISO 200* | *Canon 1D Mark II N + 400mmf/5.6 lens* | *Manual Mode*

141

ISAK'S TIPS

Different light directions can change a photo altogether and highlight different aspects of the bird, such as shape with back light, colour with front light or texture with side light. I wanted to highlight the colour of this African Skimmer's bill. The back light and dark background created little interest which put all the attention on the bright red bill of the bird. This effect could only be achieved with back light.

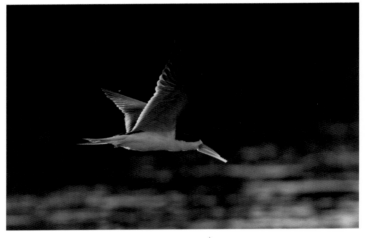

African Skimmer, Okavango River in Botswana | *1/2000 sec at f/7.1, ISO 800*
Canon 1D Mark III + 600mmf/4 lens | *Manual Mode*

Front light

Front light is the most commonly used direction of light by bird photographers. This is where you position yourself with the sun behind you when you face the subjects, exposing as much light on their bodies to the photographer by making their shadows fall away from you. Birds are beautiful creatures and, to show their feather detail, texture and colour, as much surface area on their bodies must be exposed to the light as possible. Front light is the best way to achieve this.

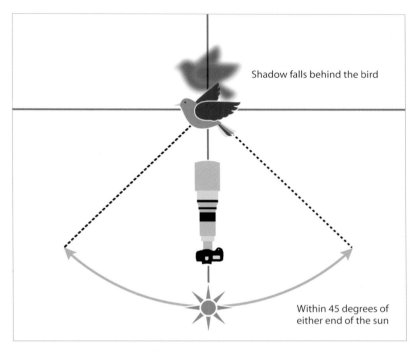

Front light: You position yourself so that the sun is behind you, making the shadow of the bird fall away from you.

Direct or filtered sunlight falls onto a bird in the daylight hours. Half of the bird would be draped in this light and half would be in the shade. The area in the sunlight reveals the colours, details and textures much better than the shaded area. The closer you can position yourself in the direction of the sources of the light, the more area you will see covered in light. Ideally, to see the most area in light you'll have to be directly in the path of the sunlight, but that would mean you block the light by casting your own shadow directly onto the bird. Preferably you would want to be just a few degrees off that position so that you're still more or less in the direction of the source but you don't cast your shadow directly onto the bird – maybe just next to it. This will make you see a large and almost entire area of the bird in the light. That would of course be possible if the sun is on the horizon and the bird is exactly in front of

you, on your level. But, what happens if the bird is in the sky or if the sun is already high, let's say at 45 degrees? You need to see as much light on the bird as you possibly can, from the ground position, so you must position yourself correctly in the 360 degrees around the bird. Choose the best spot by keeping the sun over your shoulder – even if it's high in the sky – by looking at your own shadow. When your shadow points at the bird, then you know you have the most light from behind you, giving you a view of the largest possible surface area on the bird covered in light and the least surface area on the bird in shade.

The lower the sun is on the horizon the more important your position is relative to the subject. As the sun rises it becomes less important, and if hypothetically the sunlight is directly above the bird, then your position would not matter at all. That, however, would rarely happen. At noon the sun is typically not exactly right up in the sky, but still at an angle. The closer you are to the poles, at Cape Town, for example, instead of in northern Botswana, the lower the sun will be in the sky at noon, so your position will still be important. At noon you'll still cast a shadow on the ground and you need to position yourself so that your shadow points to the bird.

Your best chance of seeing the most light on the bird is usually when the sun is near the horizon, close to sunrise or sunset. Your shadow on the ground becomes longer, indicating that you are close to being right in front of the light source. That is another reason why bird photographers love the low angle of sunlight during early mornings or late afternoons. Our subjects have jaggedy edges and normally their eyes are slightly sunken into their skulls. Thus, when they are upright and the sun starts to climb into the sky, the eyebrows or feathers above their eyes block the direct sunlight and cast shadows over their eyes. You want to see the light and colour in their eyes – this only happens when the sun is low and can illuminate the eyes completely.

Since front light makes the shadow of the bird fall away from the bird, it gives a very flat look, a two-dimensional and representative view. It's not a bad thing, but just a secondary effect of front light. If you photograph two birds that sit on the ground in front of you, one closer to you than the other, then with front light it will be difficult to see which one is closer in the image.

When your aim is to do photography from a hide to capture bird behaviour like birds in flight and action sequences, or you want to capture the colours of birds, you should use front light. Bird hides are typically built so that you sit and aim in a specific direction. It is important you check where the direction of the light will be both in the early morning or late afternoon, or whenever you plan to be there. Then you will know if the hide will be best in the morning or afternoon. If the hide doesn't limit you to only photograph in a specific direction, you need to know which direction will offer the best front light. These choices are not limited to hides – when you photograph at a dam or from a vehicle, you need to be aware of where the light source is so that you know at which point of the dam you should stand or in which direction you should photograph out of the vehicle to give you the best front light direction.

The bee-eater hide at Mashatu Game Reserve is positioned for front light, to have the sun set behind the hide in the late afternoon. This offers the photographers a view where light illuminates every part of the birds in front of the hide, with minimal shaded areas, perfect for when they lift their wings for take-off.

White-fronted Bee-eater, Mashatu Game Reserve in Botswana | *1/2500 sec at f/5.6, ISO 1600* | *Nikon D3S + 200-400mmf/4 lens* | *Manual Mode*

145

ISAK'S TIPS

When I plan game drives in my own vehicle in the Kruger National Park, for example, I always consider the position of the sun and my position in the vehicle. In South Africa the driver is on the right-hand side of the vehicle. If I sit on that side, it will be easiest to shoot to the right, so for front light I need the sun to be on the left-hand side of the vehicle. In the mornings the sun is in the east which means I have to drive in a southerly direction to be shooting to the west. In the afternoon it is the opposite, so I plan my drives to be mostly going south in the mornings and north in the afternoons during the best light hours.

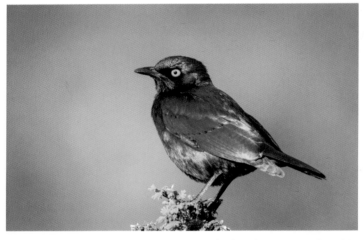

Cape Glossy Starling, Kruger National Park in South Africa | 1/400 sec at f/5.6, ISO 200 | Canon 20D + 600mmf/4 lens + 1.4x | Aperture Priority, -1/3 ev

Side light

Side light is not often used in bird photography although with the correct application it can have a dramatic effect. Side light is applied by positioning yourself to have the sun at a 90-degree angle to your right or left when you face the subject. The light hits the subject from the side, illuminating one half of the bird while the other half is covered in shade.

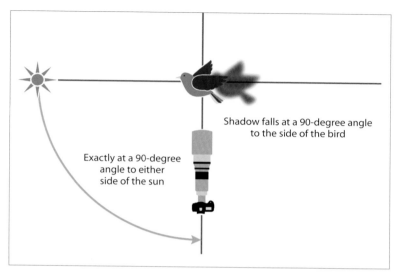

Shadow falls at a 90-degree angle
to the side of the bird

Exactly at a 90-degree
angle to either
side of the sun

Side light: You position yourself so that the sun is at a 90-degree angle to the left or
the right of you when you face the direction of your subject.

Birds don't have perfectly rounded edges, in fact they have weirdly
jaggedly shapes, edges and feathers that are not always perfectly flat
on their bodies. These bumps and textures are hidden from your view
with front or back light, but with side light they are revealed – the side
light accentuates all the non-smooth textures on the body's surface. As
the light falls on half the bird's body from your view, it makes a soft
transition to the shaded other half of the body. Where the transition is at
its optimum, the textures are best revealed. This not only accentuates the
textures, but also creates a three-dimensional effect. The differences of
light and dark on the body of the bird and in the background are quite
dramatic.

Considering your position and having the sun at a 90-degree angle to
you, the effect is best achieved when the sun is low, close to the horizon.
This has two advantages:

- The first is that the **light is direct, but still soft**. This means that the
 golden light shows contrast between the illuminated areas and the
 shaded areas but you can still see the detail in both. Ambient light like

147

the light in light overcast conditions will show little contrast between the light and shaded areas and the effect will not be achieved. On the contrary, when the light is too strong the contrast will be too strong and will completely blacken the shaded areas so that you see no detail.

- The other advantage is that when the sun is low on the horizon it will **completely illuminate the eye of the bird.** The eyebrows will not cast a shadow over the eye as they do when the sun is higher in the sky. When you have to decide between having the sun on either the left- or right-hand side of the bird for side lighting, choose the side where the sunlight falls on the side of its face. This will drape the eye of the bird in sunlight which should be one of the main considerations. Remember that birds don't sit still but keep moving around, so if for a moment it looks into another direction where its eyes are in the shade, then just wait a bit until it eventually moves its head back again.

Side light is not always planned, but here I had the sun 90 degrees to the left of me when I photographed the Red-billed Oxpecker to reveal its textures. The golden light was soft enough so that you can see the detail in both the sunlit and the shaded areas on its body.

Red-billed Oxpecker, Kruger National Park in South Africa
1/200 sec at f/5.6, ISO 200
Canon 20D + 600mmf/4 lens +
1.4x │ Aperture Priority, -1/3 ev

When the light gets stronger, just after that golden hour, then you should take notice of the bright exposure on the transition areas between the sunlit and shaded areas. Birds with bright fluffy feathers pose the biggest risk for 'burning the whites' and you should usually underexpose more in those scenarios.

Side light can create a dramatic effect during the hour of golden light, but beware that during hard light, like strong sunlight close around noon when the sun is high in the sky, this creates an unpleasant contrast in a bird photo that should be avoided. If you photograph during those conditions, try to position for front light as much as possible.

ISAK'S TIPS

Since owls are nocturnal creatures, if you portray them in their typical environment it might include the darkness as a backdrop when you photograph them at night. Using side light in this scenario, even with a strong light, creates a great effect where the textures and shape of the bird are much better revealed than with front light. The shaded areas on the bird blend in perfectly with the dark backdrop. Use a spotlight, strong torch or an off-camera flash and position the light at 90 degrees left or right of the subject.

Pel's Fishing Owl, Okavango Delta in Botswana | *1/25 sec at f/4, ISO 3200*
Nikon D4 + 200-400mmf/4 lens | *Manual Mode*

Back light

Back light is probably one of the best ways to create a stunning effect in an image. In bird photography it is often used to reveal light through the feathers of a bird or to show the profile of a bird with rim light. To achieve this effect you need to position yourself to photograph straight into the sun when you face your subject. The sun does not need to be exactly behind the subject, but rather just a few degrees off.

The effect of back light is best when you photograph very close to, or exactly into, the sun and therefore works best when the sun is low on the horizon, just after sunrise or before sunset in direct sunlight. I've also seen this effect work once when the sun had disappeared behind a mountain just before sunset. There was no direct sunlight on the subject, but the reflected diffused light still had a similar effect.

Backlight is about contrast. It's the contrast between the brightly exposed areas on the bird and dark areas in the frame that create the backlit effect. The darker these areas, the stronger the effect and the more striking the image will be. Without dark areas in the frame, the effect would be lost. It is important to choose a dark background to photograph a backlit bird. This could be a mountain, dark trees or any object in the shade.

Different birds light up differently with back lighting. If you were to take a backlit photo of a bird with smooth and flat feathers, such as a Cape Glossy Starling, then there would only be a faint rim around the bird. An ostrich on the other hand with all that fluff around its neck would create a strong rim around the neck for a dramatic photograph. Open wings works exceptionally well and can probably create the most dramatic images. Feathers are thin and light up when the sunlight strikes them from behind, no matter which bird it is. So if that same Cape Glossy Starling lifted its wings up, the formerly weak effect would change into a dramatic one.

Using back light by photographing into the sun, the feathers of this Jackal Buzzard light up beautifully. The effect is achieved only because I was able to photograph it against a mountain covered in shade as a background.

Jackal Buzzard, Drakensberg in South Africa | *1/2000 sec at f/5, ISO 1600*
Canon 1D Mark III + 600mmf/4 lens | *Manual Mode*

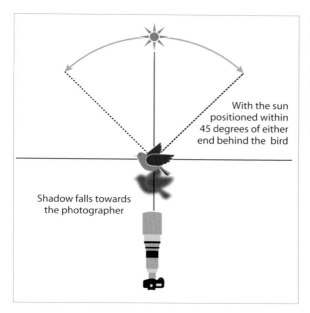

With the sun
positioned within
45 degrees of either
end behind the bird

Shadow falls towards
the photographer

Backlight: You position yourself so that the sun is directly behind your subject, making you face into the sun. This will make the shadow of the bird fall towards you.

 ISAK'S TIPS

When direct sunlight falls onto the front element of a lens, it creates distracting orange circles in your image. This is called 'lens flare' and should be avoided by using your lens hood to cast a shadow on the lens element. In addition, you should try to photograph at an angle (not into the sun) but rather a few degrees away as I have done here with this ostrich.

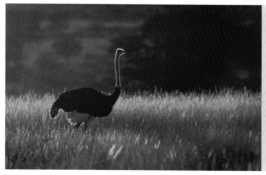

*Common Ostrich,
Kgalagadi
Transfrontier Park in
South Africa
1/1600 sec at f/5.6,
ISO 400 | Canon
5D Mark II +
600mmf/4 lens
Aperture Priority,
-1 ev*

Silhouette

Silhouette photos of birds accentuate the shape of a bird in combination with beautiful colours in the background. The combination of shape and colour is exactly what draws attention to silhouette photos. The colour in the sky is therefore key, where the most dramatic shots are usually close to sunrise or sunset when the sky turns gold. The shape of the bird is equally important. It should be clearly defined without any obstructions. A side profile is usually the best angle, although any angle will work as long as the shape is familiar, distinct and clear. The silhouette shot, like the name suggests, is about the profile of the bird and not about the detail. Therefore, the bird turns black where nearly no detail can be seen, giving its shape the attention.

Birds have diverse and interesting shapes. Using the silhouette angle of light is one of the most effective ways to showcase this.

During sunrise and sunset the sun does not stay on the horizon for very long. It is almost impossible to find a subject during this short period of time, when the sun is already in the perfect position and you've realised that the opportunity for a silhouette shot is there. Here I found a Black-shouldered Kite 15 minutes before sunset and I sat and waited until the sun got closer to the horizon. With some luck the bird did not fly away before the opportune moment, but instead took to flight just as the golden colours of the setting sun had peaked.

Black-shouldered Kite, Kruger National Park in South Africa | *1/4000 sec at f/8, ISO 500* | *Canon 1D Mark III + 600mmf/4 lens + 1.4x* | *Aperture Priority, -1 2/3 ev*

ISAK'S TIPS

Capturing the perfect silhouette shot of a bird can be harder than you think. All the elements could be there, the bird, the tree and the rising sun, but if the bird doesn't turn its head to show the profile of its beak, then the image will fail. A head turned away from the photographer does not fit the profile of a bird. In the Serengeti National Park in Tanzania I almost 'lost' this shot as the vulture wouldn't turn its head, but luckily it did so just in time when the sun was in the best position.

Lapped-faced Vulture, Serengeti National Park in Tanzania │ *1/1250 sec at f/16, ISO 100* │ *Canon 1D X + 600mmf/4 lens* │ *Aperture Priority, -1 ev*

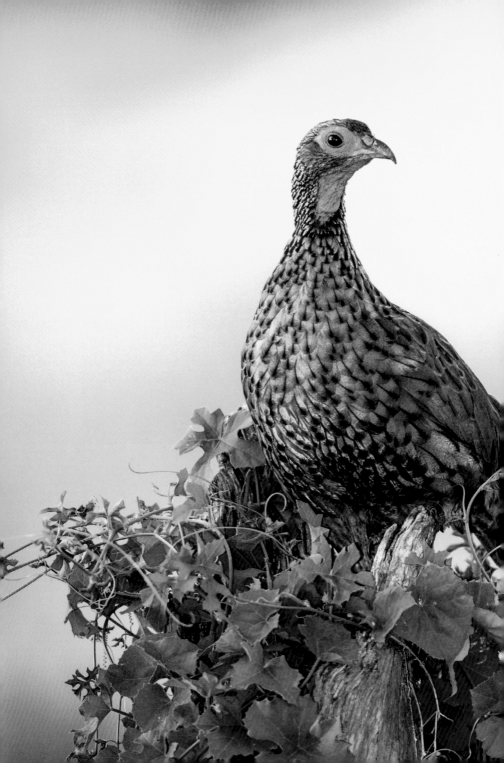

How to make sharp images

*Swainson's Spurfowl, Kruger National Park in
South Africa* | *1/200 sec at f/4, ISO 100
Canon 5D Mark II + 600mmf/4 lens + 1.4x
Shutter Priority, +1/3 ev*

Introduction

To produce sharp images is the objective of all photographers. A sharp image is a combination of the correct focus and having something well defined in the image. This could either be a portrait of a bird where you can see the detail in every feather, or a blurry sense of motion with the head of a bird perfectly defined. Having a perfectly sharp but utterly boring photo is one thing, but if you make a great effort to capture a creative masterpiece with the camera and you can't get the image sharp, then it will fall to pieces.

In this chapter I'll explain how you can utilise the latest advances in DSLR camera technology to create sharp images. This ranges from choosing the correct settings to using the correct techniques. The camera can do almost anything automatically, but for your creative vision you need to be in control of what it does. Remember, *you* know best! I'll concentrate of the basics for now. Getting sharp images of birds in flight or birds in action is a whole new ball game and is discussed in Chapter 8.

Two of the major contributors to sharp images are having the **correct focus** and having the **correct shutter speed**. Focus is a function of distance, where a lens can focus only to a specific distance away from the lens. This distance can actually be read on a scale as a measurement at the top of the lens and is expressed in metres. As the lens focus to a different object you will see the values change. This concept is called **focus plane**. So, if you have two birds sitting close to each other, and the one is five metres away from you and the other eight metres away, then you can only have one of them in focus. Depth of field (controlled by the aperture) will, however, determine how much the other one is in or out of focus.

ISAK'S TIPS

The greatest feature of digital cameras is that you get instant feedback. You can look at your image on the LCD screen at the back of the camera immediately after you've take the photo to make sure the sharpness, exposure and composition are all perfect. In other words, you fix the problems while you're photographing. It might seem obvious, but it is important to remind yourself to look at the images you are taking every now and again, especially when the birds are performing in front of you making it hard to look away from the action to take a break. You don't want to get home after a shoot only to realise that your images were underexposed or soft from a slow shutter speed.

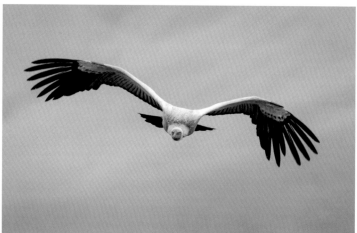

Cape Vulture, Drakensberg in South Africa | *1/1600 sec at f/5.6, ISO 1600*
Canon 1D Mark III + 600mmf/4 lens | *Manual Mode*

KEY POINTS

- Use a **single autofocus point with surrounding points.** This is a clear instruction to the camera of where focus should be, resulting in **faster** and **more accurate focus.** The 'with surrounding point' feature makes the **focus execution more forgiving** when the photographer struggles to keep the focus point on the bird.

- During **birds-in-flight** and **action** photography, keep the **autofocus point in the middle of the frame** since that is the location on the frame where the camera can execute the **fastest and most accurate focusing.**

- Birds-in-flight, action and photography of any moving subject require the camera to **'track' the subject while moving** by adjusting focus on the subject continuously. This focus drive mode is **AI Servo** (Nikon = **AF-C**) and a bird photographer's camera should **always be set to this mode** so you can be prepared for an action shot at any time. The camera focuses continuously when the shutter button is kept halfway down.

- With **back button focusing** the **focus** and **shutter release functions** are **triggered with different buttons.** You focus in continuous focus mode with a button at the back of the camera. Releasing the button locks the focus. The shutter is triggered with the shutter button at the front of the camera.

- **Composing a photo of a static bird** can be done by either **moving the single autofocus point** around in the frame to cover the bird, switching to **One-Shot focus (Nikon = AF-S)** or by using the **'focus and recompose technique'.** This is where you aim at the bird with the centre autofocus point, lock focus, move the lens to compose the shot and then take the photo.

- Use the **back-focusing technique** or **set up a button** at the back of the camera **to lock the focus.** This will enable you to **always** photograph with **continuous focus** – but when you want to **lock the focus** for composition or pre-focusing on a perch, it can be done with the effortless pressing of a single button.

- **Keeping the lens still** and having a **good support system for smooth panning** during action shots is crucial for getting sharp images. Try out different options like **beanbags**, **gimbal heads** and **fluid heads** to find the solution that works best for you.

Focus point selection

Autofocus systems have been commercially available in analog cameras since the 1990s and form part of the core of digital photography. You can't imagine photography without it – in fact bird photography would be almost impossible without it as you rely on the camera to keep your small moving subjects in focus, while you concentrate on keeping them in the viewfinder. But in a scene with various elements like trees, reeds, water and birds, how do you get the camera to focus on the bird instead of the tree?

In auto-mode (entry-level and advanced amateur cameras have this mode) the camera does everything automatically, like the name suggests, and will choose which element in the photo to focus on. It loves choosing areas with contrast such as the chest of a fish eagle where the whites meet the blacks, or an element that is closest to you. Regardless of which area it chooses, you don't want the camera to make this decision on your behalf. You want to be in control because *you* know best!

Program mode, aperture priority, shutter priority and manual mode allow you to choose between different autofocus modes (called autofocus point selection). These three different modes allow you to instruct the camera where to focus (see next page).

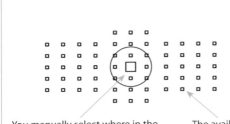

You manually select where in the
frame to focus by moving this
single AF point around

The available
positions to
move the AF point to

**Single-point
autofocus** is a manual
selection of one AF
point and works well
in portrait shots only.

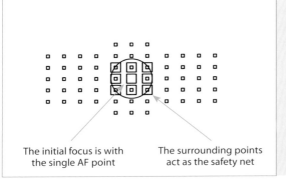

The initial focus is with
the single AF point

The surrounding points
act as the safety net

**Single autofocus point
with surrounding points**
is a manual selection of one
AF point, but the camera will
use the surrounding points
if the focus changes. This is
more forgiving and is the
best way to photograph
bird behaviour and birds in
flight.

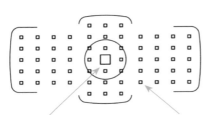

The focus point(s) that
the camera has currently
selected for focus

The available positions
where the camera can
choose to focus

Area focus makes the camera
choose from all the available
focus points where it 'thinks'
the focus should be. Not only
is focus slower because of
the additional calculations
that the camera has to make,
but the camera also does not
know where you want the
focus to be and usually focus
on the wrong object.

Single-point autofocus

Camera models each have a different number of autofocus points scattered across the frame in the viewfinder. The professional camera bodies have more points and they cover a larger area in the frame, usually up to 61 points. The entry-level cameras have about nine autofocus points but I've seen some with only three, and they usually only cover a small area of the frame, often close to the middle.

When single autofocus point mode is selected, the camera uses only one autofocus point. You can choose which of the available points it should use and that point is highlighted in your viewfinder either as a red or a black square. In your viewfinder, the element that is covered by the autofocus point is the element that the camera will try to focus on. If you want the bird to be in focus and not the tree, then you need to have the autofocus point over the bird. You can do this by either moving the lens, or by selecting a different autofocus point in your frame (the one that covers the bird).

Composition is important in all photographs, so the ability to move autofocus points is crucial. You might want the tree in the bottom left-hand corner of the frame and the bird in the top right-hand part of the frame, but have the bird in focus. For this you need to select the autofocus point in the top left part of the frame and have it cover the bird. Photographers often talk about 'moving autofocus' points, and when you look through the viewfinder you can see the red rectangle 'move' across the frame as you select different points. For bird photography, while looking through the viewfinder, it is crucial that you never take your eye off the bird as you 'move' the autofocus point. Every camera model works differently, but I've set mine to move the points with a sort of joystick control at the back of the camera – up, down, left and right.

You need to manually move the focus point to the desired position in **single-point autofocus** mode.

Black-shouldered Kite, Rietvlei Dam Nature Reserve in South Africa │ *1/640 sec at f/8, ISO 200 Canon 20D + 600mmf/4 lens + 1.4x* │ *Aperture Priority, + 1/3 ev*

One of the great advantages of using only one autofocus point is that the camera focuses fast and accurately. From all the available autofocus points, the one in the centre of the frame is best for this performance (the centre of the lens picks up contrast the best). If the camera had to choose by itself which autofocus point to use (like in auto mode), imagine how many calculations it would have to make (it would run through 45 autofocus points to see which one covered an area with the highest contrast). That would slow the focusing down so much that by the time the bird was in focus, it would have already jumped out of the frame.

Single autofocus point with surrounding points

This mode works exactly like the previous one except that it is more 'forgiving' and only works when you use AI Servo mode (Nikon = AF-C).

When you, for example, focus on the head of a bird that sits right in front of you using a single autofocus point, it is often difficult to keep this point exactly on the head of the bird while it keeps moving around. The margin of error might be very small, especially if the bird is small in your frame. If you keep the lens perfectly still with the autofocus point exactly on the bird, and then all of a sudden the bird moves its head backwards, your autofocus point would now be covering the tree behind the bird, putting that in focus instead of the bird. Then, the bird moves its head back into position, putting the bird in focus again. Birds tend to be fidgety and make small movements all the time, so to keep the lens and autofocus point on the eye of the bird (or wherever you try to focus on) is virtually impossible. The problem is that the focus would continuously keep jumping around to different elements in the frame.

The single autofocus point with surrounding points mode gives you the safety net to keep the bird in focus even if moving away from the autofocus point. The way it works is that the initial focus acquisition is still on the object covered by the active autofocus point, but then when the bird moves the camera will not readjust focus as long as the bird is still covered by one of the surrounding autofocus points. This technically slows the focus tracking of moving subjects down marginally, but the effect is small enough to make this mode the standard one for bird photographers to use. It is particularly handy when photographing action or birds in flight when the movements are so fast that you can't keep the autofocus point perfectly on the bird the entire time.

You need the tolerance that the **surrounding points** offer when photographing birds in flight.

Pale Chanting Goshawk, Kgalagadi Transfrontier Park in South Africa | *1/2000 sec at f/8, ISO 500* | *Canon 1D Mark III + 600mmf/4 lens* | *Manual Mode*

Area focus

There are many variations of this mode on different camera brands and models. It includes having all autofocus points active, 3D tracking and ring of fire, just to name a few. In this mode the camera has to calculate where it 'thinks' autofocus should be, by considering all autofocus points. Usually it selects the focus point covering an object that is closest to the photographer or the one with the best contrast. This would usually not be on the bird where the photographer would like it to be, and as I mentioned before, you know best so this mode does not offer any benefit.

For tracking birds in flight in AI Servo mode (Nikon = AF-C), the 3D tracking and ring of fire modes do offer some value. The idea is that when you aim the lens to photograph a bird in flight, the initial focus

acquisition is with the centre autofocus point, but then when the bird moves across any of the other autofocus points in the frame, the camera will keep the bird in focus. This allows for a lot more tolerance than the **surrounding autofocus points** in the previous mode and it becomes temping to switch to this mode when you're struggling to keep a bird in flight in focus. The problem is that the camera has to do so many calculations that it struggles to keep up with fast-flying birds, leaving you with soft images. There is no substitute for good technique and I advise you to rather try to improve your panning skills, to get better at keeping the autofocus point on the bird, in the **single autofocus point with surrounding points** mode. This is your best chance of getting consistently sharp images of birds in flight.

The theory of **area focus** sounds like the perfect solution, making the camera use all available focus points to track the subject. Unfortunately the reality is that the focus is slow and the camera usually chooses the wrong subject on which to focus.

African Skimmer, Okavango River in Botswana | *1/2000 sec at f/5.6, ISO 400*
Canon 1D Mark III + 600mmf/4 lens | *Manual Mode*

 ISAK'S TIPS

Set your camera to offer only a few selectable autofocus points. My camera offers 61 selectable points, but is set to only offer 15. When you quickly want to move the autofocus point to the corner of the frame, for example, it is much quicker to move the dial two or three times in the 15 point grid than up to eight times in the 61 point grid to get to the same point.

61 points

15 points

166

Focus drive

You can choose between one of two focus drive modes:

- One-Shot (Nikon = AF-Single or AF-S) that works only for static birds; and
- AI Servo (Nikon = AF-Continuous or AF-C) that works for both static and moving birds.

One-Shot mode makes the camera focus once only during the process of taking a photo. It is a two-step process where the act of focusing is done before the capturing of the photo. There is usually a split-second duration between the two stages, so if you take a photo of a bird flying straight at you, the camera will focus on the bird, but by the time it takes the photo the bird would be closer to you and already slightly out of focus.

Technically the process works as follows: As you slowly press the shutter button you'll feel that there is a point of resistance on the button, before you press it all the way down. Most photographers consider this to be 'halfway down'. At this point the camera will focus but not take the photo yet. You can often feel the lens motor 'searching' for focus for a split second. The camera makes a peep noise to indicate that it has achieved focus (you can switch that noise off in the menu). If you keep holding the button halfway down, and you move the lens or the bird jumps out of the frame, the camera will not re-adjust the focus. When you press it all the way down, the camera then takes the photo.

When you just take a photo normally, the camera still follows the two-stage process but it happens so quickly that it seems like one action, focusing and taking the photo.

One-shot mode works well for doing portraits of static birds only so it is not recommended. I always use AI Servo where the camera continuously

1. Keep the camera in AI Servo mode even when taking portrait shots. Compose the shot and move the focus points to cover the birds while maintaining the composition.

2. When the first bird takes to flight, press the shutter to capture the take-off. Then move the lens and point it at the flying bird while you switch back to the centre AF point.

3. Keep pointing the lens at the flying bird in the middle of the frame with the centre AF point over the body of the bird while you release the shutter.

When photographing bird portraits and then switching to birds in flight, always keep your camera on AI Servo or AF-C so that you are prepared for a bird in flight shot at any moment.

African Skimmers, Okavango River in Botswana | *1/2000 sec at f/5.6, ISO 640*
Canon 1D Mark III + 600mmf/4 lens | *Manual Mode*

focuses, making it ideal for moving birds, action sequences and bird portraits. In this mode, the camera focuses continuously while you keep the shutter button halfway down, continuously looking to make small adjustments in focus on the area covered by the autofocus point. A flying bird covered by the autofocus point will remain in focus in AI Servo mode. A static bird covered by the autofocus point will remain in focus in AI Servo mode. When you press the button down all the way, it captures the photo. So whether the bird is moving or not it will remain in focus as long as you keep the autofocus point on it.

ISAK'S TIPS

There is one scenario though that merits switching to **One-Shot** or **AF-S** mode. This is when you anticipate that a bird in flight will land on a specific perch, you can use this mode to focus on the perch. Then, while keeping the shutter button halfway in and keeping the lens aimed at the perch, the camera will not readjust focus. As the bird touches down, you can press the shutter all the way down to take the shot with the bird in focus.

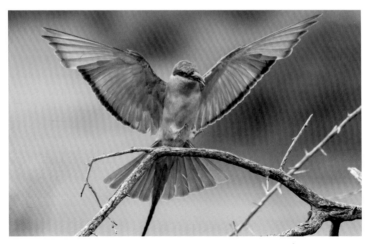

Southern Carmine Bee-eater, Kruger National Park in South Africa | *1/1250 sec at f/8, ISO 800* | *Canon 1D Mark II N + 400mmf/5.6 lens* | *Aperture Priority, 0 ev*

Support system

The effect of the slightest movement of a lens is amplified when you use longer lenses. When you look through the viewfinder of your camera with a wide-angle lens attached (such as a 24mm lens) and you hand-hold the lens, you can hardly notice the effect that a small movement has on the frame. If you attach a longer lens to your camera (such as a 400mm lens), you have effectively zoomed into the frame you had previously seen. Now the same small movement is seen up close through the lens and the effect is much more noticeable.

To produce sharp images you have to keep the lens from moving. This becomes increasingly important when you use slow shutter speeds. At 1/50 sec shutter speed the slightest movement of the lens will create a blurred photo, but at 1/2000 sec the photo will be sharp even if the lens moves significantly. Therefore, shutter speed and lens movement influence sharpness – and the focal length of the lens also plays a role. The effect of small movements on a 24mm lens at 1/50 sec shutter speed will be small enough that you can get a sharp photo. But if you use a 400mm lens at 1/50 sec shutter speed, this will result in a soft photo (if the lens was subjected to the same amount of movement).

Since bird photography mostly involves the use of long lenses, it is increasingly important to have a good support system that keeps the lens from moving. There are the two scenarios:

- **Portraits of birds** where we usually use slower shutter speeds.
- **Behaviour shots** where there is movement and we use faster shutter speeds.

When you photograph birds from a hide or from a vehicle, you normally do a combination of these two shots. You might be doing portrait shots of a Lilac-breasted Roller sitting on a perch with a beautiful green background – and then the next moment the roller looks intently in a direction and takes to flight to catch an insect. You want to capture that behaviour shot too, so you need a support system that will keep the lens still while doing the portrait shot and then the same system to offer a smooth panning movement when you photograph it in flight.

Beanbags are probably the most solid support for a lens for portrait shots. You rest the barrel of the lens on the beanbag while it takes shape around the lens for a snug support. When you want to pan with the bird flying, the beanbag is not a good support solution. At this stage you can either pick the lens up and do the shots handheld or pan using the bag. Beware not to rotate the focus ring of the lens over the bag as that will make the bird go out of focus – rather rest the lens collar on the beanbag while you pan.

Gimbal or fluid heads mounted on tripods, clamps, ground pods or door brackets probably offer the best solution for this scenario. For static portraits the mechanism can the locked tight to prevent the lens from moving or you can use your left arm to push down onto the lens to create resistance and thus keep the lens from moving. When you switch from portrait shot to action shot, then your lens is already attached to the best support system for panning shots. Now you can continue to photograph and effortlessly pan with the bird.

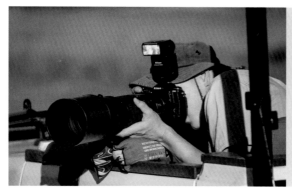

A beanbag on a safari vehicle is a stable support when you photograph bird portraits.

A monopod gives you good support and the freedom to move the lens around with ease.

When you use a long lens from a standing position and you don't have access to a monopod or tripod, then you can use your partner for support.

172

Focus and recompose technique

The centre autofocus point is the fastest and most accurate for focusing. It is ideal to use when photographing birds in flight where you keep the bird in the middle of your frame. I also recommend that you always keep your camera in AI Servo mode (Nikon = AF-C) to be ready for any shot that requires continuous focus.

But what if you want to do a composition with a bird in the top right-hand corner of your frame, but you still want to utilise the accurate focusing of the centre point? Focus and recompose is a technique that works very well for this. This technique is for photographing static birds and requires you to lock the focus in some way. This can be done by setting your camera to use the back button for focusing and the front button to release only; or by setting the back button to lock focus; or as the least favourable option by switching to One-Shot mode (Nikon = AF-S) from the continuous mode temporarily while you do the portrait shots.

The focus and recompose technique works as follows: you need to use the centre autofocus point to aim at the bird and get it in focus, then lock the focus and change your composition to have the bird in the corner of the frame. At this stage the bird remains in focus even though the focus point is covering something else. Now you can capture the photo. Remember, if you use One-Shot focus drive and focus with the shutter button, then locking focus is not with the focus lock button at the back of the camera, but by pressing the shutter button halfway down and keeping it halfway down.

The technique is also the only way to focus on a bird that is close to the side of the frame and not covered by any focus point.

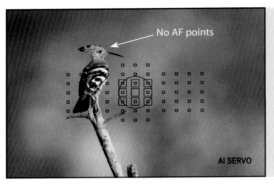

1. This is the composition I want, but there is no AF point to cover the eye of the hoopoe.

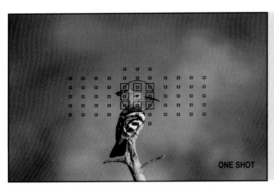

2. Switch the camera to One-Shot or AF-S so that you can lock focus. Change the composition to have the bird in the middle of the frame. Then choose the centre AF point and use it to focus on the eye of the bird.

3. Keep the button half-pressed to lock focus (or release the back focus button if you use that technique) while you move the lens to compose the shot. Then press the shutter button down all the way to take the shot.

The focus-and-recompose technique by temporarily switching to One-Shot mode.

African Hoopoe, Okavango Delta in Botswana │ *1/2000 sec at f/5.6, ISO 500* │ *Canon 1D Mark IV + Canon 600mmf/4 lens + 1.4x* │ *Aperture Priority, -2/3 ev*

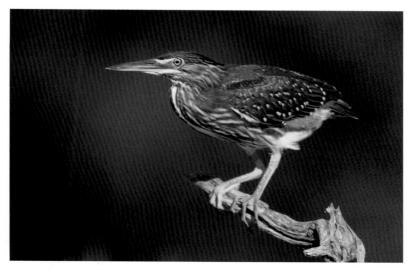

I wanted to focus on the eye of the heron but there was no focus point that covered the area so high up in the frame. So I had to use the focus-and-recompose technique to have the eye in focus while composing the bird the way I wanted it to be.

Green-backed Heron, Kruger National Park in South Africa | *1/1000 sec at f/5.6, ISO 200*
Canon 20D + 600mmf/4 lens + 1.4x | *Aperture Priority, -1 ev*

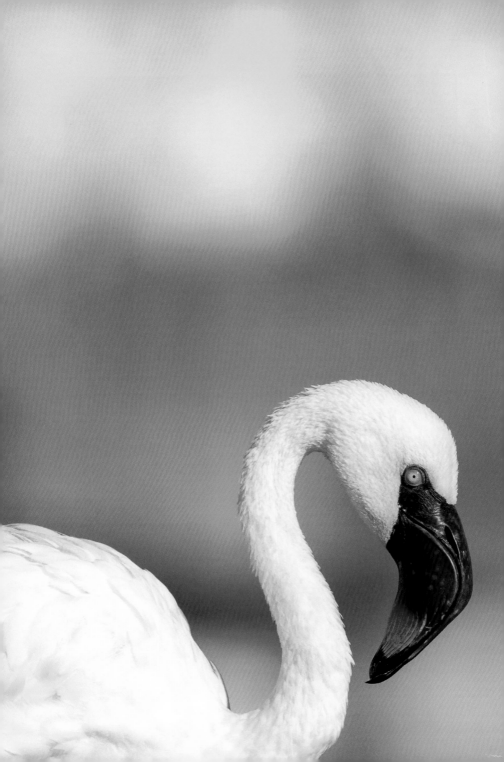

Chapter 6

Designing your images

Lesser Flamingos, Lake Bogoria in Kenya │
1/800 sec at f/7.1, ISO 500 │ *Canon 1D Mark IV*
+ 600mmf/4 lens + 1.4x │ *Manual Mode*

Introduction

Composition is the most important creative element in any type of photography. In fact, it is probably the most important thing to consider when creating a striking image. A technically perfect photo without a good composition has no impact, but a creative composition that is pleasing to the eye catches the attention of everyone. Photography is art and, therefore, it is the artist's decision as to how to arrange elements in his/her frame that will create an attractive composition.

In bird photography you have the chance to compose your photos in camera when you photograph static birds, but it is almost impossible to compose an action or bird-in-flight photograph in camera where the challenge is to just keep the bird in the frame and in focus. For those shots our objective is to capture the action in the middle of the frame and crop for a composition during post-processing.

There is no right or wrong method when it comes to composition, but there are guidelines that can be followed to create a more pleasing composition. Most often you would combine a number of these guidelines and sometimes it's the deliberate breaking of them that creates a stunning image. Think of composition as your artistic freedom, and no matter what you do, the image will be judged on the way people feel when they look at it. It needs to evoke an emotion in the viewer, and that could be from using exceptional light, including the environment in the photo, capturing action with impact which is large in the frame, or simply showcasing the bird's beautiful colours against a dark backdrop.

In this chapter I've mapped out some of the **Do's** and **Don'ts** of composition for bird photography. Remember that these are not rules, but merely guidelines that can be followed. It is impossible for every image to follow the same guidelines, so it's your artistic choice to apply these in a way that you see fit.

KEY POINTS

- **Composition** refers to the way you **arrange the elements in your frame** to create an image with artistic appeal that will evoke an emotion in the viewer. Keep the composition simple with only the minimum elements required to give a clear message to the viewer.

- Do **not frame** the birds **too tightly.** Allow **enough space around the bird** or group of birds in the frame for a sense of freedom. Position the subject to the side in the frame, leaving more space in front of it in the direction it is facing, so it has room to 'move into'.

- The **rule of thirds** is the most effective composition guideline. Draw two equally spaced horizontal and vertical lines across the frame. There will be four points where these lines cross, referred to as the intersecting points. Place **anything of interest** in the frame **over any of these intersecting points**.

- The **background** behind the bird is the **most important compositional consideration** in the image. Choose a clear background, without clutter or distracting highlights, to separate the subject from the background.

- **Dark or natural-toned backgrounds** have much **more appeal** than having the sky as a background. It makes the bird stand out better and reveals its colours and textures in greater detail. To keep the bird in focus is more difficult with a natural-toned background as there is little tolerance for not keeping the focus point exactly on the subject.

- **Never photograph a bird flying away from you** or with its head turned away from you, even if just slightly. The angle of the body of the bird does not influence the direction it will turn its head. When the body faces you, it reveals the colours on its chest and when turned away from you it reveals the colours on its back. For a portrait shot you have to consider the angle of its head. The **best angle** is with the **head turned slightly towards you from parallel**.

- The **best postures** of a bird in flight are with its **wings fully extended** either **upwards or downwards.** These two postures create impact – it's a personal choice as to which one you like the best. Unless the bird is soaring, you should avoid keeping photos with the wings in the horizontal position.

- **Don't crop too much.** Try to get the **composition correct in the camera** even if the bird is small in the frame. Never just take a photo and think "I'll just crop it later". Rather try to get closer or consider adding some other natural elements in a 'wider' composition.

- **Don't clip the wings** or any other part of the bird unless you do a tight-cropped portrait or a photo where you deliberately crop the body or joints of the bird. In that case you should make it look like it's done intentionally.

General guidelines

Subject placement

Composition is the arrangement of elements in your frame. This becomes increasingly important when you have only one subject or element in the frame that you need to arrange. The subject placement becomes the composition so it needs carefully consideration. There are a few recommendations that will help you arrange single birds or flocks of birds – in flying or static positions.

Space to move into

One of the generic rules of composition for people or animals is that they need space to move into. This creates a sense of freedom of movement whether they are already in motion or static. The space should be created in front of them, for them to look towards or move into. In bird photography you should see in which direction the bird is looking. This is determined by the direction that the bird's head and beak is pointed to.

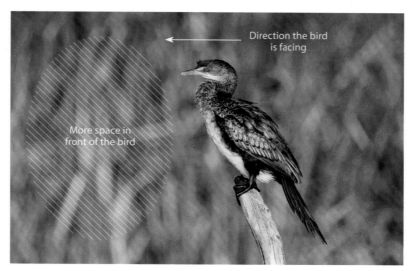

Direction the bird is facing

More space in front of the bird

The bird is looking to the left and should thus be placed on the right side of the frame with more space on the left to look into.

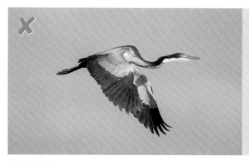

The Black-headed Heron should have more space in front of it than behind it.

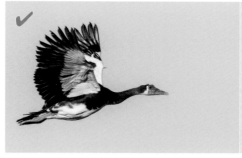

This Spur-winged Goose has space for it to 'fly into'.

Rule of thirds

This is one of the most well-known rules for subject placement. If you draw two evenly spaced lines both horizontally and vertically across your frame it divides the image up into 'thirds' and there would be four spots where the lines intersect. Any of these four spots becomes a good place to put your subject, or a point of interest. This could be the body of the bird when it's small in the frame or perhaps the bird's eye in a tight portrait shot. The lines themselves also become important. If you have a flock of birds in a line, place them across one of the lines instead of in the middle of the frame. Make sure that some point of interest covers one of the lines or the four intersecting points.

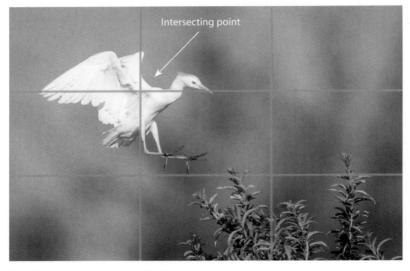

Place the subject across one of the intersecting points.

Placement of the Malachite Kingfisher in the corner of the frame over one of the intersecting points will give the image more artistic appeal than when it's placed in the middle of the frame.

Correct placement of the subjects in the frame following the rule of thirds.

Symmetry

Placing a subject straight in the middle of the frame is considered a photographic crime, but not so if you're doing a tight portrait or have a symmetrical subject. In bird photography that means that your subject should be facing you, looking straight at you or straight away from you and have a posture where the one side mirrors the other side exactly. The symmetry is what draws attention and should be emphasised by placing the subject in the middle of the frame.

This Bearded Vulture is too symmetrical not to be placed in the middle of the frame for more impact.

A perfect symmetry in both subject and background works perfectly when placed in the centre of the frame.

Flocks

Composing a flock of birds can be very difficult. The challenges usually include where to cut the flock off and where in the frame to compose them. If there are many birds tightly fitted together, whether they are flying or sitting on the ground or in a tree, if you can get close enough to fit the whole flock in without leaving any open spaces on the edges, then the theme of the photo changes to **patterns** and **texture**. This would only work, however, if the birds are distributed evenly across the image.

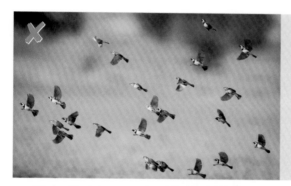

Too few birds for an even texture and open spaces on the edges makes these sort of images fail.

These Red-billed Queleas form a tight flock and create an even-textured image.

Flock on ground in a line – compose in bottom of frame

For a flock of birds on the ground we have to convey the feeling that they have the freedom to fly up into the sky. Usually when you photograph a flock of birds from their level, then they are a straight line in your frame. Compose them in the bottom in the frame to leave space above them.

A line of birds composed in the middle of the frame.

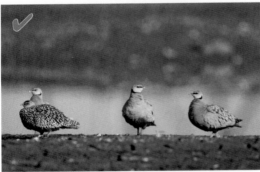

Cropped to be composed at the bottom of the frame.

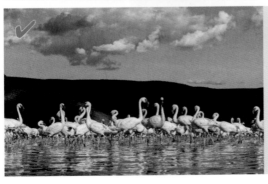

It is ideal to compose the image in camera.

Keep birds defined

When you photograph small flocks of birds flying, you should try to keep each bird defined without overlapping another one. This is usually impossible to do while you are taking the photos, but when you take a series of photos you might have a chance of capturing a frame where it's just perfect. When birds overlap, you often find them with two heads or four wings, or perhaps just a bulky bird that causes subconscious distraction.

Slight overlapping occurring in the bottom left corner.

No overlapping and each bird on its own being well defined.

Focus on closest bird

When you have more that one bird in your frame the question is always, which one do you focus on? If you want to use a shallow depth of field as a creative effect, then the impact of your decision will be greater than when you want to put all the birds in focus by using a wide depth of field. When the birds are close to being on the same focal plane, i.e. the same distance away from you, then it matters less than when the distance between you and the birds varies a lot. Always focus on the one in the front that is closest to you. The human eye naturally looks at the closest subject in a composition first, so that is where the focus should be.

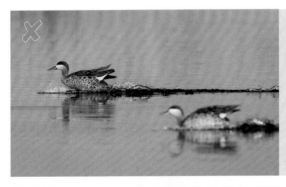

The viewer's eye is drawn to the closest subject, but if it's out of focus it will be distracting.

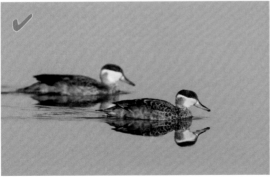

It feels natural to look at the subject closest to you first.

Head angle slightly towards you from parallel

When you photograph portraits of birds you often end up with hundreds of photos where the bird has the same posture, but you have shots of it turning its head in almost every position. When you look through these shots, the ones with the best impact will be where the head is not turned perfectly parallel to you, but just a few degrees towards you from parallel. This is also the angle at which the tip of the beak to the eye is on the same focal plane (in focus). Any photo where the head is turned slightly away from you loses a connection with the viewer.

The head is turned slightly away from you.

The head is facing you straight on.

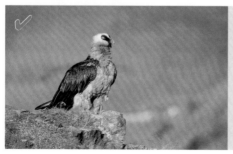

The head is turned a few degrees towards you from parallel.

Glint in the eye

A glint in the eye of the bird creates an impression of life in the subject, making a stronger connection with the viewer than without that glint. These glints could come from a catchlight caused by sunlight reflected in the eye, or a flash light, or even ambient light that can sometimes create a faint highlight in the eye. The way the bird positions its head also plays a role. When it looks down or slightly away from you, or the light source is behind the bird, you cannot see the highlight in the eye from your angle. Your best chance to capture a glint would be with front lighting or side lighting.

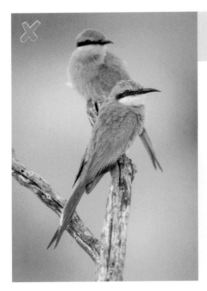

There is ambient light with no catchlight.

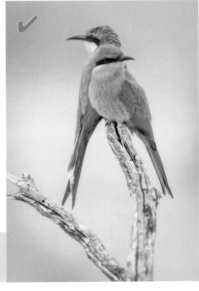

Fill-flash creates the glint.

Focus on the eye

The eye of any subject is where the first attention is drawn by a viewer. It's human nature to look a subject in the eye, that's where you can connect to it, to see emotion and life, acting like a window into the soul. It is, therefore, important to make sure that that is where focus is or at least make sure that the eye is also in focus if you use a wide depth of field. In wider shots it's less important than in tight portraits where the eye of the bird is large in the frame. This becomes a key feature of the image where the composition usually follows the rule of thirds with the eye placed on one of the 'third' lines or intersecting points.

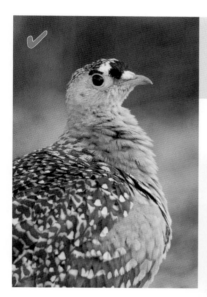

No matter how the head of the bird is turned, always focus on the eye.

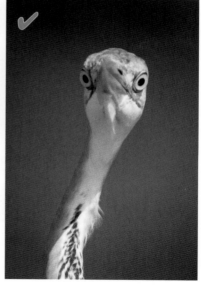

Chop off properly

Tight portraits of birds require you to chop some parts off the bird. It's unusual to get so close to birds, but if you do manage to, such as having the neck, eye and beak fill your frame, then it creates real impact. It is, however, very important to know exactly where to chop off the parts of the bird. The secret is to make sure it looks intentional. So, if you cut a leg, then don't do it at the tip of the foot, close to the edge or close to any joints. Do it in the middle of the leg halfway between the foot and the knee or halfway between any joints in the upper legs.

It usually looks best to either chop the legs or the tail, but not both.

Chopping off only the tail looks good.

Chopping off the tail where no legs are visible is good.

Chopping the bird just below the shoulders is good.

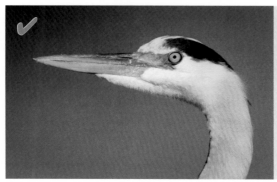

Chopping the bird on the neck between the head and the shoulders is good.

Background

Apart from subject placement, choosing the right background is one of the most important considerations in bird photography. The effect of the correct background can be dramatic, accentuating the features and colours of a bird, giving the effect of it 'popping' out from the background. Composing the subject in a different position in the frame is done by moving the lens up and down, and left and right, but to select a different background behind your subject usually involves changing your position relative to the subject. Sometimes there is a significant change in simply moving a few centimetres up, down, left or right, while other times you have to change seats in a hide or move your vehicle a few metres forwards or backwards.

Out of focus effect

The bird photographer usually wants to separate the bird from the background to make the bird 'pop' out and cast the viewer's attention solely on the bird. The only exception is when you want to show the bird's environment, typically in a wide shot. This separation of bird from background is a combination of using a shallow depth of field and having the bird far away from the background, relative to how close the bird is to you. To accentuate a shallow depth of field effect, you should get closer to your subject even if it is standing close to the background.

The bird is too close to the background making it in focus and having that contrast distract the viewer's attention away from the bird.

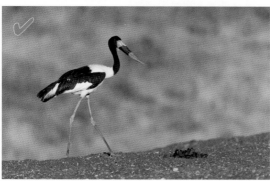

Choose a subject that is far away from the background relative to you.

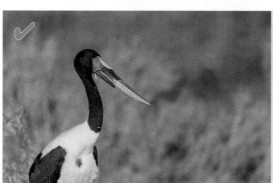

The closer you can get to your subject the better the shallow depth of field effect is.

Colour

We are drawn to colour. The brighter the colours and the closer to pure prime colours, the more we love the photograph. Colour grabs our attention and makes us *look*. A colourful background can lift an image and complement the lack of colour in a dull bird. The dry season in southern Africa can be difficult to find colour in the veld as everything turns dusty-brown or yellow. The wet season might bring days with rain that spoil your bird photography trip, but with it comes greenery and colour for better backgrounds.

The Laughing Dove is often overlooked because of its dull colours and having a dull-brown background does not help.

The same bird against a beautiful bright green background can make a stunning photo.

Natural-toned backgrounds

Although we most often see birds either on the ground or sitting against a sky backdrop, it is the out-of-focus, naturally toned backgrounds in bird photos that grab our attention. Maybe it's because this is different from how we usually see them or perhaps because the bird 'pops' out so nicely from the background. To find a bird against this background is difficult, and a portrait shot of a static bird is one thing, but trying to capture a bird in flight with this background is especially hard to do. The slightest mistake by the photographer will make the camera focus on the background instead of the bird and then it is too hard to re-focus on the bird before the opportunity is over. To get a photo of a bird in flight against a naturally toned background is a great technical achievement with enormous aesthetic appeal.

The blue sky as a background is not bad, but the image would be better if there was a natural-toned background.

A natural-toned background is more striking.

Comparison of light on the bird and light in the background

- *Bright bird, dark background*

 The human eye loves contrast and it is drawn to the brightest subject, making the bright bird against a dark background the ideal situation. Dark backgrounds can be hard to come by, so look for big trees that are covered in dense leaves, or use side lighting to pick the shadow of a mountain as a background. Be sure to check your exposure where the tendency is to overexpose the image when you don't apply exposure compensation.

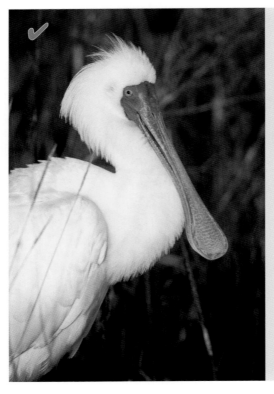

The contrast created by the bright bird against a dark background is a strong creative element.

- *Bright bird, bright background*

 A bright bird against a bright background somehow has aesthetic appeal. Since there is less contrast than with other backgrounds or birds, the viewer's attention still remains drawn to the bird. There are surprisingly many very bright birds and the chances are good that you find them against clear skies or white clouds. Make the most of this opportunity by concentrating on getting the exposure correct on the bird.

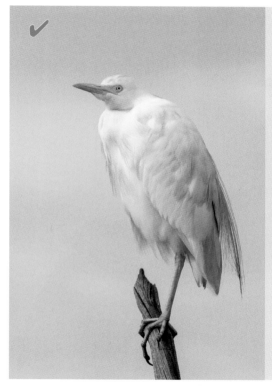

The viewer's attention remains with the bird as its brightness is close to that of the background.

- *Dark bird, bright background*

 A dark bird against a bright background not only makes the exposure extremely difficult, but the bright backdrop takes some attention away from the bird. To correct the exposure the photo should be overexposed, which brightens the background even further. These backgrounds typically include the sky or white clouds or when you photograph into the sun. Fill-flash would be your best way to salvage the situation.

The bright sky behind a dark bird takes the attention away from the bird.

Even the good golden light cannot save this photo where the early morning bright sky is too overpowering.

- *Dark bird, dark background*

 A dark bird against a dark background makes the bird difficult to see. Ideally you should look for a slightly brighter background that is a different colour from the bird.

The bird blends into the background making it difficult to see.

A neutral or even-toned background makes the bird stand out much better.

- *Sky as a background*

 To photograph birds against the sky is probably a realistic representation of their natural environment, even if a bright background is not considered 'good'. With good clear skies and sunlight on the bird, you can capture it against a beautiful deep blue backdrop. When the weather is overcast, however, the same photo will have the clouds in the background, and when you expose for the bird, the contrast in exposure is such that the sky will go completely white or 'washed out'. This can create a beautiful high-key effect with soft light to reveal all the detail in the bird – so forget about the background and make sure your exposure on the subject is correct.

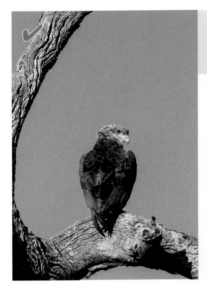

Clear skies and sunshine create deep blue backgrounds.

Overcast conditions are ideal for the high-key effect.

Bright highlights

The human eye is drawn to bright light. Photographs with bright spots in the background tend to draw the attention of the viewer away from the subject. These spots usually appear when you have the leaves of a tree as background and the leaves are not dense enough so they let spots through the gaps. Look for a darker background or where the leaves are much denser.

Bright spots in the background draw the attention away from the bird.

A uniform darker background keeps the attention on the bird.

Photographer's angle

The angle at which you photograph a bird not only helps to bring the viewer into the world of the bird if taken from its level, but it will also have impact as it is unusual to see a bird this way. We always see birds high up in the trees or down on the ground, but that does not mean we should photograph them from that angle. For birds on the ground you have to lower your angle, getting closer to the ground or use a long lens and photograph from a further distance. Use a long lens for birds in the trees or find a way to get higher by using a slope or look for birds on lower branches.

This angle is too much down onto the bird, creating the top–down look with a distracting in-focus background.

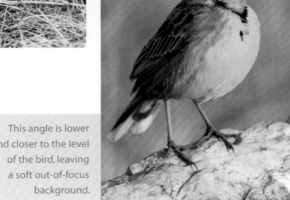

This angle is lower and closer to the level of the bird, leaving a soft out-of-focus background.

Portrait or landscape

When you photograph bird portraits, you have the option of turning the camera 90 degrees for a portrait orientation instead of the traditional landscape format. Some portrait shots of birds work better in portrait orientation. This usually has to do with the shape of the bird. The tall slender ones, such as herons, egrets and flamingoes, are higher than they are broad so fit a portrait format. Ducks, geese, rollers and all the other birds are broader than they are tall and so fit the landscape format better.

Tall birds fit a portrait orientation.

Short and broad birds fit a landscape orientation.

Reflections

A clear reflection is a great way to draw attention to an image – perfect symmetry is very eye catching. In bird photography reflections are common when photographing birds wading in the water. If the water is shallow and there is little wind, there is a better chance of getting a perfect reflection. Ripples in the water, gunk or debris floating about can spoil a perfect reflection, distracting the viewer's attention away from the bird. If the reflection is perfect, then include it in full, but if not then do not include it.

An imperfect reflection should not be included in the composition.

Without the distracting imperfect reflection it is a stronger image.

A perfect reflection can be included in full.

Left to right or right to left

In the Western world we read from left to right and our eyes have become used to entering a page or a frame from the left and scanning across it to the right. In a bird photograph your eye will try to find something, like a twig, on the left side of the frame, leading it until it finds a point of interest before exiting the frame. You want the viewer's eyes to see as much detail as possible before having finished looking at the photo. The point of interest is usually the eye of the bird and so you want to put the eye on the right-hand side of the frame while still giving it space to move into. The sense of movement from left to right that is in harmony with the way we read might also be a reason why some images look better when composed like that. If in doubt, flip the image horizontally to see if that way looks better – sometimes they do, for no reason at all!

The viewer's eye enters the photo from the left, moves towards the eye of the bird which is the point of interest, then exits the frame without looking at the rest of the photo.

Left to right usually works better.

Frames

There is a reason why people put pictures in frames. It makes them more defined, in their place, showing the viewer that everything that is important is within these borders. The same can be done in the field in bird photography where you can use natural frames like branches or leaves.

This weaver is defined in the shapes created by the sticks.

Leaves are a common natural frame in bird photography.

Break the rules

There's a saying that rules are there to be broken. That is also true in bird photography. You should, however, understand the 'rule' that you are breaking, whether it is having bright highlights in the background, or having the bird flying away from you in the frame. These photos only work when they create a specific mood or feeling in the viewer, triggered by the very reason that rule was created in the first place. For example, positioning a bird in the corner of the frame with space to move into creates a sense of freedom. If you want to create a feeling of it being 'trapped', then it should be positioned on the opposite corner of the frame.

This Woodland Kingfisher displays in early morning light. Facing away and without space to move into is breaking the 'rules'. The photo instead has balance and colour in a composition that showcases behaviour and the environment.

Action and birds in flight

Size in frame

Tight

A bird in flight that sits tight or even cropped in the frame has great impact in a photograph. The bird would usually take up 25–50% of the surface area of the frame. These photos are created through careful consideration of the focal length used when the size of the birds are taken into consideration during your vision and planning of the shots.

These shots are usually not intentional, but rather a result of the bird being closer to you and larger in the frame than anticipated. It takes great skill to keep the bird in the frame during a sequence of action shots or birds in flight without clipping any parts of them off.

Cropped wings and taking up 50% of the surface area

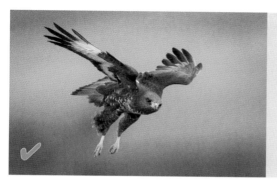

It is easier to take a wider photo and then to crop tighter during post-processing.

Medium

The most common size of birds in flight in a frame is about 10-20% of the surface area, which is classified as medium. It is important to give the bird space to fly into when choosing a placement in the frame.

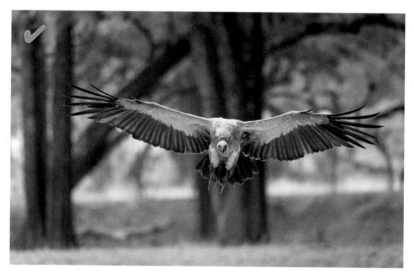

This White-backed Vulture is positioned slightly off-centre to give it room to 'move into'.

211

Small

It often puts a bird in perspective if you can show the environment that is typical for that bird. This means using a wider lens to include more of the environment. It is important to keep the bird significant in the frame even if it is smaller in the frame than usual. Keep the bird as 3–10% of the surface area in the frame. Make sure it is clearly defined and that the background is not too contrasting or distracting that it carries more weight in the photo than the bird. The position of the bird is very important and here the rules of third can be considered.

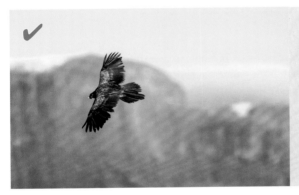

The Drakensberg mountains are the perfect backdrop to show the typical environment of the Bearded Vulture.

Wing position

It feels difficult enough to get a sharp photo of a flying bird and you often feel chuffed with the results even if they're not in the correct posture. If you are looking for ways to improve your birds-in-flight photos, then pay attention to the wing position. Of course this is impossible to do in camera while you're photographing, but when you review your photos, look for either a fully extended upwards or downwards position. The rest of the positions are not nearly as striking. It's personal preference whether you like the up or down position and often also varies with the species of bird.

Here the wings are close to being horizontal, which is the worst position.

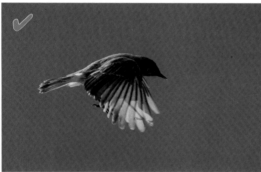

They are all the way down here.

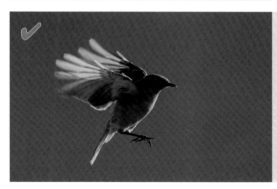

Here the wings are fully extended upwards, creating the best impact.

Angle

Just as in portraits of birds, you'll notice that the photographs with flying birds angled slightly towards you from parallel have the greatest impact. Birds typically fly into the wind, so that is a good measure for planning your shots. Keep in mind the angle towards the sun for good light and that birds have not read the bird photography books, so they don't always fly into the wind, especially when an insect in a different direction to the wind catches their attention.

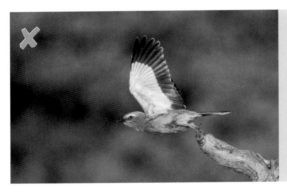

The bird flying slightly away loses impact.

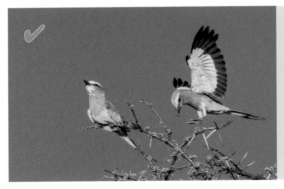

The bird is angled slightly towards the photographer from parallel.

Bird portraits

Size in frame

Tight

A tight bird portrait either includes a cropped portion of the bird or a whole bird fitting tightly in the frame. The bird takes up 25–50% of the frame, but beware that placement of the subject becomes more important when the bird is larger in the frame. You can't just put the bird straight in the middle of the frame. Moving it very slightly in any direction makes a big difference. Be careful that it does not feel too trapped or restricted. These photos have impact and explore the details that make up the beauty of birds.

A cropped part of the bird reveals the finer details.

A tight fit with just enough space around it – be careful that it does not feel too trapped or restricted.

Medium

The bird takes up around 10–20% of the area of the frame when it is a medium size in the frame. This is probably the most common size of birds in the frame, even with the longest lenses, because birds are so hard to get close to. It's good to consider the rules of third with birds this size in the frame.

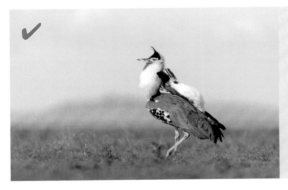

The horizon is at a bottom third with the bird positioned on the right with room to move into.

Small

We love to grab the long lenses first when we see a bird to photograph. Look for interesting things in the background that might merit grabbing a wide lens instead to show the bird in its typical environment. Keep the bird small in the frame so that it covers from 3–10% of the surface area of the frame.

A zebra in the background was the perfect opportunity to show the creatures that share the bird's habitat.

Diagonal perch

It's a common rule of image design that diagonal lines are more aesthetically pleasing than straight horizontal or vertical lines. Birds typically choose sticks or branches as perches and these are either horizontal or diagonal. It is difficult to control where a bird will sit and if it chooses a horizontal perch, then there is little you can do. Instead look for diagonal perches often visited by birds.

Horizontal perch

Diagonal perch

Diagonal perch

In front or behind perch

A bird sitting on a perch that is parallel to you would sit either in front or behind the perch, relative to your position. Whether the bird sits on your side or the other side probably does not matter much and cannot be controlled, but it's important to notice the difference. When the bird sits on your side, it faces away from you but reveals the colours on its back to you. It also has to turn its head back towards you to have a good head angle for your photo. When the bird sits on the other side of the perch, then you see its feet and colours on the chest. The head angle will either be turned straight at you or at the perfect angle, slightly towards you from parallel.

Sitting on the other side of the perch

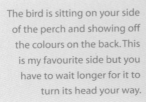

The bird is sitting on your side of the perch and showing off the colours on the back. This is my favourite side but you have to wait longer for it to turn its head your way.

Compositional sins

Placement in middle

The crosshair syndrome is something we all suffer from when we start out. We are so enthralled by what we see through the viewfinder that we forget to compose and just put the subject in the middle of the frame. When you photograph bird action or birds in flight, then it is the right way of photographing, but when you do portraits and have a chance to think about composition, then you should apply your creative thoughts.

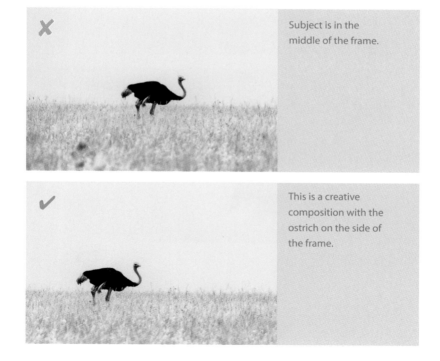

✗ Subject is in the middle of the frame.

✓ This is a creative composition with the ostrich on the side of the frame.

Shadow over face

It's difficult enough to get a sharp image of a bird taking off and we are often proud of our results even if they are not perfect in every department. The face and eye of the bird is the most important part – that is where the viewer's attention is drawn and when there is a shadow over the face, the image will fail. You should always try to angle yourself towards the light, having full front lighting is the best, where the sun is over your shoulder.

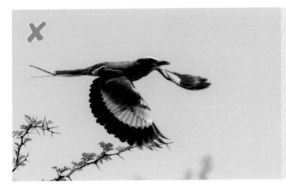

The shadow over the face makes the image fail and is a result of the photographer being at the wrong angle relative to the sun.

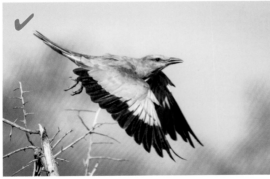

Front lighting ensures that the face of the bird is in the sun.

Invisible feet

When we photograph birds on the ground, their feet are often obstructed by grass or small mounds of ground. The lower you get to the ground (which is preferred), the worse the effect is. It's actually better to see the feet but if they are obscured by some natural element, then you should have enough room at the bottom of your frame to include them. Even if you can't see them, the imaginary feet would feel chopped off if your frame is too tight at the bottom.

The imaginary feet are chopped off.

It's best when the feet are visible.

Unnatural perches and elements

Bird photographers are nature photographers and your aim is to show how beautiful birds are, in their natural environment. It's better to exclude all unnatural elements in your photo, unless you are specifically trying to show how the birds have adapted to an unnatural environment created by humans. Perches put up for birds at hides often have metal poles or wires. Look out for them and try not to include them in your frame.

Avoid unnatural perches.

Things growing out of birds

Sometimes it's impossible to have a clear background in your photograph when you can't eliminate the distracting elements, but are rather left with the decision of where to place them in the frame. Keep an eye open for elements 'growing' out of the subject like sticks or branches that are directly behind the subject. Also look out for shapes like lines in the background that seem to run through the body of the bird creating the impression that it's cut by the lines.

This egret is wearing a crown.

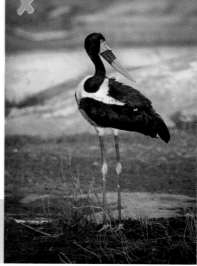

The water in the background cuts through the head of the bird.

223

Nothing but front lighting

There is nothing wrong with trying to photograph a bird against the sky in sunny conditions – in fact that is their natural environment. However, the brighter background often makes exposure difficult, especially if you want to see the detail on the bird when the sunlight has created heavy contrasts between the sunlit areas and shadows on the bird. When you are not positioned with the sun behind you for full front lighting, then you will be faced with a large dark shadow across the bird against the bright sky. You will see no detail and the image will fail. Only photograph a bird against the bright sky in sunny conditions when you have the sun behind you.

Shadows over the bird combined with a bright sky make the image fail.

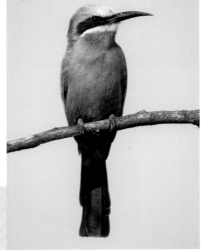

Front lighting illuminates the bird even if the background is bright.

Cropping too much

Something I see too often on safari is when people don't get close enough to the birds or use a lens that is too short to allow the bird to be large in the frame. Because it's easier to capture a bird in flight when it's smaller in the frame, they then crop it to make a full-frame image of a bird that originally only took up 5% of the frame. The quality of such an image is very poor and only good to use in a small format. Our challenge as bird photographers is to get close and use our skills of panning or anticipation to capture the bird large in the frame. Don't crop too much.

Apply your skills to get closer or use a longer lens – but don't crop too much and then expect good quality.

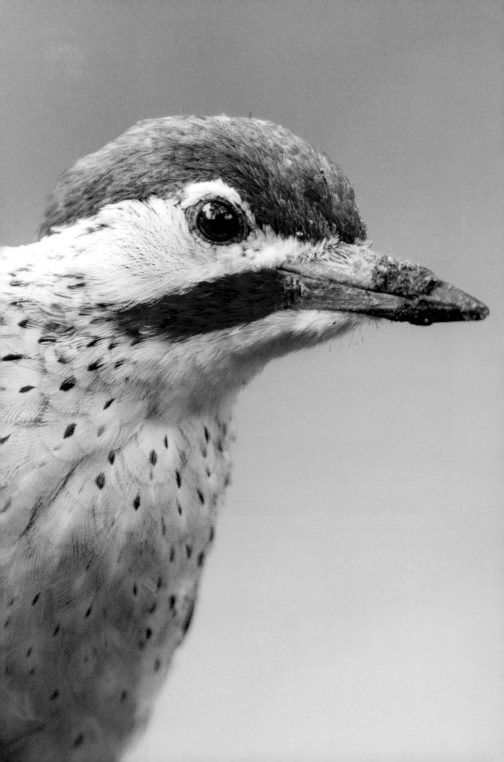

Chapter 7

Getting up close to your subject

Bennett's Woodpecker, Okavango Delta in
Botswana | *1/160 sec at f/5.6, ISO 800*
Canon 1D Mark IV + 600mmf/4 lens + 1.4x
Aperture Priority, 0 ev

Introduction

There is a general sentiment in bird photography that you can never be too close to the birds.

- Birds are typically small and skittish so to have them large in your frame you need to get close – even with a long lens.

- For large birds, such as vultures or flamingoes, it's also true because dirty air and heat waves between you and your subject, resulting in fuzzy images, can be reduced when you get closer to your subject.

- People's general observation of birds is mostly from a distance. Close-up photographs where the bird is large in the frame but you still see the environment in which it lives draws immediate attention to the photograph. But to get close to the birds requires the correct approach, which depends on your *way* of approach – on foot, in a vehicle, a boat, sitting in a hide or setting up a mobile hide.

Bird photographers become obsessed with getting that 'wow' shot. This usually involves you trying to get as close to the bird as possible, positioning yourself to the light and background, hoping for action and behaviour or simply coming up with a fresh approach on a common subject or a unique image.

Hides are one of the most common places to do bird photography where you can get close to birds. There are a lot of hides in the national parks, game reserves and bird sanctuaries throughout southern Africa, so you'll probably find one at any place you go to. Birds would see the hide as one whole structure and not notice the people individually inside it. They usually have a bench with a counter and a small opening through which you can observe the birds. Birds also accept hides as a natural feature in their environment, allowing you to be close to them without scaring them away. If you were to stand outside the hide at the same distance

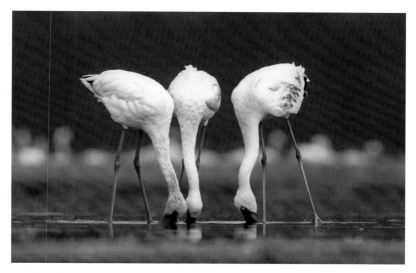

I was lying flat on the ground and patiently waiting for the birds to return after they moved away when I approached them on foot. This enabled me to get close to them and photograph them at the best angle.

Lesser Flamingos, Lake Nakuru National Park in Kenya | *1/800 sec at f/8, ISO 1250*
Canon 1D Mark IV + 600mmf/4 lens | *Aperture Priority, -1/3 ev*

from the bird, it would probably fly off as it 'sees' you as something else, a threat. Your best chance of keeping the birds relaxed around the hide is to sit still and keep quiet.

The problem with most bird hides in southern Africa is that they are not built with photographers in mind. They are too high, too far away from where the birds are (if any), and not angled with the direction of the light in mind. They are built for *bird watchers* who look at birds through binoculars and don't mind the photographic challenges. There are but a handful of photographic-friendly bird hides and, not surprisingly, they are very popular with photographers. In these hides you often find a bunch of photographers who fire away at anything that flies. You would also find people who are there for bird watching or just want to sit and enjoy nature, but their experience can quickly be ruined by the firing

brigade, so in these public hides it's important for the photographers to be respectful and keep as quiet as possible. Hopefully one day the camera manufactures will develop 'quieter' cameras, but in the meantime it's something everyone has to live with.

ISAK'S TIPS

When I do bird photography I'm usually doing it from a vehicle or a boat. This means you have to apply your skills in sneaking quietly up to the birds because you are entering their territory, pushing the boundaries of their personal space. This can be exhausting and frustrating when the bird flies off just as you're picking up your lens after stalking it for a while. When you find a place where you can sit still and relax and have the birds come to you instead of the other way round, it is much less stressful and a greater experience of the natural world – sitting on the beach is a good example. Initially the birds keep their distance, but then slowly they get closer and closer – sometimes they get annoyingly close, making it impossible for your lens to focus. This strategy requires patience because nature can't be rushed, but I've had some of my best moments with birds when they choose to come close.

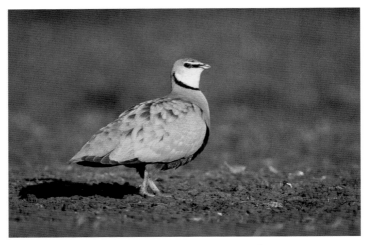

Yellow-throated Sandgrouse, Amandelbult in South Africa | *1/2000 sec at f/8, ISO 640* | *Canon 1D Mark II N + 600mmf/4 lens + 1.4x* | *Manual Mode*

 KEY POINTS

- The challenge as a bird photographer is to get close to your subjects and to **photograph** them from the correct level, **at their level**. Birds on the ground should be photographed from ground level; birds in the lower branches of trees from a vehicle or standing position; and birds at the top of trees or flying in the sky from a raised platform or the side of a mountain to get to their height.

- When you approach a bird **on foot,** you have to **move slowly** and **watch the reaction of the bird**. When it looks at you or seems nervous, then stop until it relaxes again.

- **In a vehicle** you have to learn how close you have to park next to a bird with your specific focal length lens. You have **one chance to get it right** as you move in slowly and have to switch off the engine to eliminate vibrations and camera shake. Turning the engine back on to reposition usually scares the bird off.

- A **small boat** is like an open safari vehicle. You are more exposed, making it very important to **keep any movements to a minimum**. The bird sees the boat as a unit and when you stand up and break the shape, it becomes unfamiliar to the bird making it harder to get close to it.

- A **bird hide** is a great place to get very close to birds. As long as you **keep movements and noise to a minimum** there is not much else you can do to get closer to the birds. Explore all the hides in the area. There is usually one that is better for bird photography than the others.

- It is easy to **attract birds with food, water and sounds**, but it is unnatural, so do this cautiously and respectfully.

- A **wide-angle** close-up photo of a bird is striking because it's unusual but it's very difficult to get. Hide the camera right in front of a popular perch or close to the shore where you know a bird will get close to it. Trigger it with a long-distance **remote**. It takes a while for the birds to trust an unfamiliar object, so **don't expect results immediately**.

Get to the bird's level

Birds spend their time on the ground, in trees, high up at the top of trees or flying across the sky. Photographs of birds at their level present a more accurate or realistic description of them – they draw the viewer of the photograph into the bird's world. It shows the bird the way it is instead of just showing how we usually see them. The challenge that faces bird photographers is to get to that level of the bird, physically. Birds on the ground or ones that sits on the lower branches of a tree are not too hard, but how do you get to the top of a tree or up in the sky to photograph those birds at their level?

Waterbirds that are on the water's surface, or groundbirds and shorebirds that can be found on the ground surface should be photographed at a low level, as close to the water or the ground as possible. When you photograph birds on foot, such as next to a dam or walking along the beach, then the approach is to drop to the ground to lie flat behind the camera and photograph them from that position. It can be very uncomfortable, especially if the ground is hard; and keeping your head lifted up behind the camera takes some effort. Not only will you get dirty, but you also feel very restricted in moving the lens around. Capturing action and behaviour will be much more difficult to execute because of this limited movability. It takes some getting used to, but the results are worth it. I remember when I first tried this it often took me so long to find the bird through the viewfinder that I missed the shot altogether. Something to rest the lens on helps – I suggest a beanbag or a support head mounted on a ground pod.

Some of the new photographic hides that are built in southern Africa are sunk into the ground to offer low angles on birds and mammals like the C4 underground hide in the Mashatu Game Reserve in Botswana. This offers a more comfortable option. If you're doing game drives in nature reserves and national parks, then getting out of the vehicle for the low-angle shots might be difficult to do when there are passing vehicles. Some parks and reserves do not allow you to get out of your vehicle.

When you are on a boat, the best approach for photographing birds on the water surface is to rest your lens on the side of the boat where it is closest to the water level. To get the same effect from the shore, you need to lie down on the ground next to the edge of the water – get as low as you can and as close to the edge of the water. Just beware of the surf and water that could splash onto your lens.

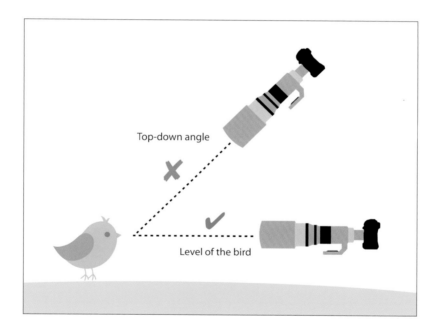

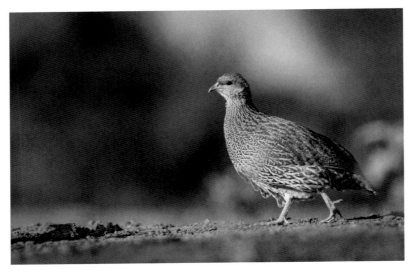

When photographing birds on the ground from a standing or elevated position, you get a 'top-down' view which doesn't draw you into the world of the bird. Lie on the ground or photograph from a sunken hide to get to the bird's level.

Natal Spurfowl, Mashatu Game Reserve in Botswana | *1/2000 sec at f/5.6, ISO 800*
Nikon D3S + 200-400mmf/4 lens | *Aperture Priority, -1/3 ev*

Typical birds like weavers, shrikes, flycatchers, starlings, bulbuls, drongos, bee-eaters and parrots, for example, spend a lot of their time close to the ground, not too far from a standing person's eye level. This makes it much easier to photograph these species at their level – they typically forage on the ground but require the safety of an elevated perch or just prefer hanging around on the lower branches of trees. They can be photographed on foot, from a vehicle, boat or a hide while still being close to the level of the photographer.

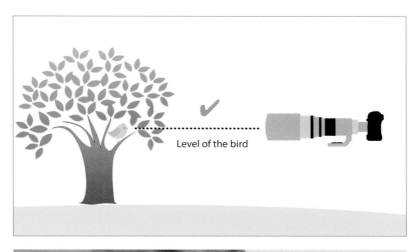

Level of the bird

Most small- to medium-sized birds like to perch on the lower branches of trees and can be photographed at eye level from a vehicle, boat, hide or a standing position.

Swallow-tailed Bee-eater,
Okavango Delta in Botswana
1/1600 sec at f/8, ISO 800
Canon 1D Mark IV +
600mmf/4 lens + 1.4x
Aperture Priority, 0 ev

Birds that soar high above the ground, such as raptors, and birds that perch on the top of trees present the most difficult challenge when they are to be photographed at their level. Photographing flying birds, such as soaring vultures, from the ground up has its own appeal, and images taken of the bird straight up can be quite striking. The first prize, however, is to get to the level of these birds and there are many approaches.

- You can do it from a slope or side of a mountain where you are level with the top of the trees and their bases are lower down the slope or in the valley. When a bird sits at the top of a tree, then it might be high up from the base of the tree, but relative to you it is on the same level.

- I enjoy driving along large riverbeds like the Letaba River when heading north from Letaba Camp in the Kruger National Park. You are elevated and the large riverine trees on the slope below you offer you an eagle's view.

- I've climbed the Magaliesberg mountains and was able to photograph a colony of vultures at their soaring level when I was nearly at the top of the mountain. They are curious by nature, so usually come close to inspect you.

- Another way to approach this is to build a raised platform or tower. I've seen some photographic hides purpose-built on raised platforms to get the photographers to the top of the trees.

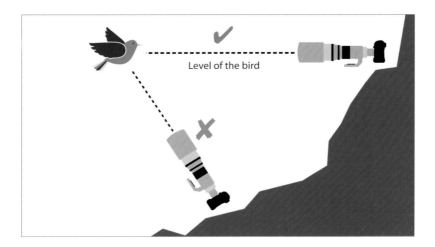

Level of the bird

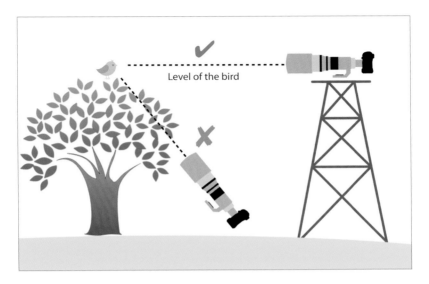

Level of the bird

This Bearded Vulture was photographed from a hide positioned on the slopes of the Drakensberg. From the vulture's perspective it is soaring high above the ground, while the photographer can get an eye-level shot.

Bearded Vulture, Drakensberg in South Africa | *1/2500 sec at f/4, ISO 400*
Canon 1D Mark II N + 600mmf/4 lens | *Aperture Priority, 0 ev*

237

 ISAK'S TIPS

It's all well and good when suggesting that you get to the bird's level when it's on the ground. You simply get out of your vehicle and lie on the road. Unfortunately getting out of your vehicle is prohibited in most of southern Africa's national parks and lying flat on the ground is not only uncomfortable but you can get very dirty. An easier way to get closer to the level of the bird is to use a longer lens. Then you can be further away from the bird and still have it the same size in your viewfinder. In this way the angle you photograph the birds is closer to the ground than with the shorter lens.

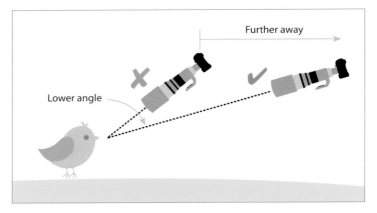

Capped Wheatear, Rietvlei Dam Nature Reserve in South Africa
1/320 sec at f/5.6, ISO 200
Canon 20D + 600mmf/4 lens +
1.4x | Aperture Priority, -1/3 ev

Get close on foot

It is unusual to do bird photography on foot in the national parks in southern Africa as there is dangerous game around. This group of photographers was led by a walking safari guide in the South Luangwa National Park in Zambia.

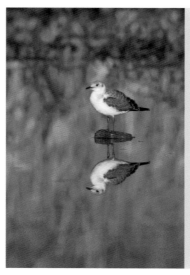

In and around the cities it is common to take photographs by standing next to a body of water like a pan or lake. Here we were able to get photographs next to a pan in the middle of a residential area in Johannesburg.

Grey-headed Gull, Bonearo Park in South Africa | *1/2000 sec at f/8, ISO 800* | *Canon 1D Mark IV + 600mmf/4 lens + 1.4x* | *Manual Mode*

In southern Africa it is not common to do bird photography on foot. Bird watching on foot works fine as you only need to identify a small brown bird in the shade of a tree that would not let you get nearly close enough for you to photograph it. One of the reasons you don't do bird photography on foot is that in the wilderness areas there are dangerous animals lurking around in the bushes. Hippos, buffalo, elephants, lions and leopards are typically the animals you want to avoid. Another reason is that you don't have to – there are enough reserves or sanctuaries with hides or good networks of roads so that you don't have to go walking about. The only few occasions I've done bird photography on foot are in a botanical garden, in the camp of a national park to look for habituated birds, or when I stand with my tripod next to a dam to photograph the waterbirds. I have had good success doing this and learnt a few tricks to sneak up really close to my subjects.

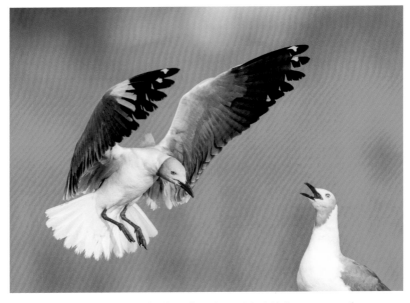

When you approach a colony of gulls on foot, they might initially move away from you for a while. But when you stand still behind your tripod, they'll continue with natural behaviour right in front of you.

Grey-headed Gull, Bonearo Park in South Africa | *1/2500 sec at f/5.6, ISO 1250* | *Canon 1D Mark IV + 600mmf/4 lens* | *Manual Mode*

 ISAK'S TIPS

- Don't walk straight to a bird – zig-zag your way closer to it as if you are pretending to walk past it.

- Approach slowly while you look at the bird's movements and reaction, and stop when you see that it has spotted you (usually they look straight at you with the 'alert' look) or if it has stopped what it was doing. Remain motionless until the bird carries on with normal activity again. Then approach slowly again and repeat this cycle until you have the bird large in your frame.

- When are you close enough to a bird? I would suggest that if it's a rare species, then take some 'safety' shots initially before you are as close as you'd like to be. If it's a common bird that you've photographed before, then go for gold and don't stop until you're at your preferred distance from it.

- My friend Shem told me that birds identify people by their legs. So if you can hide your legs by crouching, sitting or leopard crawling, then they see you as something else and may well be more tolerant.

- If you are walking using a long and heavy lens, take a tripod or monopod for support.

- Try to break your silhouette and much as possible by keeping large objects behind you.

- Objects that move around, such as camera straps and hair blowing in the wind, will frighten the bird, so remove the straps and wear a hat.

Get close in a vehicle

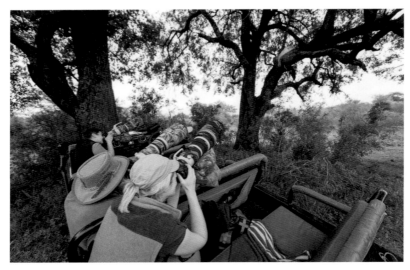

Photography from a vehicle is very common in the national parks and nature reserves in southern Africa. This might involve your own private vehicle or an open safari vehicle. It is, however, more difficult to get close to birds in an open safari vehicle as birds are easily scared off by the more noticeable movements and shapes of the photographers.

A private vehicle is like a
moving hide and with the
correct approach you can get
very close to small birds.

*Cape Longclaw, Rietvlei Dam
Nature Reserve in South Africa
1/320 sec at f/5.6, ISO 400
Canon 20D + 600mmf/4 lens +
1.4x | Aperture Priority, 0 ev*

On a cold morning the birds are less likely to move, so you have a better chance of
getting close to them. This korhaan was standing next to the road on a freezing cold
morning and did not move even when I parked my vehicle right next to him.

*Northern Black Korhaan, Rietvlei Dam Nature Reserve in South Africa | 1/320 sec at f/11, ISO
200 | Canon 20D + 600mmf/4 lens + 1.4x | Aperture Priority, -1/3 ev*

243

We are blessed with many national parks, nature reserves and bird sanctuaries in southern Africa where we can just drive around and get close enough to many birds to do quality bird photography. In a way this can make you a bit lazy – think about photographers in Europe who have to build dedicated hides or go camping in the wilderness for weeks just to get close enough to a few species of birds. Bird photography from a vehicle is very comfortable. You can choose to cover lots of ground or just sit and wait at a waterhole. Birds have accepted vehicles as objects in their natural environment and they are not threatened by them. A vehicle acts as a hide where the bird sees it as a whole unit instead of the individual people that drive around in it. The birds still have personal space and, even though its easier to get closer to them in a vehicle than on foot, you need to apply some stalking skills to get very close. In the national parks and nature reserves the birds have become so habituated to driving vehicles that if you drive past one you can get to within a metre of it if you maintain your speed. As soon as you slow don't stop next to it, it will fly off.

 ISAK'S TIPS

- The same as with walking, don't drive straight at a bird. It would feel threatened. Rather pretend to be driving past it or zig-zag your way closer.

- Sudden movements frighten birds. You might be lucky to get your vehicle very close to a bird, but as soon as you start winding down your window, will be frightened away. If you do this slowly and carefully, the bird might stay, but then when you pick up that big white lens to put it halfway out of the vehicle and rest it on the beanbag, then the bird would probably be gone by the time you try to find it through the viewfinder. One important trick I've learnt is to stop well away from the bird when you first see it. Then wind down your window and put your lens out. Hold onto the equipment with your one hand while starting the vehicle and drive closer to the bird with the equipment ready and in place.

- When you approach a bird in a vehicle, you have one chance to get to the correct distance and position. Experience will teach you what this is. When you use the vehicle's window or door as support, then it's better to have the engine switched off. So when you approach and move into position, don't do this hesitantly because the bird won't tolerate the noise of the engine and

movement of the vehicle for long. Move into position with purpose and switch the engine off immediately. If you're in the wrong position and you have to switch the engine back on, the bird will fly away.

• As mentioned above, you have one chance to get into position and switch the engine off. So how close or how far do you stop from the bird? This will depend on your lens. If you have a 400mm lens, you need to get a little bit closer than if you use a 600mm lens. Experience will teach you to judge the size that the bird will be in your frame by just looking at the bird, and it helps if you keep using the same lens.

• Some birds are much more tolerant of vehicles than others and this is something you'll learn from experience by going to the same reserve over and over again. Bustards, rollers and starlings don't seem to mind vehicles too much, while some of the smaller birds, especially shrikes, are hard to get close to.

• Some of the groundbirds, like Kori Bustards, ground-hornbills and waders, keep walking and don't mind vehicles. But this will require constant repositioning.

• A safari vehicle is typically an open vehicle where the birds can clearly see the people – their movement is not hidden like in a closed vehicle. This makes it more difficult to approach the birds.

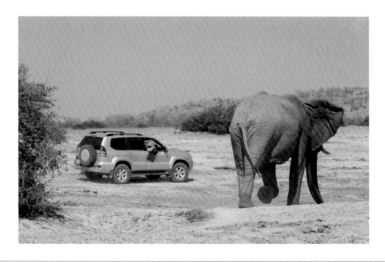

Get close by boat

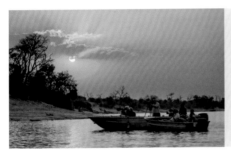

Birds quickly get habituated to boat 'traffic' on the popular rivers for bird photography – such as here on the Chobe River on the border of Botswana and Namibia.

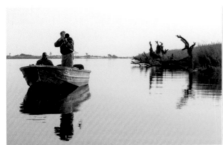

This photographer is breaking the silhouette of the boat and would not have been able to get close to the birds.

A boat is a great way to approach birds. Boats are usually open so you feel more part of nature – but that has the same disadvantages as an open safari vehicle where the birds can see you, requiring you to keep any movements to a minimum. A boat is stable, has more space to pack out all your equipment, and is a great platform to set up a tripod for support when you do long lens photography.

Birds react in the same way to a boat as they do to a vehicle. You need to switch the engine off when you're in position and have your lens ready before you get to the bird.

Get close in a hide

A hide is your best chance to get close to birds without making much of an effort. As long as you sit still and keep your movements and noise levels to a minimum, the birds will come to you. At most hides in southern Africa you can photograph both animals and birds from the hides, such as here at the C4 underground hide in the Mashatu Game Reserve in Botswana.

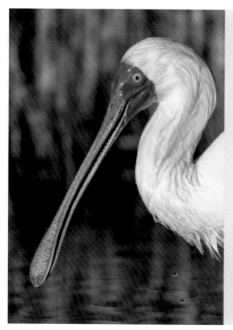

When I sit in a hide I like the idea of birds choosing to come close to me, instead of the other way around.

African Spoonbill, Marievale Bird Sanctuary in South Africa | *1/2500 sec at f/5.6, ISO 200*
Canon 20D + 600mmf/4 lens + 1.4x
Aperture Priority, -2/3 ev

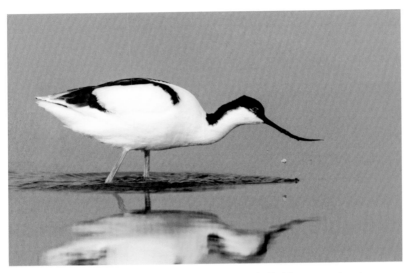

In putting up a mobile hide next to the water at Marievale Bird Sanctuary close to Johannesburg, I managed to get the closest I've ever been to a Pied Avocet.

Pied Avocet, Marievale Bird Sanctuary in South Africa | 1/500 sec at f/8, ISO 500 | Canon 1D Mark III + 600mmf/4 lens | Aperture Priority, +2/3 ev

A hide, as the name suggests, is a great place for bird photographers to be hidden from the view of birds. The birds also become used to the hide construction in their environment and wade, sit or swim around the hide in a carefree way, whether there are people in the hide or not. We don't have particularly good photographic hides in southern Africa, and in our national parks I can count the good ones on one hand. In Europe the bird photographers have built sophisticated photography hides where they use one-way glass so that the photographers can be very close to the birds. The glass is good enough quality not to influence the standard of the photographs, but the birds become totally oblivious to the presence of any photographer and can come up to a few centimetres away from the glass. Being so close to the birds has opened up new possibilities for bird photography. In these hides the photographer also controls exactly where the bird will sit, giving it only one perch as an option, positioned for the perfect light and background. The hides are purpose-built for water reflection, nesting sites, low down to be at the bird's level, high up in the canopy of trees or at a raptor feeding station.

For hides in general, keeping noise and movements to a minimum will keep the birds from being frightened off. For the rest, it's a great place to spend some peaceful time and see how nature unfolds around you.

A mobile hide, such as a small tent with an opening for a lens, is not commonly used in southern Africa. Issues with safety from animals and security are perhaps a concern, but it is a great way of getting close to birds at unique places, where no-one else has been. One of the ways to create the striking images that we aspire to is by capturing something unique or in a unique way. Mobile hides are a great way to do that.

ISAK'S TIPS

- To setup a mobile hide, find an area with potential such as next to an open pan or at a nest site of a bird. Look on Google Earth and contact the land owners if anything grabs your attention.

- Set up the hide and leave it there for a week for birds to get used to it. Camouflage it as much as you can.

- Think about light. Would it be for morning or afternoon front lighting? Then position accordingly.

- Remember, comfort is important. Take a comfortable chair, pillow, coffee and snacks, and even a book to read because you might spend a long time there.

- Birds can't count, so when you go to the hide, ask someone to go in with you and then they should go out after a minute while you stay behind. The birds see that people have gone in, but they think they have all gone out again, and that nobody is in the hide.

The thinking photographer

Feeding station

It can be very entertaining to see how innovative people can be to get close to birds. I've seen people dressing up as cows; others building a frame in the shape of a swan, draped in white cloth to hide in while swimming in the water while a lens sticks out from the chest of the swan. But luckily we don't have to resort to those extremes. Providing food and water for birds is probably the easiest way to attract them. It does not take long for them to see and remember the place with free snacks and drinks and soon there will be plenty of birds that are approachable to the photographer. Setting up a feeding station in the garden of your home will attract a lot of birds. Feeding birds in national parks, game reserves and bird sanctuaries is strictly forbidden though.

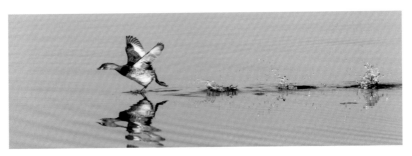

Little Grebes react well to the sounds of other grebes as they are very territorial.

Little Grebe, Marievale Bird Sanctuary in South Africa | *1/2500 sec at f/5.6, ISO 800* | *Nikon D3S + 200-400mmf/4 lens* | *Aperture Priority, 0 ev*

ISAK'S TIPS

- Cater for all diets: seeds for the seed-eaters; suet and bonemeal for the insect-eaters; peanut butter to attract woodpeckers and white-eyes; fruit for the fruit-eaters; and sugar water for the sunbirds.

- Never overfeed – just put out enough food to last the morning or the birds might start depending on the food which will alter their natural behaviour.

- When you start feeding, then you need to keep it up. Regular feeding will create a stronger acceptance by the birds.

- If you want to take photos, put up beautiful perches with a nice background. Only create one or two where the birds can sit so that you eliminate too many options.

- Accept that it will take time, from a week to month, for the feeding station to become active.

This beautiful bird was attracted to the water from the garden watering system in the tented camp in Mashatu Game Reserve in Botswana. In the dry season you can be sure that birds will be plentiful at any watersource.

Green-winged Pytilia, Mashatu Game Reserve in Botswana | *1/250 sec at f/11, ISO 800* | *Canon 20D + 600mmf/4 lens + 1.4x* | *Aperture Priority, -2/3 ev*

Use a remote camera

Wide-angle shots of birds, where they are large in the frame but wide enough so that you can see their environment, are a great way to create a 'different' shot of a familiar subject. The only problem is that if you thought it was hard to get close to the birds before, then this is even more challenging. For a bird to be large in the frame in a wide-angle shot, you need to be very close to it – less than a metre in some cases. It is virtually impossible to sneak up that close, so the solution is to use a remote camera. The advantage of the wide-angle lens is that even with a medium aperture, such as f/8 or f/11, the depth of field is so great that you can switch it to manual focus where everything in a wide-distance range will be in focus, so you don't have to worry about focusing. Just put it out, next to the rock that the bird will jump onto or the shore where the flamingoes will stroll past, aim for a level composition and move away. Without you being there the birds will get close to your camera and lens as long as it's well concealed. The birds do tend to keep a distance from new, unfamiliar or suspicious objects.

For remote camera photography, you either need to set the camera to take photos at set intervals or use a wireless remote. When you set the camera to take photos at set intervals, remember to start with a fully charged battery and make sure you have a large enough memory card in the camera with enough space. If you use the wireless remote, then remember that the range is not significantly far. You still need to hide yourself away, perhaps behind a bush a few metres from the camera. You need to be able to see what goes on in front of the lens so that you can release the trigger at the right moment. Some wireless remotes only work on line of sight, so make sure there are no obstructions between you and the camera.

Remote camera photography is a hit-and-miss affair – don't be discouraged by disappointing results. It often looks like the bird is right there in front of the lens, only to realise afterwards that it was an optical illusion and the bird was in fact far away from the lens and a mere dot in the photograph.

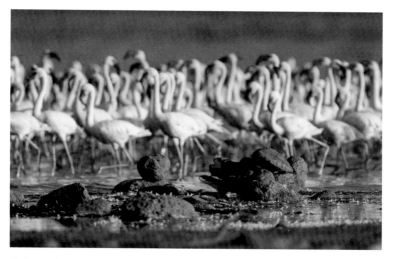

Birds are always wary of unusual or unfamiliar objects. It was a long time before the flamingos came close to my camera hidden in a pile of rocks.

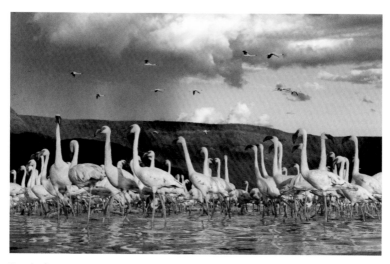

Results from a remote camera are a hit-and-miss affair but they can be spectacular. I took over 1000 photos in this scene – and only a few were usable.

Lesser Flamingos, Lake Bogoria National Park in Kenya | *1/1000 sec at f/11, ISO 640* | *Canon 1D Mark III + 24-70mmf/2.8 lens* | *Aperture Priority, -1/3 ev*

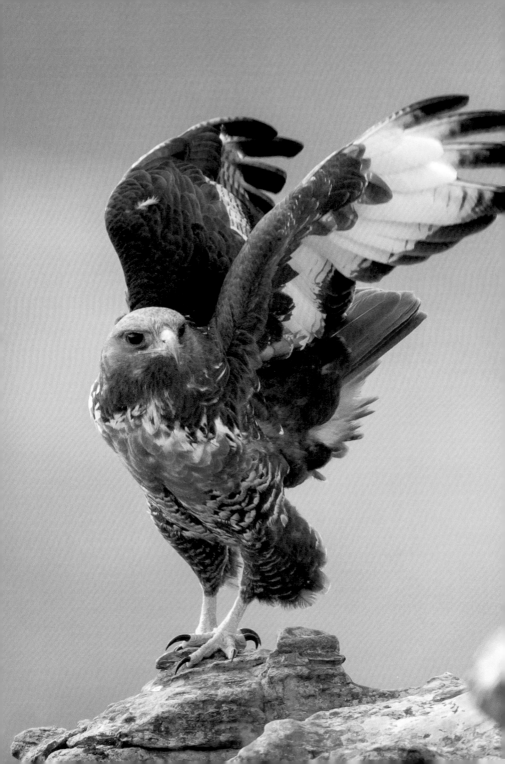

Chapter 8

Capturing bird behaviour

Jackal Buzzard, Drakensberg in South Africa |
1/2000 sec at f/5.6, ISO 1000 | Canon 1D Mark
II + 500mmf/4 lens | Aperture Priority, 0 ev

Introduction

It's not just any person that would wake up with a smile at 2:30am on a Saturday morning in the summer months in South Africa – to drive an hour to a bird hide to secure a spot by 4am for a morning's photography session at a popular bird sanctuary. Bird photographers are not only obsessed with creating beautiful images, but are also addicted to the challenges that photographing bird behaviour brings. It is the ultimate technical challenge in nature photography and nothing feels more rewarding than scrolling through your photos on the LCD screen at the back of your camera and finding the perfect frame where you've captured a beautiful bird in golden morning light with its wings in a spectacular posture.

Birds are fascinating creatures and their images not only show impact, but bird photographers are addicted to showcase them in the most beautiful way possible. No matter how striking the images are we have an unquenchable thirst to create better, more spectacular images all the time. It is this thirst that drives us to wake up at ridiculous hours, explore new locations, and make us use all our spare cash to buy the latest in camera and lens technology. There is just something about this passion that none of the other photographers can understand.

Action photography of any kind requires good technical skills, physical skills and knowledge about your subject. Bird behaviour requires the most demanding photography you can ever do. It is by no means easy – but practice does make perfect. Initially you should not be discouraged by failure, but the more you go out to take photos of birds in flight the better success you'll have. Apart from the skills required of the photographer, it also pushes the capabilities of the camera equipment. It is demanded of the camera to focus faster, track the bird through the sky more accurately, take as many photos in a second as possible, all while

still performing the basic camera functions of capturing photos with the correct exposures.

In this chapter I'll explain how to set up your camera and discuss the techniques required for capturing spectacular postures and action sequences.

A juvenile Great Spotted Cuckoo chick being fed by Meves's Starlings, its brood parents, offers days of repetitive behaviour. This makes it easy to position yourself for the light and anticipate the bird's next move to capture a good photograph.

1/2500 sec at f/8, ISO 1000 | *Canon 1D X + 600mmf/4 lens* | *Aperture Priority, +2/3 ev*

A juvenile Grey-headed Gull touches down on the water in golden light. The camera's ability to take a sequence of photos in rapid succession made it possible to capture this frame just as its leg touched the water.

1/2000 sec at f/8, ISO 800 | *Canon 1D Mark II N + 600mmf/4 lens + 1.4x* | *Aperture Priority, -1/3 ev*

 ISAK'S TIPS

Bird behaviour includes birds in flight and action sequences, and the photography thereof is similar to photographing action and behaviour in other genres of photography. Things happen fast and unexpectedly and do not allow much room for mistakes. Your best chance of capturing these sequences of action is to always use the centre autofocus point, and to aim it at the action in the middle of the frame in the horizontal orientation. It is impossible not to clip parts of your subject when you frame them too tightly. It is also impossible to compose your shot during an action sequence. For these reasons I suggest you always allow extra space around the subject by zooming out slightly (or using a shorter focal length lens) to capture the subject in the middle of the frame without chopping anything off. This would then allow you to crop for a better composition during post-processing.

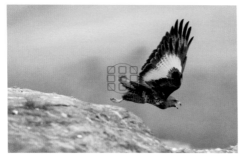

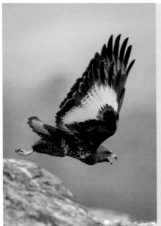

For birds in flight, keep the autofocus point in the middle of the frame (as close to the middle as possible), follow the bird through the viewfinder and crop for composition during post-processing.

Jackal Buzzard, Drakensberg in South Africa | *1/1600 sec at f/5.6, ISO 1250* | *Canon 1D Mark III + 600mmf/4 lens* | *Aperture Priority, +1/3 ev*

KEY POINTS

Set your camera up as follows:

- **Autofocus mode: AI Servo (Nikon = AF-C).** This will make the camera focus continuously on the subject as it moves through the sky when you keep the shutter button halfway down.
- **Autofocus area**: Select a **single autofocus point with surrounding area**, also known as autofocus point expansion. This will make the camera focus using one point only, which is faster and more accurate, while still being forgiving enough that it won't 'lose' the subject when you struggle to keep the autofocus point exactly on the subject as it moves.
- **Drive mode: High speed continuous shooting**. This will make the camera take a series of continuous photos as you press the shutter button and keep it in.
- Keep the **priority between focus and release** to an average between the two (presuming your camera settings include this option in the menu).
- Keep the **tracking speed to a medium level**. This is a good average between keeping the focusing fast but still forgiving when you struggle to keep the subject in the middle of the frame.

Use the following technique:

- Use **fast shutter** speeds to **'freeze' the motion**. Anywhere between 1/1600 to 1/4000 sec. The smaller and faster the bird, the faster shutter speeds you will need.
- To **ensure good shutter speeds** use your camera **in aperture priority mode** with the **widest aperture** (like f/4 for example) and a **high ISO** – always take notice of the shutter speed values that the camera chooses automatically in this mode while looking through the viewfinder. Manipulate the shutter speeds by changing the ISO.
- Always **use the centre autofocus point** and keep the **subject in the middle** of the frame. Crop for composition during post-processing.
- **Zoom out slightly** or use a wider lens so that the **subject is not too large in the frame**. When birds lift their wings, it takes up a lot of space in the frame and you should not clip it.
- Look for **repetitive or predictive behaviour**. It's always easier to capture that action shot when you can anticipate the bird's next move.
- When a bird is static, look for its **signals** to be ready when the **bird takes to flight**. These might include the bird defecating, looking intently in a specific direction, leaning forward or shaking its feathers.

Setting the camera for action

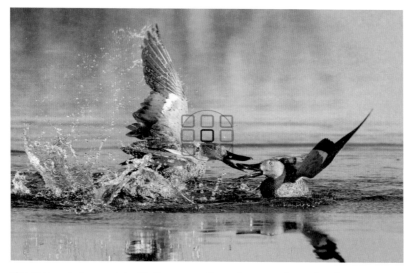

The single autofocus point with the surrounding point expansion makes the camera focus fast but is still forgiving enough to keep the subject in focus even if it moves off the focus point.

Cape Shoveler, Marievale Bird Sanctuary in South Africa | *1/1600 sec at f/8, ISO 1000*
Canon 1D Mark III + 600mmf/4 lens | *Aperture Priority, +2/3 ev*

Setting the camera correctly is the art of tweaking its functions and options to utilise its full capability. Photographing bird behaviour requires specific features and functions that need to be set up in a very specific way, making the photographer's tool work for you under the correct conditions. Getting the shot, however, is a combination of having the camera set up correctly and a photographer's technique, and the one would be useless without the other.

In this chapter I'll explain how to set up your camera specifically to help you capture bird behaviour. Every photographer has a different style of photographing, so some of my recommendations might help you more than others. For the average photographer, however, these set up options would offer you the best chance of capturing bird behaviour.

ISAK'S TIPS

The image stabiliser (Nikon = vibration reduction) on lenses is a hindrance when you photograph bird behaviour, causing delayed reaction to your movement of the lens, so I suggest you keep it switched off. It is a valuable function when you photograph portrait images of static birds, especially in low-light conditions. When you do, it would allow you enough time to switch the image stabiliser on for those shots.

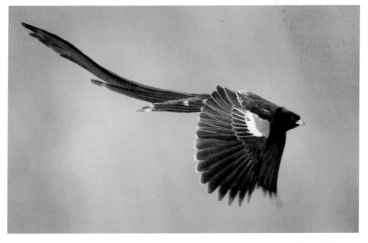

This widowbird was photographed with the image stabiliser switched off to reduce the delayed movement of the lens.

Long-tailed Widowbird, Rietvlei Dam Nature Reserve in South Africa | 1/1000 sec at f/5.6, ISO 400 | Canon 1D Mark II N + 600mmf/4 lens + 1.4x | Aperture Priority, 0 ev

Drive mode

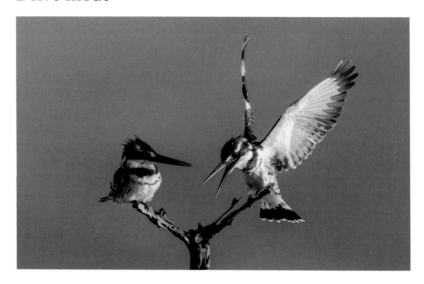

The advantage of digital photography is that once you have the camera and lens, it does not cost you any money to take a lot of photos. Use this to your advantage to capture the best postures.

Pied Kingfishers, Pilanesberg National Park in South Africa | *1/2000 sec at f/8, ISO 1250*
Canon 1D Mark III + 600mmf/4 lens + 1.4x | *Manual Mode*

Like most of the genres of photography, bird photography is the quest for perfection. You want to get the bird perfectly sharp, with the perfect background in the perfect light. It could happen that you focus, aim and take the shot feeling great about your achievement, but then when you get home to review your photos on your computer you realise that the bird had its eyes closed at the exact moment you pressed the shutter. Birds do this so quickly that it's impossible to tell during the moment you take the photo – and it can end up being ruined.

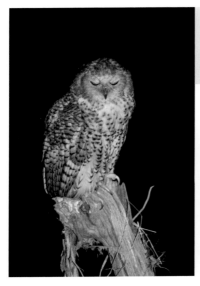

You never know when a bird might close its eye or when the image might come out just a little too soft.

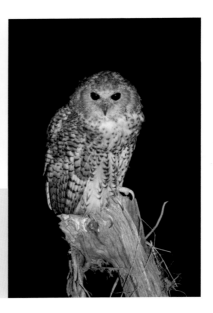

Take a sequence of photos in rapid succession, even if these are just portrait shots to make sure you capture a sharp image and that the bird has its eyes open.

Pel's Fishing Owl, South Luangwa National Park in Zambia | *1/60 sec at f/6.3, ISO 2500* | *Canon 1D X + 600mm f/4 lens + 1.4x* | *Shutter Priority, 0 ev*

This example is one of the reasons why you should not just take one photo, but many in rapid succession (also referred to as 'bursts') even if you just do portrait shots. Another reason is that when you take photos of an action sequence, you never know which exact moment in the sequence will be the perfect one. The same applies to birds in flight. You want to capture the photo with the wings fully extended upwards showcasing it in its best possible posture. The motion of flight and action happen so fast that it's impossible to anticipate the pivotal moment of the sequence and to just take a single photo at that exact moment.

The continuous high and low burst rate indicator for Canon

Ch Cl

The continuous high and low burst rate indicator for Nikon

Luckily DSLR cameras allow us to take more than one photo at a time with a mode called **continuous drive mode**. When you select this mode the camera will keep taking a sequence of photos in rapid succession when you press the shutter button and keep it in. This is the *click-click-click-click-click* that you hear in a bird hide when photographers see a bird flying past. As the bird disappears into the distance things usually calm down inside the hide again.

The rate at which the camera can take the photos is governed by how quickly the shutter can flip up and down physically. This is measured in 'frames per second' and the latest DSLR cameras can achieve up to 14 frames per second. The number of photos it can take at the highest rate before slowing down is governed by how large the buffer memory of the camera is and how quickly the camera can clear the buffer memory by downloading the images to a memory card. The buffer is the size of the camera's internal memory where photos are stored when using this mode. While you take photos and fill the buffer memory, the camera starts downloading them from the buffer memory to the memory cards – this is to clear space for more photos to be stored. As a general rule of thumb, the better and newer your camera model, the better frame rate and larger buffer memory it usually has.

Bird photographers need a camera with good performance on both burst rate and buffer memory. The more photos you can take in rapid succession mean that your chances of capturing the perfect frame in a sequence of action are increased. While that is a good thing, there is nothing worse than photographing a bird coming in to land and firing away at 14 frames per second when the bird is still far away. Then, as

the bird comes closer and is about to land, it opens its wings in that final glorious posture as its claws touch the perch ... but by that time your camera buffer has filled to capacity, bringing the rate down from 14 to 1 frame a second at the pivotal moment, resulting in you missing the best photo in the sequence. A large buffer is essential. It also helps to have a memory card with fast 'write' speeds to help the camera clear the buffer memory to the card quickly. With a large buffer memory and a memory card with fast 'write' speeds, you can gain a few critical extras shots in a sequence that might just help you to get that special shot.

Most cameras have a button or dial assigned to set the drive mode (Canon = AF DRIVE, Nikon = dial) and the options include **self-timer, single shooting** and **continuous shooting.**

- The self-timer can be set either as 2 seconds or 10 seconds and is handy when you want to take a family portrait and have yourself in the photo. When you press the shutter button, the camera waits a few seconds before it takes the photo.

- In single-shooting mode the camera will only take one photo when you press the shutter button, even if you keep it in. This might be good for landscape photographers, but I wouldn't recommend this mode for any kind of bird photography.

- With the continuous drive mode, some camera models allow for the choice between a high speed (for the fastest burst rate) or a slow speed (for a slower burst rate). This means, for example, 4 frames per second instead of 14 frames per second.

I recommend always using continuous drive mode for the fastest possible burst. With bird photography you never know when an exciting moment might catch you totally off guard. But then you need to be able to point your lens at the action, knowing that you're photographing at the highest burst rate to utilise all the capabilities of the camera and giving you the best chance to capture a great photo.

When you take a portrait photo of a static bird, you often try to take just a single photo, but in continuous drive mode the shutter button is so sensitive that when you press it the camera takes two or three photos. This can get annoying and often feels like a waste of photographs. In my

opinion this still does not merit switching to single-shot mode. You will risk missing out on action photos when it happens unexpectedly. Having some duplicate portrait images is not nearly as bad as the nightmares you'll suffer when you know you've missed out on good action images. With experience you'll learn the 'feel' of the shutter button and you'll get better at just taking a single photo at a time in this mode.

ISAK'S TIPS

When you do flash photography where you need the flash to fire on every photo, I advise setting the drive mode to low-speed continuous shooting (Canon: **⌷L**; Nikon: **CL**). The flash recycling cannot keep up with high-speed continuous shooting even if you have a flash battery pack. In the low-speed continuous shooting mode you'll have a better chance that the flash will keep up, making sure that every photo is well exposed. In this way you can take longer bursts of photos as the camera buffer will take longer to fill up.

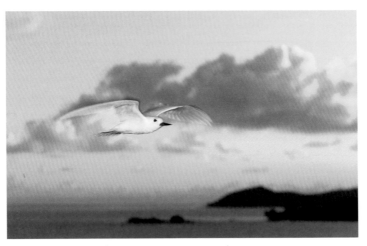

White Tern, Seychelles | *1/125 sec at f/5.6, ISO 100* | *Canon 1D Mark IV + 70-200mmf/2.8 lens* | *Aperture Priority, +1 ev*

Shutter speed

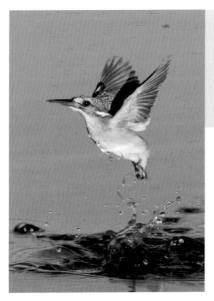

Small flying birds require the fastest shutter speeds.

Malachite Kingfisher, Marievale Bird Sanctuary in South Africa | 1/4000 sec at f/8, ISO 800 | Canon 1D Mark II N + 600mmf/4 lens | Aperture Priority, -2/3 ev

Larger birds do not require shutter speeds as fast as small flying birds do, especially when they soar or glide without flapping their wings.

Bearded Vulture, Drakensberg in South Africa | 1/800 sec at f/5.6, ISO 400 Canon 1D Mark III + 600mmf/4 lens Manual Mode

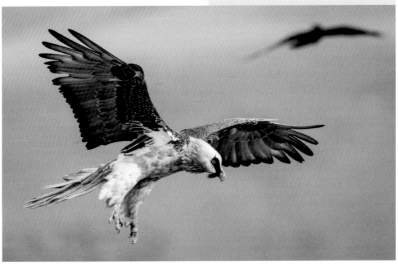

Technically speaking, the biggest contributor to the success of any bird-behaviour photo is the shutter speed. Fast action requires fast shutter speeds to 'freeze' the moment and create a sharp image. Unless you want to show the motion with creative blur or capture a hint of movement with blurry wingtips, you would always want the fastest possible shutter speed. Most DSLR cameras' limit is 1/8000 second shutter speed so that would be the ideal. But photography is a game of compromise where the fastest shutter speed cannot be selected at the cost of low image quality. There is always a trade-off. Photos taken at high shutter speeds in low light might produce grainy images (poor image quality), but choosing better quality will result in slower shutter speeds, resulting in sharp images – you have to find the balance. You need to use the fastest shutter speed that will still deliver good quality and sharp images.

The Malachite Kingfisher is one of the most beautiful birds you'll ever see. They are tiny, but spectacularly draped in all the colours of the rainbow. Photographing these little guys dive into the water is the ultimate thrill in bird photography and requires the fastest shutter speed you'll ever (realistically) need at 1/4000 sec. Compare this with the Cape Vulture, for example. They are massive birds that mostly glide in the air while making minimal wing movements. They look best though when they came in to land, and, relative to a kingfisher, they flap their wings very slowly as they touch down. This means that you do not require as fast a shutter speed as you do with the kingfisher – 1/1250 sec is more than adequate. Different birds fly at different speeds, and thus require different shutter speeds. To be on the safe side, it won't hurt to use faster shutter speeds than I suggest, as long as you don't compromise quality. You may have got a sharp image of a flying bird at a slow shutter speed once, but that probably was just a lucky shot. Slow shutter speeds will not consistently deliver sharp images.

This chart will help you to maintain the correct shutter speed for the correct application:

Shutter speed	Activity	Species	Example
1/5 sec–1/40 sec	Slow-motion panning of birds in flight	Any species	
1/50 sec–1/160 sec	Portrait of static bird	Any species	
1/200 sec–1/320 sec	Hint of movement	Any species	
1/400 sec–1/640 sec	Faster movement, hovering, with blurred wingtips	Any species	
1/800 sec–1/1250 sec	Take-off, landing and flight	Vulture, crane, heron, stork	
1/1600 sec	Take-off, landing and flight	Egret, eagle, skimmer, ibis	
1/2000 sec	Take-off, landing and flight	Duck, goose, flamingo, hornbill, gull, tern	

Shutter speed	Activity	Species	Example
1/2500 sec	Take-off, landing and flight	Grebe, roller	
1/3200 sec	Take-off, landing and flight	Weaver, dove, bee-eater	
1/4000 sec	Take-off, landing and flight	Kingfisher, sunbird	

Different shutter speeds for different birds

It is essential to be in control of the shutter speed, whether you choose it or whether the camera sets it automatically. But how do you do it? Which mode do you shoot in? There is no right or wrong answer here and in theory any mode can deliver a good result. My advice would be that aperture priority would produce the most consistent results. Good images of birds also depend on the photographer's skillful application of depth of field (controlled by the aperture). Aperture priority is the best way to be in control of aperture. The shutter speed will be controlled by you adjusting the ISO. But, as explained in Chapter 2, an alternative is to use the new functionality on the latest DSLR cameras where you can use manual mode with auto-ISO as long as that allows you to still adjust the exposure compensation. Nikon's 'ISO sensitivity settings' also work in a similar way. You set both aperture and shutter speed while the camera selects the ISO. This is the best of both worlds, but you need to be cautious that the ISO does not go too high and result in poor image quality.

The best possible settings for 'freezing' the motion in bird behaviour photos would be as follows:

- f/5.6 aperture. An aperture one stop smaller than the widest (e.g. f/5.6 on a 600mmf/4 lens) will increase the sharpness of the lens while still creating the shallow depth of field effect.

- 1/4000 sec (fast enough to get any size bird sharp)

- ISO 100 (the lowest ISO for the best image quality)

Although these settings are what we strive for, there would never be enough light for a correct exposure if we were to use these, so in the real world we have to make compromises. What we compromise is the trade-off of one value for another and this is the challenge of photography. I call it the **train of thought**. Given the amount of light and the action I want to photograph, what do I sacrifice to give me the best chance of still getting the shot at the best possible quality? You have to decide for yourself which levels of aperture, shutter speed and ISO are acceptable to you, and at which levels you'd start compromising the one for the other. This becomes a complicated mathematical equation and it's almost impossible to calculate it perfectly every time. There are many variables that make it complicated, such as the ISO performance of the specific camera model, what level of ISO is acceptable to you, how rare is the opportunity or bird that you're photographing, etc. But to keep things simple, here is a train of thought to use for the average bird-in-flight opportunities:

- Set your camera to Aperture priority with the following values: f/4 at ISO 2000. Make sure your exposure is correct by adjusting the exposure compensation, and then take notice of the shutter speed set by the camera.

- The priority is to aim for a good shutter speed first (1/2000 sec), then a good ISO (ISO 800) and then a good aperture (f/5.6).

- Once 'good' values are achieved in all three elements, you then aim for the 'ultimate' shutter speed first (1/4000 sec), then the ultimate aperture (f/8) and then the ultimate ISO (ISO 100).

- The tolerances would be an ISO value of 2000 and an aperture of f/4 since that is the widest of the lens in this example. There is no tolerance on shutter speed since it is our first priority to get to the correct level.

- The 'good' and 'ultimate' aperture values will depend on the lens that you use. One stop up from the largest aperture is usually noticeably sharper, so if you use an f/4 lens, for example, your 'good' aperture value will be one stop up from f/4 which is f/5.6. You'll notice that I like to use f/4 and f/5.6 in my bird photographs. This is personal preference as the shallow depth of field effect is more important to me than the slightly sharper photos I'll get at f/8 (which is two stops up from the largest aperture and the 'sweet spot' of the lens).

Priority	Element	Value to aim for
1	Shutter speed	1/2000 sec
2	ISO	800
3	Aperture	f/5.6
4	Shutter speed	1/4000 sec
5	Aperture	f/8
6	ISO	100

Train of thought

The train of thought should be followed in the order of priority: Start with f/4 and ISO 2000.

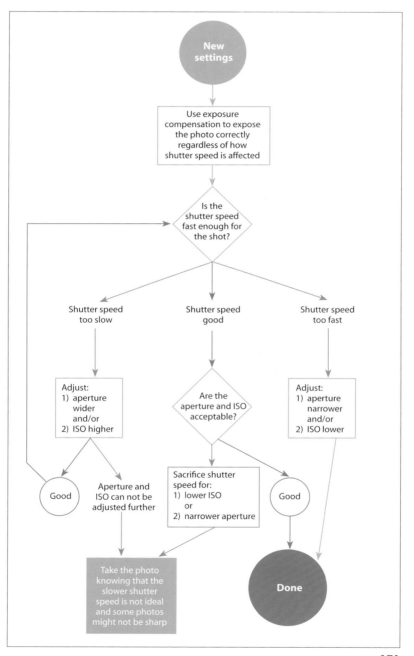

Knowing now what we 'aim' to do, let me explain how the train of thought works by using the following example.

- If we are in the field under clear sky conditions and start photographing from before sunrise when it is still dark, light is the biggest constraint. As we photograph the light gets better and becomes brighter.

- Initially we would have to set our aperture as low as possible to f/4, the ISO as high as possible to ISO 2000 and accept whatever shutter speed the camera selects for an even exposure, no matter how slow it is. At first it might be as slow as 1/10 sec, but it will get faster and faster as the sun rises until it reaches 1/2000 sec.

- Now we've reached a good shutter speed, so we can start changing the setting that was next in our 'priority' list. That is ISO. So as the light gets better, we start to lower the ISO.

- At this stage the shutter speed remains at 1/2000 sec and the aperture at f/4, but the ISO goes lower, dropping from ISO 2000 to ISO 1000 and downwards until it reaches ISO 800.

- Now that the ISO has reached a 'good' level, we can start changing the f/stop narrower from f/4 to f/5.6. When the aperture reaches f/5.6, we have reached 'good' values for all three elements having the following: 1/2000 sec at f/5.6 and ISO 800.

- If the light gets better from this point, we can start to change the shutter speed to the 'ultimate' value of 1/4000 sec, and then ISO down to ISO 100 (or as low as it can go).

If you want to freeze the movement in an action sequence or a bird in flight, here is my advice to achieve this under different conditions:

- **Low and consistent light**: This would normally be when you photograph on a clear day before sunrise or after sunset, or when you photograph in heavily overcast conditions. Whether the bird is in the sky, on a perch or on the water, the light on the bird remains constant. In this case use manual mode (without auto-ISO). Start by choosing the largest aperture like f/4 on a 600mm lens, ISO 2000, and then choose a shutter speed for an even exposure. Verify the exposure every five minutes in case there is a slight change in the brightness of the conditions.

Overcast conditions create low and consistent light.

Black Heron, Marievale Bird Sanctuary in South Africa | 1/400 sec at f/8, ISO 800 | Canon 20D + 100-400mmf/5.6 lens | Aperture Priority, -1/3 ev

- **Low and variable light:** This would usually be when you photograph inside a forest with dappled light. As the bird moves between the dark shaded areas and the spots of sunlight, the exposure on it changes drastically. You must rely on the camera to take care of the exposure by adjusting the settings automatically, while concentrating on the bird. In this case use aperture priority mode. Set up the exposure for the shaded areas, knowing that the settings will be more than adequate for the sunlit areas. Start by choosing the largest aperture, such as f/4 on a 600mm lens, ISO 2000, and then leave the camera to choose a shutter speed for an even exposure. When you switch from photographing in the shaded areas to photographing in the sunlit areas and time allows, you would change the ISO down, knowing that you can get better image quality and still maintain good shutter speed under the brighter conditions. But, just be cautious, when you switch back to photographing the bird in the shaded area, you need to remember to adjust the ISO higher again.

A Verreaux's Eagle-Owl sitting in a Mashatu tree. The sun spots through the leaves, changing with the wind, created low and variable light.

Verreaux's Eagle-Owl, Mashatu Game Reserve in Botswana | 1/80 sec at f/4, ISO 1600 | Canon 5D Mark II + 600mmf/4 lens | Aperture Priority, -2/3 ev

- **Good and consistent light**: This would typically be when you photograph in the middle of the day with clear skies or light overcast conditions. Whether the bird is in the sky, on a perch or on the water, the light on the bird remains constant. In this case use manual mode (without auto-ISO). Start by choosing your preferred aperture, such as f/5.6 on your 600mm lens, a good ISO like ISO 400, and then choose a shutter speed for an even exposure. If the shutter speed is less than 1/2000 sec, push the ISO up slightly. As long as you keep photographing in the same direction, the light should remain constant leaving your exposure unaffected.

Mid-morning in September in Botswana usually means clear skies that deliver good and consistent light.

White-backed Vulture, Khwai River in Botswana | 1/500 sec at f/5.6, ISO 160 | Canon 1D Mark III + 600mmf/4 lens | Aperture Priority, +1/3 ev

- **Good and variable light:** This would normally be when you photograph in the middle of the day in partly cloudy conditions where the light changes from bright sunlight to lightly shaded. As the variable conditions change the exposure on the bird, you must rely on the camera to take care of the exposure by adjusting the settings automatically. In this case use aperture priority mode again, and set the exposure for the lightly shaded conditions, knowing that the settings will be adequate when the sunlight appears again. Start by choosing your preferred aperture, such as f/5.6 on your 600mm lens, a good ISO like ISO 400, and then leave the camera to choose a shutter speed for an even exposure. When conditions change from lightly shaded to sunlight, change the ISO down one stop, knowing that you can get better image quality and still maintain good shutter speed. But, just be cautious, when conditions change back to lightly shaded, you need to remember to adjust the ISO one stop higher again.

Summer in the Okavango Delta of Botswana creates good and variable light as cumulus clouds fill the skies in the afternoons.

Little Egret, Okavango Delta in Botswana | 1/2000 sec at f/7.1, ISO 400 | Canon 1D Mark III + 600mm f/4 lens + 1.4x | Aperture Priority, -2/3 ev

ISAK'S TIPS

The ability to recover detail from underexposed images is a great advantage for bird photographers. Typically when light becomes low, you have to choose between lowering the shutter speed (that risks the sharpness of the image) and increasing the ISO (that risks poor image quality). But an alternative is to leave the shutter speed and ISO unchanged and just take the photo anyway. In this way you are guaranteed a sharp image but it will be very underexposed. In post-processing you can then increase the exposure back to normal levels. This will give you a sharp image that still has good image quality. These maintained levels of quality have been a feature of the latest top-end Canon and Nikon cameras. Nikon is still ahead of Canon in this regard, allowing you to 'fix' underexposed images to a better extent.

Exposure can be increased during post-processing.

Underexposing this photo created a faster shutter speed, just fast enough to get it sharp.

Striped Kingfisher, Okavango Delta in Botswana │ *1/160 sec at f/5.6, ISO 1250*
Canon 1D Mark IV + 600mmf/4 lens + 1.4x │ *Aperture Priority, -1 ev*

Learning behaviour

Bird photographers often have a more intimate experience of their subjects than bird watchers. In order to get a good photo of a bird you have to anticipate what its next move will be. Bird photographers sit and stare at their subjects for hours through their lenses in anticipation of the next take-off, landing, fly-by, feeding, pruning, wing-stretch, yawn, mating, mating displays, territorial displays and territorial fighting as this behaviour creates photos with impact that showcases their beauty. Bird watchers are interested in getting the 'tick' and moving on to the next species, but bird photographers are happy with the challenge of taking a spectacular photo of only a few species. During this process you get to know the species of birds that you photograph very well, each with their own unique features and mannerisms.

The direction in which a bird takes off is key to creating impact. Always try to have the bird take off angled slightly towards you.

Pale Chanting Goshawk, Kgalagadi Transfrontier Park in South Africa | *1/2000 sec at f/8, ISO 500*
Canon 1D Mark III + 600mmf/4 lens
Manual Mode

It is vital in any kind of action photography to be ready for what happens next. With experience it becomes second nature, but you still have to be focused, ready for what happens next and to anticipate it. That unique moment of action, where the two Bearded Vultures lock their talons in a stunning display of power, for example, only happens once and if you miss it you won't get another chance. Learning the behaviour of your subjects is key to getting good action photos.

Any kind of repetitive action makes it easier for you to set up for the next installment of the action. It helps you to envisage the shot, choose the right lens, choose the correct camera settings, and then knowing what to expect makes it easier to point your lens in the right direction when it happens. In fact, repetitive behaviour is such an advantage that if you come across it, such as spotting a particular bird building a nest, it's worth spending all your time there until you get all the shots on offer.

Birds are creatures of habit and usually have a favourite perch. When you hang out at the same spot at your local bird sanctuary, you will quickly learn which perch is the favourite of the kingfisher or swallow, for example, and the next time you see them around you can aim your lens at the empty perch in anticipation of it landing there and taking a stunning action photo. Bee-eaters have stunning colours and the best repetitive behaviour you will encounter – they often use a perch on which to sit and launch repeated attacks on insects, flying back and forth, always landing on the same perch.

Repetitive behaviour to look out for includes:

- Bee-eaters catching insects and returning to the same perch.
- Swallows or raptors building nests, carrying building material and returning to the same spot.
- Flycatchers, rollers and kingfishers feeding their young and returning with insects to their nests.
- Waders like plovers, egrets, stilts, avocets and sandpipers patrolling the beach, walking back and forth along the edge of the shore.

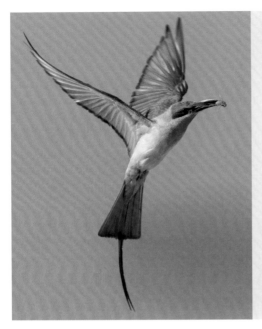

Bee-eaters at their nests follow the same flight path as they fly in and out repeatedly throughout the morning.

Southern Carmine Bee-eater, South Luangwa National Park in Zambia | 1/2500 sec at f/5.6, ISO 800 | Canon 1D Mark IIV + 70-200mmf/2.8 lens Manual Mode

Small birds like kingfishers move extremely fast. Even the larger birds like Red-billed Teals can be sitting still on the water one moment and launching itself into the air the next. If you want to catch that moment when a kingfisher launches itself downwards for the dive or a Red-billed Teal shoots up into the air when it takes to flight, you need to have the reactions of a cat. Luckily birds do 'tell' us when they're about to take to flight.

Different species have different signals and you just have to know what to look out for:

- Most birds defecate just before they take to flight – they want to get rid of all excessive weight to minimise the effort of flight.

- Social birds like flamingoes often get vocal before they take to flight.

- Birds in a small group either take to flight all at exactly the same moment or one by one. Flamingoes, vultures and most species of ducks take off one by one, so if you see one go, you know they will all go.

- Pruning, stretching and shaking feathers could be a signal that a bird is getting ready for flight, but it could also be a signal that it is getting ready for resting. If the bird had been resting before they do this behaviour, it's a good sign that it is about to take off.

- Raptors are continuously looking around, staring into the distance for potential prey with those sharp eyes. When they start bobbing their head while keeping their eyes fixed in a direction, then it signals a good chance for a take-off. If they are unsuccessful, they start looking around again until locking onto the next target.

- Bee-eaters have similar signals to that of raptors, moving their head around continuously, but are much faster than raptors. When they lock onto an insect, they stare intensely, moving their head slowly while following their target and then in a split second they're off.

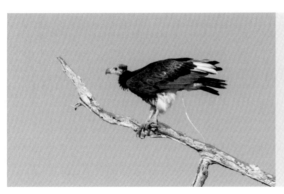

Defecating is a clear sign that the bird wants to shed weight before taking to flight.

White-headed Vulture, South Luangwa National Park in Zambia │ 1/2500 sec at f/8, ISO 800 │ Canon 1D X + 600mmf/4 lens + 1.4x Aperture Priority, +2/3 ev

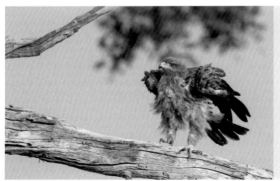

A bird ruffling its feathers could mean that something is about to happen.

Tawny Eagle, Okavango Delta in Botswana │ 1/1600 sec at f/5.6, ISO 800 │ Canon 1D Mark IV + 600mmf/4 lens Aperture Priority, +1/3 ev

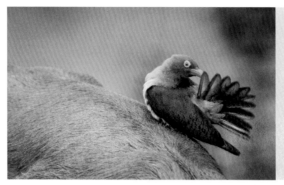

Pruning is a bird's way of getting matters in order. Often it leads to the bird taking to flight – although it's not always a given and they can make bird photographers wait in vain.

Red-billed Oxpecker, Kruger National Park in South Africa | *1/125 sec at f/8, ISO 400* | *Canon 1D Mark II N + 600mmf/4 lens + 1.4x* | *Aperture Priority, 0 ev*

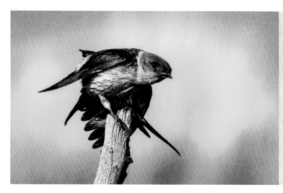

A wing stretch by this swallow means the chances are very good that it will take off soon.

Greater Striped Swallow, Marievale Bird Sanctuary in South Africa | *1/800 sec at f/11, ISO 400* | *Canon 20D + 100-400mmf/5.6 lens* | *Aperture Priority, -1/3 ev*

ISAK'S TIPS

Wind direction governs the direction that birds sit in, take-off in and land in. In a slight breeze they usually sit facing into the wind while take-off and landing is easier into the wind. The direction in which they fly normally is not governed by the wind, but rather by their destination. It does, however, affect the path they would take just before they land. When they fly downwind towards a perch, they would first swoop around the perch and then come back and land into the wind. Why is this important? Well, birds look best in the photo in sitting, take-off, landing and flying postures when they face slightly towards you from parallel. Knowing which way they will face will help you choose a direction that is best to photograph at. Assuming that you photograph with the sun directly behind you, when you arrive at a bird hide and the wind is blowing right into you, you know you're in for a tough day with all the action facing away from you. Ideally you want the wind to blow away from you, not straight but about 45 degrees away from the sun, since that would mean the birds land and take off towards you. So looking at the sun, it's always better if the wind blows away from the sun. Not all birds take off into the wind – perched birds that are in hunting mode and looking for a meal, such as rollers, bee-eaters and eagles, would take off in the direction of the meal regardless of the wind direction.

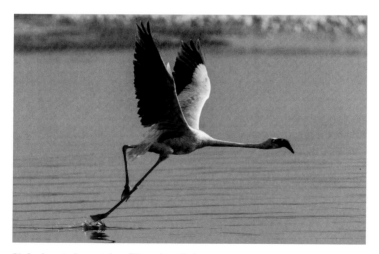

Birds almost always take off into the wind.

Lesser Flamingo, Lake Bogoria in Kenya | 1/2500 sec at f/7.1, ISO 1000 | Nikon D3S + 200-400mmf/4 lens | Aperture Priority, 0 ev

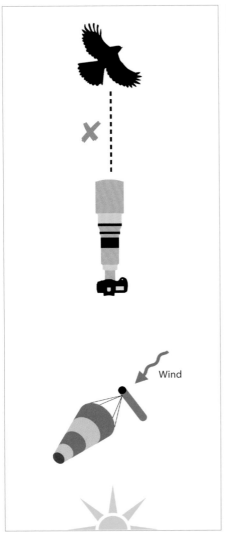

When the **wind blows towards the sun**, the birds will fly away from you when you keep the sun behind you.

When the **wind blows away from the sun**, the birds will fly towards you when you keep the sun behind you.

Technique

Smooth panning and support

Capturing bird behaviour requires you to follow the action as it happens through your lens by moving the lens sideways and keeping it aimed at the bird in flight or action sequence. Small lenses are light enough to hand-hold for short stints, but after hand-holding for long periods at a time your arms start to feel the weight. Long and heavy lenses are almost impossible to hand-hold, so you need a good support system that allows for the supporting of the weight and the smooth panning of the lens.

There are a variety of different options on the market each working best in different scenarios. A tripod works well when you can stand behind it next to the lake, but it won't work when you photograph from a vehicle.

Support systems that work well under different conditions:

- **Tripod with gimbal or fluid head**: This is used when standing is required such as next to a lake, in a hide if there is enough space in front of you to set it up, and low-angle shots where the legs are flattened.

- **Monopod with gimbal or fluid head**: Best used where space is limited such as on a safari vehicle, and walking long distances through the veld where support is required infrequently.

- **Panning plate**: Used on a beanbag from your vehicle or safari vehicle, or on a beanbag in a hide.

- **Beanbag**: The most versatile support system that can be used in your vehicle, a safari vehicle, on the ground when you're doing low-angle shots or on the platform in front of the openings of a hide.

- **Ground pod with gimbal or fluid head**: On a beanbag from your vehicle or safari vehicle, on the ground when you're doing low-angle shots or on the platform in front of the openings of a hide.

- **Handhold**: Anytime an opportunity presents itself where there is no time to put it on a support system.

- **Door bracket**: Used in your own vehicle or a safari vehicle. A door bracket is heavy but sturdy and can be used with a gimbal or fluid head.

Apart from choosing the right support system for the right scenario, it is key to be comfortable behind your lens. Following small fast-moving birds through a long lens is hard enough, so you don't want to make it any more difficult by having to hunch down, twist your head and limit your freedom to move the lens to the far left and right. Make sure that the support system offers you the chance to sit or stand comfortably behind it with your chest facing forward and the lens at such a height that you can just see over the top of it. This is important so that you don't have to hunch down too far when you look through the lens, and when you take your head away you can have a large enough field of view to spot any incoming bird.

 ISAK'S TIPS

Gimbal and fluid heads are the most popular heads designed for an effortless panning motion with birds in flight. These heads can be screwed onto tripods, monopods, and even ground pods that sit snuggly on top of beanbags, wooden counters in bird hides and even on the bare ground. Choose whether you are a gimbal or fluid head person by trying each one out.

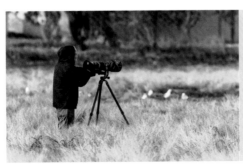

A gimbal head supports a 600mm lens.

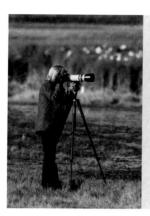

This photographer used a fluid head for her 100-400mm lens.

The correct focal length

A bird with is wings stretched fully upwards is one of the most powerful postures in bird photography and is usually the objective when you aim at a bird that looks ready to take to flight. But because photographers are concerned about image quality, we always strive to have the bird as large in the frame as possible to minimise the loss of quality that occurs with cropping. The problem is, however, that birds can extend their wings quite high, with the tip of the wing at the top almost reaching twice the length of the bird's body alone. This often is quite surprising and can lead to a part of the wing being chopped off. Considering the effort you went through to get the shot, it will be very disappointing to find you have chopped off the wings during that ultimate posture.

Choosing the correct focal length is crucial for getting the shot. Rather leave yourself with enough space in the frame than risk clipping the wings. This means either zooming out slightly or using a shorter lens. But how big must the bird be in your frame? When birds sit on a perch, ready for take-off, my rule is that you need to account for a height that is at least twice the length of the bird's body, while still having the bird in the middle of the frame. Using the portrait orientation is one way to help, but I often also pan with the bird as it leaps off the perch for a few seconds and for that the landscape orientation is much easier. I would then crop it to portrait mode afterwards if needs be.

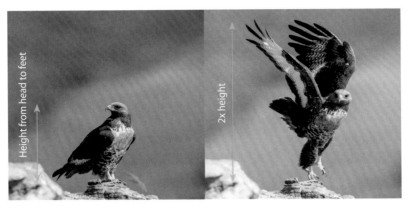

As a general rule of thumb when a bird lifts its wings, its height (measured from the top of the head to the bottom of the tail feathers) doubles in the frame.

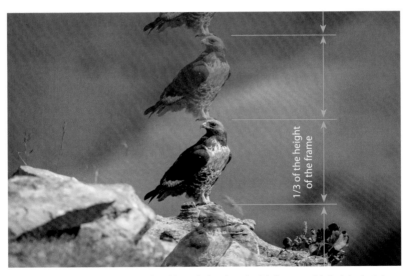

When you plan a shot, choose a focal length that has the bird at one third of the height of the frame. When it lifts its wings and doubles in height, there will be enough room left in the frame for a 'comfortable' composition.

Jackal Buzzard, Drakensberg in South Africa │ *1/2000 sec at f/5.6, ISO 500* │ *Canon 1D Mark III + 500mmf/4 lens* │ *Aperture Priority, 0 ev*

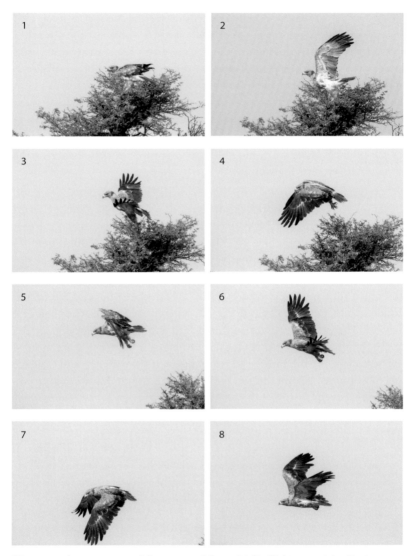

When you take a sequence of shots as you follow a bird in flight, you might clip the wings in some of the frames. The smaller the bird is in the frame, the easier it is to fit it in perfectly every time – but that may mean sacrificing quality when the bird has to be cropped significantly afterwards.

Tawny Eagle, Kgalagadi Transfrontier Park in South Africa | 1/2000 sec at f/8, ISO 640 | Canon 1D Mark II N + 600mmf/4 lens + 1.4x | Manual Mode

291

"You can never have enough lens" is a typical saying among bird photographers. With your small and skittish subjects it's always a challenge to get close enough to them. Converters are a great way to add some extra focal length, but if you use a converter to photograph birds in flight then beware of the following:

- Converters slow down the autofocus performance of lenses. 1.4x converters still offer reasonable performance, but 1.7x and 2x would risk losing the shot altogether because of slow focusing. Converters for take-off shots work fine, but tracking birds as they fly across the sky requires fast focusing.

- Converters compromise the quality of the images slightly. On good lenses you'll hardly notice the difference but it still has a small effect. I would recommend using converters only on prime lenses and the best quality zoom lenses like the 70-200mmf/2.8 and the 200-400mmf/4 if you have no other alternative.

Because birds are skittish and 'busy' creatures they don't often allow you much time to take photos of them. Often when you spot a bird and decide to take your lens out, it only allows you one or two shots before it flies off. That means you get one chance to take the photo and you need to use the right lens first time. It's hard to know which lens is going to be the perfect fit for the bird by just looking at it. Experience and practice will help you to pick up the correct lens first time and that will make you get more shots.

 ISAK'S TIPS

When you spot a bird that is about to take-off it does not matter how much experience you have, you still pick up the wrong length lens every now and again. If the lens is way too short, you'll just have to live with the fact you are going to crop the image significantly. If the lens is too long, you instinctively know that the bird is so tight in the frame that when it takes off you'll probably clip some of its wings. What do you do then? Well, since the bird would normally not allow you enough time to change lenses before it takes off, the best chance of making the most of the opportunity is to twist the camera to a portrait orientation where its fully extended wings will fit in the frame. The other option

is to hope for the best and aim with the centre focus point right in the middle of the bird's head. That would put the bird as low down in the frame as possible without losing focus – and then pray that when it takes off you don't clip a wing.

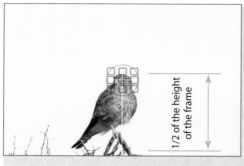

I knew that this bird was too big in the frame and that when it took to flight I would probably clip its wings. However, there was no time to change lenses, so I took a chance and put the AF point on the eye of the bird. This meant that I might hopefully have the bird fitting perfectly into one of the frames of the sequence of shots when it took to flight.

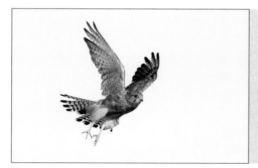

I was in luck – I had one frame where it fitted in the frame perfectly. Having the bird so large in the frame also meant that it is a great quality photo.

Greater Kestrel, Etosha National Park in Namibia │ *1/3200 sec at f/5.6, ISO 800* │ *Canon 1D Mark IV + 600mmf/4 lens* │ *Manual Mode*

The take-off shot

From all the postures of a bird in action or a bird in flight, one of my favourites is a bird leaping forward with its claws barely touching the perch and its wings fully extended upwards as it takes to flight. This also happens to be one of the easier action shots to get as it involves good reflexes rather than good tracking skills. You have the choice of either attempting to grab just the actual take-off shot or pan with the bird for the first few seconds of flight. The latter is much more difficult as you have to anticipate what speed and direction it will fly in, but the advantage is you might also capture the take-off shot. The first few seconds of flight involve a lot of wing movement with stunning postures. It is also the part of the flight that is slower than when it has built up speed and cruises across the sky.

You tackle this shot by first identifying the opportunity. A bird sitting still on a perch is usually a good start.

- Choose a lens with a focal length with just enough room to fit the bird in if it has its wings fully extended.

- Whether you're trying this shot in portrait or landscape orientation, a good measure is to keep the bird exactly in the middle of the frame and have enough space above the head of the bird to the edge of the frame to fit twice the bird's body length in.

- Now that you have the correct lens, aim at the bird using camera settings that allow for the correct exposure and enough shutter speed for a sharp image. If you plan just to capture the take-off, then support the lens so that it does not allow for much movement and keep your eyes fixed on the bird. As soon as you detect a hint of movement, then press and hold the shutter button for a few seconds.

- If you plan to pan with the bird for a series of photos in flight, then use a support system that allows for a smooth panning motion. Keep your eye on the bird and expect it to fly in the direction it is facing. The trajectory that the bird will follow is a guess at this stage, most probably about 30 degrees upwards. Good reflexes and hand-eye coordination will help – these are skills that develop with experience.

- Look through the viewfinder and keep your eye on the bird. If you detect a slight movement then start pressing and holding the shutter button. At this stage you have to reply on your instincts. Things happen almost automatically and you have to trust your reflexes to execute accurate panning with the bird.

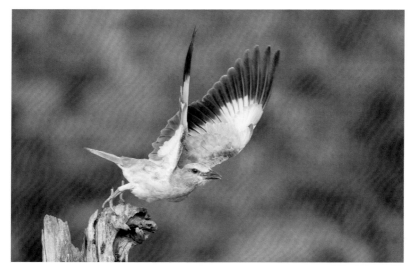

This roller, leaping forward with its claws still on the perch, indicates a dramatic posture.

European Roller, Kruger National Park in South Africa | *1/2500 sec at f/5.6, ISO 800* | *Canon 1D Mark II N + 400mmf/5.6 lens* | *Aperture Priority, -2/3 ev*

ISAK'S TIPS

The correct way to capture a take-off shot is to aim the centre autofocus point to the body of the bird and press the shutter the moment the bird leaps forward and lifts up its wings. The challenge is not only to have the reflexes of a cat to press the shutter at the correct moment, but when the autofocus sensitivity is too high, the bird often leaps away from the autofocus point making the camera refocus on the background (if this has a lot of contrast). When the bird is sitting on a branch with clear skies in the background, it is not a problem. What I do when the background is contrasting and I'm worried about losing focus at the pivotal moment, is to either switch the autofocus sensitivity right down, or use focus lock to keep the focus on the focus plane of the bird. Just beware that it would risk losing focus while you pan with the bird. But if you're happy with just the actual take-off posture, then it's fine.

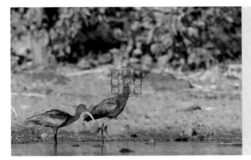

I focused on the bird with the centre AF point placed on its head. I kept the shutter button pressed down half-way to continuously focus on the bird while I waited for it to take to flight.

Here the autofocus was set very sensitively. As I released the shutter when the ibis leapt forward (out of the AF point), the camera refocused on the background. Setting the autofocus less sensitively makes the focus reaction time slower, keeping the bird in focus.

Glossy Ibis, Mashatu Game Reserve in Botswana | *1/2000 sec at f/5.6, ISO 1000* | *Nikon D3S + 200-400mmf/4 lens* | *Manual Mode*

Slow-motion panning

It is not uncommon to arrive at a bird hide excitedly early in the morning, long before sunrise, but then as the sun gets closer to the horizon you start to realise that the clear skies that were forecast for this day have turned into low hanging clouds. The prospect of a morning with no light just about ruins your second cup of coffee and your mind begins to contemplate the idea of packing up and leaving.

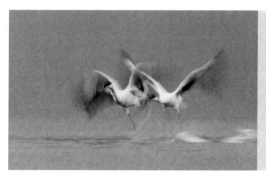

These flamingos running on the water during low light created the perfect opportunity for me to try slow-motion panning shots.

Lesser Flamingos, Lake Nakuru National Park in Kenya | 1/25 sec at f/13, ISO 100 | Canon 1D Mark IV + 600mmf/4 lens + 1.4x | Shutter Priority, -1/3 ev

I believe there is a good photo in every opportunity, and low-light conditions present the chance for something creative. Slow-motion panning is a great way to show a sense of movement in a photo and is ideal to try when the light is low as this creates the low contrast required for the artistic effect. The idea is that you use a very slow shutter speed and then pan with the birds as they fly across the sky. The image will be blurry from all the motion and movement of the lens, blurring the background severely, the bird a little less, and then having some part of the bird in sharp focus. Your success with this style of photography will depend on how accurately you can move the lens at the same speed as the birds fly. The typical success rate is quite low, averaging only one shot kept in 50 attempts, so don't be too hard on yourself if you don't get it right at first.

This technique can be used under any lighting condition. In harsh light the shadows across the birds from the midday sun create a harsh contrast and an unpleasing effect. The strong light also makes it difficult to slow the shutter speed down enough, often requiring you to use the narrowest

aperture possible, which is a recipe for highlighting all the dust spots on your sensor. Early morning soft light or overcast conditions work best.

The artistic blur of these images is a factor of movement. The faster you move the lens, or the slower your shutter speed is, the more blur you'll have in the photo. For the same blur effect you should move your lens sideways much faster at 1/50 sec than when you use 1/5 sec, for example. But the chance of getting a part of the image sharp (like the head of the bird) is much better if you use a faster shutter speed. Therefore, your best chance of success is to photograph fast-flying birds, using a faster shutter speed and panning with the birds by moving your lens sideways fast. The general rule of thumb is that the faster shutter speed you use, the better the chance of getting something sharp in the image, but the less blurry your image will be.

I've found that 1/25 sec to 1/40 sec is the shutter speed range that offers the best balance between the artistic blur and having something sharp in the image. At these slow speeds being able to pan exactly at the same speed as the bird is crucial for getting something sharp in the photo. You should try to pick something on the bird, the head or the chest, for example, then keep that part of the bird in exactly the same position in the frame for the duration of the pan. It sounds simpler that it is and I suggest you practise first at a place where birds fly constantly past you, from side to side and back again. For this effect to work the best, you need the birds to fly past you from one side to the other, parallel to you. As the birds fly past, you'll notice that there is not up and down movement. The pan relies purely on a horizontal movement. Therefore you can use the image stabiliser in mode 2 (Nikon = vibration reduction in 'active' mode), although I have not noticed a better success rate with this mode or even with using the image stabiliser at all. Another way to improve is if you have a good support system it will help your ability to pan at a constant speed. Fluid heads with their built-in resistance work the best. Any other type of support is also fine to use and definitely beats hand-holding the lens.

Aperture is irrelevant in slow-motion panning photos since the blur is created from movement and not depth of field. Shutter priority mode is the best to use. You choose the shutter speed and ISO and the camera will

select the aperture for an even exposure. Keep your eye on the aperture selected by the camera. In low-light conditions with a slow shutter speed, the camera would choose a narrow aperture (like f/22) which allows you to bring the ISO down, close to ISO 100 for the best image quality, as long as the aperture is still more than the minimum value.

ISAK'S TIPS

A slow-motion panning shot is a great way to put a new twist on a familiar photo. If you've spent the morning photographing egrets flying back and forth to their nests in a tree on an island, for example, you probably have a whole bag full of sharp images in a variety of postures before the morning is over. Instead of just accumulating more of the same photos, try a few slow-motion panning shots for fun.

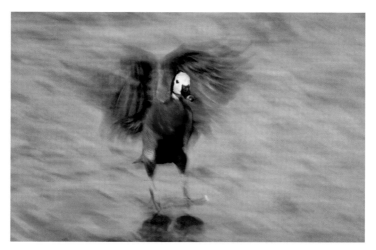

At the Austin Roberts Bird Sanctuary in Pretoria there are a number of White-faced Whistling Ducks that fly back and forth over the water in the mornings and offer you all sorts of interesting shots. A slow-motion panning shot of a duck landing was a great way to add some variety to my shots.

White-faced Whistling Duck, Austin Roberts Bird Sanctuary in South Africa | 1/30 sec at f/29, ISO 200 | Canon 1D Mark III + 600mmf/4 lens | Shutter Priority, 0 ev

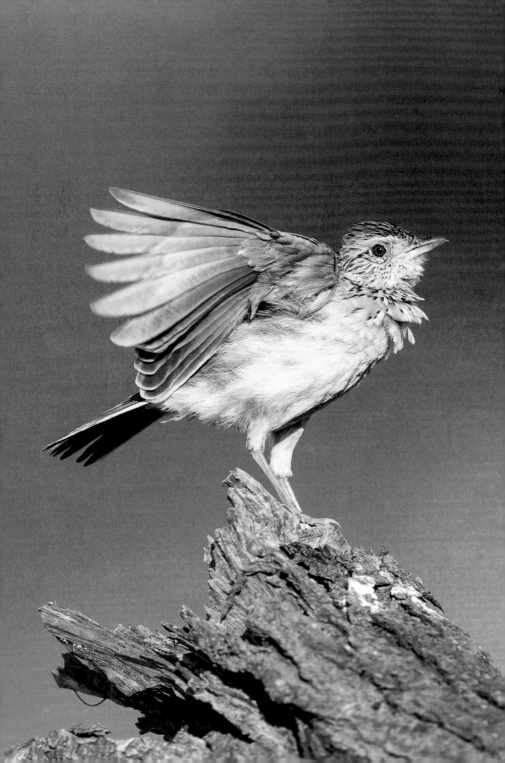

Bird photography hotspots

Rufous-naped Lark, Okavango Delta in Botswana
1/2500 sec at f/4, ISO 320 │ Canon 1D Mark IV +
600mmf/4 lens │ Aperture Priority, 0 ev

Introduction

One of the reasons why bird photography is so popular is because you can do it anywhere. There are birds everywhere. The birds at a particular place might not be the most eccentric, but there are always birds to be photographed wherever you are.

I often read articles in magazines about places in southern Africa where the writer describes it as 'good for birding', 'so many birds around', or 'a great place to see birds'. If creates the impression that it would be good to do bird photography, but the truth is there is a big difference between seeing birds and photographing birds. Bird photographers need to find a place that is photogenic, with good light, where there are lots of birds, or at least approachable birds so that you can get close enough to photograph them.

Bird photographers travel far and wide to get specific photographs of a targeted species. Everyone wants to have a photograph of a Bearded Vulture landing on a rock – even if it's a cliché, it's one to have in the catalogue. To get that shot you have to travel to the Drakensberg mountains to find them, but you can't just go anywhere – although you might see Bearded Vultures soaring when you visit some of the resorts in the Drakensberg, these sightings are never good photographic opportunities, so you have to go to a specific place that is considered a photographic hotspot for Bearded Vulture photography. This is typically a place where you see lots of them and you can get close enough to take photographs.

What I have also realised over the years is that there is always a good place to photograph a particular species. For years I've been driving around in the Kruger National Park in the summer months trying to get a good photo of a Southern Carmine Bee-eater in flight. In the summer months you find them scattered throughout the savanna after

the breeding season. Through lots of effort I finally managed to get close enough to one, with almost perfect light and an almost perfect background. It took off and I got one photo with wings fully extended and I was ecstatic having finally got a shot that was 90% perfect in my opinion. Then one October a friend invited me to join him to photograph the bee-eaters at their breeding site on the Okavango River in Botswana. When we arrived and I saw a colony of thousands of birds I realised that this was something special – these were the shots I had always wanted. Thousands of bee-eaters were continuously flying in and out of the nests, and we were standing metres away with our lenses mounted on tripods at the top of the bank, firing off shots. Landing, take-off and portrait shots in the best light and perfect background were filling our memory cards quickly and I though to myself, "Why have I ever bothered to struggle to get a photo of them in Kruger?"

There will always be great places to photograph a particular species. A few places are good for a number of species. Some of these places are common knowledge among bird photographers, while new places are discovered all the time. In this chapter I'd like to share with you some of my favourite bird photography places.

ISAK'S TIPS

Photographers are often obsessed with upgrading to the latest camera and lens technology. It is easy to get caught up in this never-ending cycle. Your old equipment was still good enough to use yesterday when it was the latest in technology, so why is it not good enough to use today? New cameras and lenses might allow you to get some photos you couldn't get before because of the improved technology, or perhaps they might just improve the quality of your photos, but that will only be a small improvement.

If you have to choose how to spend your time and money, I suggest you travel to new and exotic destinations rather than upgrading to the latest equipment. You will add more variety and incredible photos to your portfolio when you visit new places (even if your camera equipment is old), than staying at home with the latest equipment because your budget is finished. A portfolio with a *good variety* of photos is more attractive than one that only contains photographs of Egyptian Geese – even if they are stunning photos.

 KEY POINTS

- When you plan to photograph **a specific species** or you have a specific shot in mind, then know that there will be **one place** where those opportunities are **better than anywhere else**. It might not be common knowledge and it might depend on the season, but when you find that place, you won't believe how much easier it is to get those shots.
- Every photographic location offers some photographs that are easier to get than anywhere else. Concentrate on **getting those shots first** when you visit that place.
- A place that is regarded as **good for bird watching** is not necessarily **good for bird photography**.
- A **bird photography hotspot** might not mean there are many different species of birds, but it's a place where the **birds are used to people** and they display natural behaviour even when you are close to them.
- At times it might be difficult for you to get away from home to do photographic trips, so **find a few bird photography hotspots**, like bird sanctuaries or parks, **close to your home** that you can visit over the weekends.
- Southern Africa is a dry region, so **rivers or bodies of water** are always a good start when you look for a **bird photography hotspot**. The best places are those that are unpolluted and where the birds see lots of people, such as rivers with regular traffic of small boats.
- The **islands of the Seychelles** offer fantastic bird photography as the **birds have no natural fear of people** and you can get to within a metre of them. This opportunity means that you don't even need a long lens and getting so close to the birds offers a unique perspective.

Kruger National Park in South Africa

The Kruger National Park in South Africa is southern Africa's iconic wildlife destination. There are few places in the world that offer so much variety for bird photography in one place. The Kruger National Park is the size of Switzerland, but what makes it attractive is that it offers many species of birds, the birds are approachable and used to people and vehicles, the park is easy to get around in, and it's very affordable. For bird photographers this is the one place where you can get really close to rollers, oxpeckers, starlings, woodpeckers, hornbills, guineafowl, spurfowl, vultures, Bateleurs and Woodland Kingfishers unlike anywhere else. When you consider that getting close to your subject is one of the biggest challenges in bird photography, then the place that can get you the closest to most of the species must rank as the top destination.

Many South Africans have grown up going to the Kruger National Park with their families over the school holidays and perhaps that is part of the good sentiments around Kruger. We are all thankful that Paul Kruger had the foresight over a hundred years ago to declare that large piece of land along the Lebombo Mountains in the Lowveld as a national park to save it from the mindless hunting and animal extortion that was going on at that stage. Today this national park is the flagship park in southern Africa and a model for all other protected areas.

The park is located on the eastern border of both the Limpopo and Mpumalanga provinces of South Africa. It covers a number of biomes and bird habitats that are accessible by the excellent network of roads in the park. The main roads are tarmac and are the most popular, but there are also many well-maintained gravel roads that are much quieter.

305

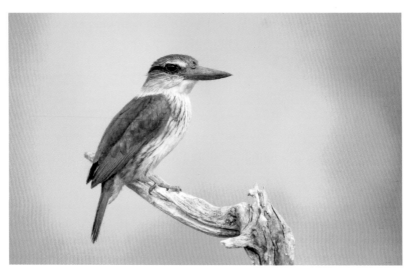

Brown-hooded Kingfisher, Kruger National Park in South Africa | 1/320 sec at f/5.6, ISO 200 | Canon 20D + 600mmf/4 lens + 1.4x | Aperture Priority, 0 ev

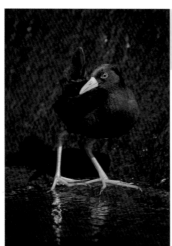

Black Crake, Kruger National Park in South Africa | 1/400 sec at f/8, ISO 200 | Canon 20D + 600mmf/4 lens | Aperture Priority, -1 2/3 ev

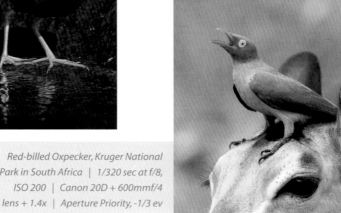

Red-billed Oxpecker, Kruger National Park in South Africa | 1/320 sec at f/8, ISO 200 | Canon 20D + 600mmf/4 lens + 1.4x | Aperture Priority, -1/3 ev

You can often drive for hours before seeing another vehicle. There are a number of camps located in the park that offer self-catering chalets, safari tents and camping accommodation options. These are designed for people that prefer to self-drive or be part of an organised tour. It is easy to self-drive through the park with the added benefit of being in total control of what you do – you can decide how long you want to sit at a sighting; whether you wait for that Martial Eagle to take off; or perhaps how long you wait and photograph the Yellow-billed Stork fishing in the shallows of a dam.

The camps have set opening and closing times that change every month, but they generally close before sunset and open after sunrise. You need to adhere strictly to these gate times or you may end up with a hefty fine. That does not, however, mean that you should race towards the camp when the sun is getting close to the horizon. The speed limit on the tarmac is 50km/h and 40km/h on the gravel roads. So plan your drives carefully and rather be too conservative on the time estimation.

The park receives thousands of visitors every year and that is what makes it a great destination for bird photography – it means that the birds have become totally habituated to the traffic and vehicles passing them every day. At private game reserves you can't get within 20 metres of an oxpecker on an impala – both animals have a large personal space, but in Kruger you can drive up to an impala with an oxpecker, roll down your window, stick a big white lens out and photograph the bird that's sitting five metres away from you.

Not only is driving around a good way to look for birds to photograph, but the camps themselves offer better bird photography opportunities than you may realise. There are many birds in the camps as they are attracted by food and water. They are also habituated by the bustle of people in the camp every day, making them approachable and oblivious to the bird photographers. Woodpeckers are always difficult to get close to on game-viewing vehicles, but in the camps they hop around in the camping area in the morning looking for leftover food thrown away by the campers or perhaps for the insect that has made this his home. In this environment you can get within metres of birds that take no notice of you. The bird activity reaches a peak at about two hours after sunrise when most people have left the camp for their game drives and the birds

then investigate the food left behind. Any time of the year is good for bird photography in the Kruger National Park.

- Summer (from November to February) is the breeding season and the bush is a buzz of activity with all the migrant birds that have made the journey south to spend the warm summer months in this part of the world. There always seems to be something happening – birds building nests, feeding chicks or fledglings, and making the most of this season of plenty.

- Winter (from May to August) is when there are fewer birds around but it's easier to find them near food and water sources. It's a great season to spend time looking for pools of water in the dry riverbeds, driving along the flowing rivers or just sitting and waiting next to a dam. Although the dry open areas still have a few raptors and typical species, the bird activity is stronger close to the water sources.

The park is very affordable, so if you are looking for a holiday destination where you can spend lots of time doing bird photography that won't break the bank, then Kruger is a top destination for you. A long lens, such as a 400mm to 600mm, will be most often used, but don't forget to take shorter lenses, such as your 300mm, 70-200mm and wide-angle lens for the camps where you can get very close to the birds.

South African National Parks | www.sanparks.org | +27 (0)12 428 9111

 ISAK'S TIPS

- Being the first vehicle out of the camp gate is always a thrill, not necessarily because of the bird photography you will do in the next half an hour, but rather because you have the first view of whatever animals are on the road. Lions and leopards love to walk and sleep on the roads in the morning and if you are the first out, you will see them before they disappear into the bushes. This is, however, not the main reason for going out early – you will also be able to drive away from camp for a long time without encountering other vehicles; a great opportunity to have a peaceful experience without the interference of other vehicles around you.

- When you stop next to the road to photograph a small brown bird and put that big white lens out of the window of your vehicle, someone will inevitably stop next to you to ask what you are photographing. They will look intently into the direction that your lens is pointing, missing the bird, and expecting one of the Big Five. You should mentally prepare yourself for such encounters and not be annoyed – just tell them you're photographing a small bird, or wind up your other window so they can't talk to you.

- Front lighting is typically the most popular to use. So if you're driving and sitting on the right-hand side of the vehicle, then plan your routes so that you drive south in the morning and north in the afternoon when the light is at its best. It's always easier to photograph from your window, even if the seat next to you is vacant and you have an opportunity to photograph through the other window.

- If you are serious about photography on a self-drive trip, then there can only really be two photographers in the vehicle: the driver with the passenger seat open next to him; and the other photographer sitting in the back seat. In this way both of you can photograph in both directions with enough space for your equipment.

- Most of the hides in the park are good for game and bird watching while only a few can be classified as bird photography hides. Lake Panic close to Skukuza Camp is a great bird photography hide, located right next to a dam. You will get great shots of Pied Kingfisher, African Darter, Goliath Heron, Black Crakes and African Jacanas.

Marievale Bird Sanctuary in South Africa

Marievale Bird Sanctuary in South Africa remains one of the best wetland ecosystems for bird photography. This small sanctuary has good networks of roads that run along the water with bird hides that offer the bird photographer great opportunities for capturing photos of its residents either from a vehicle or from one of the hides. There are an incredible number of birds in the wetland, mostly the common waterbirds, but it has also become famous for photographs of the colourful Malachite Kingfisher that seems to breed every year with great success.

Marievale is conveniently located close to Johannesburg and Pretoria, making it a very popular place to spend a weekend morning. Photographers have the opportunity to typically get good photos of the African Swamphen, ducks, geese, cormorants, darters, spoonbills, herons, egrets, kingfishers and even flamingoes. For photographers the most noticeable feature at Marievale is the good light – morning photography can last at least two hours before the light gets harsh and although mornings are the best time for photography, the afternoon light also has a special quality.

Black-winged Stilt, Marievale Bird Sanctuary in South Africa | *1/2000 sec at f/6.3, ISO 200* |
Canon 1D Mark II N + 600mmf/4 lens + 1.4x | *Aperture Priority, -2/3 ev*

*Pied Avocet, Marievale Bird Sanctuary
in South Africa* | *1/1000 sec at f/7.1,
ISO 200* | *Canon 1D Mark II N +
600mmf/4 lens* | *Aperture Priority,
0 ev*

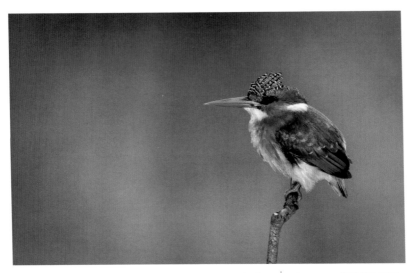

Malachite Kingfisher, Marievale Bird Sanctuary in South Africa | *1/640 sec at f/10, ISO 1250*
Canon 1D Mark III + 600mmf/4 lens + 1.4x | *Aperture Priority, -2/3 ev*

The Blesbokspruit that runs from the industrial towns of Springs to Nigel in Gauteng province's East Rand feeds the wetland. The bird sanctuary is a reserve that is tucked in between the mine dumps of this gold-producing region. The reserve is quite narrow and extends for a good few kilometres along the wetland. It's not only the waterbirds that can be photographed here, but on some of the two-track gravel roads that run through the sanctuary you find yourself in typical highveld grassland which is perfect habitat for chats, longclaws and widowbirds. The grassland is also a good place to look for photos of Black-shouldered Kites and Marsh Owls in the winter when they hunt in the late afternoon light.

The reserve has gated access and the guards will let you in before sunrise. It is well maintained with a picnic site that is popular over weekends and well-maintained toilet facilities at all the hides. The reserve doesn't really cater for people to stay over, so if you're coming from afar, then it would be best to stay at a guesthouse in the nearest town of Nigel. You would need a vehicle to get around and all of the photography is done from

either your vehicle or the hides. Marievale is especially popular with birders. They often enjoy walking around in the reserve and although it's good for spotting birds and looking at them through binoculars, they are too skittish to pose for people with long lenses on foot.

The bird photography is good all year round but is best in summer – even more so if the summer is a dry one where the wetland becomes the only source of water in a large area. In winter, from May to August, you find lots of terns, shovelers and Spur-winged Geese. The resident Spotted-necked Otters can also be seen regularly in this season, especially from Darter Hide. In early summer the activity starts to pick up and you might start seeing the Malachite Kingfishers regularly on their favourite perch right in front of the Hadeda Hide. At this time lots of Squacco Herons and spoonbills can be seen. During the height of summer in January and February the juvenile Malachite Kingfishers appear and start fishing in the shallow water right in front of Hadeda Hide. This has become a major drawcard to this hide, making it the most popular one in the reserve. During this time you might also see more of the other birds like Fulvous Whistling Ducks, African Rails, African Swamphens, Pied Avocets and Black-winged Stilts.

Photographers from the photographic clubs in Gauteng have been visiting Marievale for years and they say that although its still great for bird photography, it's merely a shadow of its former self. The mines in the area have been pumping heavy-metal contaminated water into the Blesbokspruit that has not only polluted the water, but has also fertilised the reeds which have become overgrown across the whole wetland. The management of the sanctuary is putting in a great effort to control the reeds. Today there are only a few patches where you can see the open water without obstruction and those are the best places to observe and photograph the birds. If you drive around and do photography from your vehicle, then a beanbag or door mount offers good support.

Great effort goes into the maintenance of the hides, which are always clean and well suited to photographers with benches and a counter in front of the openings that is just big enough to fit a large lens through. In the hides both a tripod or a beanbag will work well:

- The tripod can be setup in front of the openings, high enough for the lens to fit through while the photographer can sit on the benches.

- If you prefer a beanbag, then it can be rested on the bottom part of the opening.

- The counter in front of the opening is wide enough and high enough to use a ground pod with mounted gimbal or fluid head if you prefer that support option.

The good light and abundance and variety of birds make Marievale the best bird photography spot in Gauteng. You need to take your long lenses to photograph here – a 400mm to 600mm lens will work best but also take a shorter lens like a 300mm or 200-400mm lens for the large birds that sometimes sit on the perches very close to the hides.

Marievale Bird Sanctuary | http://www.nigel.co.za/marievale | +27 (0)11 734 3661

 ISAK'S TIPS

- Don't be fooled when you get to Marievale for the first time. It's located between mine dumps and can look dodgy and unsafe and you will wonder if you're at the right place. Once the sun rises and birds start to perform, your mind will change!

- Some of the perches put up in front of the hides are dead ugly with plain sticks mounted horizontally between two metal poles and attached with wire. Avoid getting any of those in your photographs. However, in some places photographers have put up much more aesthetically pleasing perches.

- Marievale seems to have its own weather that is totally different from the area around it. It might be sunny in the neighbouring town, but covered in mist at Marievale. When you leave home early on a Saturday morning, you may see the stars and clear skies, but then when you arrive at Marievale the clouds appear with the sunrise and you face a bleak morning with dull photos. The opposite is also true where it could be raining in Johannesburg but there will be patches of clear skies over Marievale. My advice is not to take notice of the weather forecast or the weather close to Marievale. If you plan to go, then go. If the weather is not suitable for photography, then at least you'll have a nice view while you drink your coffee!

- All the hides, with the exception of the Shelduck Hide, are designed for morning front light. The birds are most active in the morning, so that is the best time to visit Marievale.

- At the hides the birds appear quickly and seemingly out of nowhere from the left or right and then either do a fly-by or land in the stretch of water right in front of you. You need the reactions of a cat to pick your lens up and get the bird in the viewfinder. It helps when there are a few photographers in the hide who can help to spot birds and then call out the direction from where they're coming.

- The hides can be very popular, especially over weekends. Arrive early to make sure you get a space. I remember arriving one Saturday morning in summer at 4:30am and finding it already full.

- Winter can be especially cold next to the water in that part of the world. Remember to dress warmly and if you think you've taken enough warm jackets, scarfs, beanies, gloves, then take one extra jacket in case.

- Take a flask of coffee and snacks to enjoy in the hide or at the picnic site during your trip. Murphy's law is that the moment you pour that cup of coffee, the action will pick up insisting you focus on the photography.

- The low-water bridge on the far end of the reserve is great for both morning and afternoon light. Unfortunately only one vehicle can be parked on the bridge at a time, but it's far from the popular spots in the reserve.

- Keep your eye out for sightings of serval. This rare and elusive cat is at home in a wetland habitat and people often see them at Marievale.

Giant's Castle
in South Africa

Giant's Castle Game Reserve is nestled in the central region or tne Drakensberg mountain range in the KwaZulu-Natal province of South Africa and has become synonymous with the photography of the iconic Bearded Vulture from a vulture hide built into the side of the mountain. It is the best place for getting shots of these birds in flight, landing, taking-off or interacting, and you can even get close-up face shots when they glide past within metres of the hide. Even if you don't take photos, just to see these majestic birds swooping past the hide or gliding in the distance against the mountain background is a thrill.

Giant's Castle is a small reserve with spectacular views of the mountain. It is a great getaway place if you want to experience the tranquil mood of the Drakensberg by doing some of the day walks on the routes that are on offer or simply enjoying the views of the mountains from your chalet. But Giant's Castle is best known for its vulture hide where you can get close-up views of the resident raptors of the Drakensberg. The hide has been considered one of the best photographic hides in Africa for many years for its large, one-way glass windows from which these iconic birds can be observed.

The hide is large enough to fit six people comfortably and is built into the slope of the mountain and is well camouflaged. There is really only room for three photographers as only three of the gaps to photograph through face the perches. Below each of the large observation windows are smaller openings, hidden with a piece of cloth with a hole for the photographers to put their lenses through.

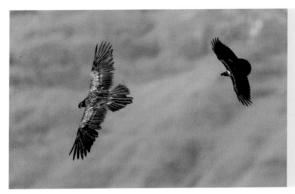

Bearded Vulture and White-necked Raven, Drakensberg in South Africa | 1/2500 sec at f/5.6, ISO 800 | Canon 1D Mark II N + 600mmf/4 lens | Aperture Priority, 0 ev

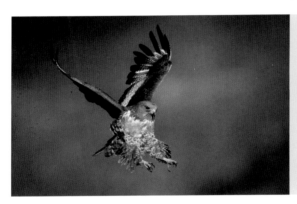

Jackal Buzzard, Drakensberg in South Africa | 1/3200 sec at f/4, ISO 200 | Canon 1D Mark II N + 600mmf/4 lens | Aperture Priority, -1/3 ev

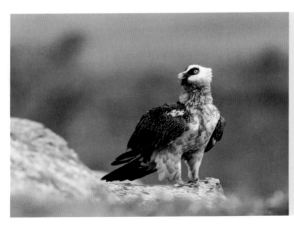

Bearded Vulture, Drakensberg in South Africa | 1/2000 sec at f/5.6, ISO 800 | Canon 1D Mark III + 600mmf/4 lens | Manual Mode

The Vulture Hide at Giant's Castle faces west, allowing for morning front light.

From 50 to 100 metres in front of the hide are a few rocks that are favoured perches by the birds. When you look back from these perches to the hide you realise how well the hide is camouflaged and it's even difficult to pick out the lenses pointed at you from that distance. This makes it an ideal way to see the birds up close without disturbing them or them knowing about you, especially if you keep very quiet and minimise movements in and out of the hide.

The hide is located a few kilometres from the camp and you have a choice of either driving there yourself if you have a 4x4 vehicle and the skills to negotiate the tricky terrain, or you can arrange that the camp takes you up there in their vehicle. Just make sure you get to the hide well before sunrise so that you're set up and ready to photograph when the first rays of sunlight strike the mountain. When you book the hide you get a bucket of bones each day that you can put out on the rock perches to attract the birds. Bearded Vultures are the main attraction at the hide and they love the bones, especially the marrow inside the bones which is their main food. The bones also attract other birds and you can expect to see Cape Vultures, Lanner Falcons, Verreaux's Eagles and Jackal Buzzards. Other small mountain birds like Red-winged Starlings, Familiar Chats and Buff-streaked Chats hop around in the grass in front of you and can be entertaining to photograph while you wait for the raptors to arrive. The bones unfortunately also attract White-necked Ravens that are considered to be pests. There are large numbers of them,

flying off with the bones and sometimes finishing them off before the raptors get the chance to eat. It is, therefore, advisable to put the bones out in small portions at a time so they can last the whole session. The ravens are aggressive birds that harass any raptor that attempts to take bones, but when hungry enough they will tolerate the harassment and this often leads to good interaction photos. Black-backed Jackals are also attracted by the smell of the bones and when you see vultures and jackals together, be sure to have your camera ready to capture a jackal snapping at the vultures.

The hide faces the perches in the direction of the Drakensberg mountain and thus positioned for good morning front light with the sun rising behind the hide. The mountain is the background of the perches, a fair distance away, and this allows for a soft out-of-focus and neutral background. Early morning light covers both the perches and its mountain background in gold. The light gets harsh quickly, however, and from 10am all the good light will have disappeared. This is often the case in the popular winter season where most days are cloudless. A lot of people only photograph in the morning and return to camp by 10am. Light overcast conditions would be ideal to photograph for the rest of the day although late afternoon backlight creates special photographs with light through the wings of the birds against the dark mountain covered in shade. As far as I'm concerned, this light is worth staying in the hide for the whole day.

The hide is open the whole year round and can be booked through the reservations office at the Giant's Castle Camp. It has become increasingly popular, so make sure you book well in advance. The camp has very comfortable chalet accommodation with a restaurant if you don't want to self-cater. The hide costs around R215 per person and allows you full-day access. Winter is the best time to go as there is less food around for the raptors, so the bones that are put out attract their attention much more than in the summer months. Winter is cold and in the mountains can be especially so with snow when a cold front moves through – make sure you take warm clothes. Variable weather is great as that brings wind. The Bearded Vultures typically only glide in wind and with strong wind your chances of seeing them in early morning good light increases. Windless days can be very quiet in the morning until the thermals pick

up which the vultures use to glide in. Unfortunately the thermals only appear late in the morning when it's getting warmer and the light is already hard.

Ezemvelo KZN Wildlife | http://www.kznwildlife.com | +27 (0)33 845 1000

ISAK'S TIPS

- The most popular rock perch is close enough to fit a Bearded Vulture in the frame with its wings fully extended as it comes down to land, with a full-frame camera on a 600mm lens. With anything more than that you'll be clipping wings, so I recommend sticking to that combination. The Jackal Buzzards are less skittish and will land on the closer perches, but because they are smaller birds, they will also fit into the frame with that combination. If you have a crop-factor camera body like a Canon 7D or a Nikon D300, then I recommend using a 400mm lens.

- Always keep looking or have someone stand guard to watch for approaching birds. The landing shots are the most spectacular but they often surprise you because of the speed with which they swoop in and their amazing camouflage against the mountain background.

- The openings for the lenses under the big windows have a wooden block above them. You can attach a ballhead on a superclamp to this, upside down, and then hang the lens from it. This makes a long lens very manoeuvrable and offers the best support.

- Make sure you have enough food and drink with you to last an entire day. The days can get long especially late morning and early afternoon when the action has quietened down, but good food and drinks will keep your energy levels up.

- If you take non-photographers with you, make sure they have good reading material to occupy them when there are no birds.

- Minimise movements since birds pick up on this and might be more skittish around the hide. When you leave the hide for a toilet break or to put out more bones, avoid staying outside for too long. Raptors have incredible sight and they see you long before you've spotted them.

Kgalagadi Transfrontier Park on the border of South Africa and Botswana

The Kgalagadi Transfrontier Park is considered by some of southern Africa's best bird photographers as a top destination for raptors. Bateleurs, Martial Eagles, Lanner Falcons, Tawny Eagles, snake eagles and owls and are some of the most photographed species and nowhere else will you get a chance to photograph them as well as you can here.

This arid region has the advantage of grassland and scattered large Camel-thorn Acacia trees that make ideal resting, observation posts and nesting sites for the raptors. In addition, there are plenty of permanent waterholes and the area is a long distance away from the dangers of poisoned carcasses from farmers, so there is a healthy population of raptors throughout the park. The park has two major roads that follow the Nossob and Auob riverbeds. The river beds are the bloodstream of the park and where most animals congregate, so driving along these roads you will have the best chance of seeing many birds and animals.

As a national park you are limited to self-driving, and there are set gate opening and closing times, which vary each month as the seasons change. There is camping or chalet accommodation at the three main camps, and in addition there are also a number of wilderness camps with a few chalets but they do not have facilities. These camps offer guests a real wilderness feel without the hussle and bussle of the bigger camps.

321

*Spotted Eagle-Owl,
Kgalagadi Transfrontier
Park in South Africa
1/500 sec at f/5.6, ISO 800
Canon 1D Mark III +
600mmf/4 lens
Aperture Priority, +2/3 ev*

*Pale Chanting Goshawk,
Kgalagadi Transfrontier Park in
South Africa | 1/2500 sec at f/7.1,
ISO 640 | Canon 1D Mark III +
600mmf/4 lens + 1.4x
Manual Mode*

*Namaqua Sandgrouse,
Kgalagadi Transfrontier
Park in South Africa
1/2000 sec at f/8, ISO 400
Canon 1D Mark III +
600mmf/4 lens
Manual Mode*

There are now also a few lodges that have been created on both the South African and Botswana sides where guests can stay if they want a break from self-driving.

The best light in the Kgalagadi, like everywhere, is early morning and late afternoon. The birds are most active in the morning so I suggest getting out of bed early and leaving the camp for your game drive as soon as the gate opens. In both the Nossob River Road and the Auob River Road there are permanent, pumped waterholes, approximately 15–25 kilometres apart. That is where most of the action happens, but don't be fooled and rush from waterhole to waterhole. Keep your eyes open and look for a photographic opportunity where you can stop the car and spend some time. Finding a Martial Eagle that is building a nest is a great example. The eagle would be flying back and forth carrying sticks to the nest and will offer you plenty of opportunities as it's coming in to land. Make a note of where you've found such an opportunity because you might want to return later to photograph it in better light or perhaps when the angle of light has improved. I find that the most rewarding photography is when I can sit and wait for nature to unfold around me – so try to find opportunities that offer that. Drive slowly and look carefully. When you see a Pale Chanting Goshawk fly down to the ground into the tall grass, look carefully as it might have spotted a snake and you'll get a photograph of it taking off with the snake in its beak.

When you don't feel like driving around the whole day, parking at a waterhole is sure to give you photographic opportunities, even if it's all

quiet when you first arrive. The birds and animals are thirsty and have to drink so you are bound to see something exciting soon.

Portrait shots of the raptors are a good way to start a trip, but you ultimately want to get some good in-flight shots and then behaviour shots too. I have recently seen someone's photos of a sequence of shots where a goshawk caught a sandgrouse in mid-air as it came down to land next to a waterhole. Each photo in the series is pin sharp with the goshawk in incredible postures as it caught the bird. These are the types of photos that only the Kgalagadi can offer you. It's also important not to ignore the other special small birds, such as Sociable Weavers that build the huge straw nests, and their host guardians, the Pygmy Falcon.

Some of the waterholes, like Cubitje Quap, offer amazing opportunities of sandgrouses in flight. The waterhole is right next to the road on the western side that allows for full front light in the morning. Many photographers park their vehicles there in the mornings. The birds come down in large flocks around two hours after sunrise.

When you self-drive you are restricted to the normal roads and often the birds or animals are just too far away to photograph. You are not allowed off-road even if your vehicle could manage to, so you require the longest lens you can lay your hands on – 600mm lenses with a 1.4x converter is the workhorse combination in the Kgalagadi. Other lenses are also important though, especially if you want to take some photos of the landscape or of birds in their environment.

They say that when you go to the Kgalagadi for the first time, you cry twice. You cry when you arrive and then you cry when you have to leave. The Kgalagadi is a desolate place and if you expect to have a game-viewing experience similar to that in the Kruger National Park, you will be quickly disappointed. It's not until you learn that you have to look hard, be patient and then learn to appreciate the wilderness flavour that the Kgalagadi offers that it starts to grow on you. The more you return, the more you fall in love with it, and soon an annual trip to this arid park will become an institution.

South African National Parks | www.sanparks.org | +27 (0)12 428 9111

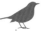

ISAK'S TIPS

- The bright sand of the Kgalagadi reflects the sunlight well and acts as a giant filter when you photograph soaring birds from straight underneath. Taking photographs like this usually creates hard shadows under the wings of the birds where there is a lack of detail in the image. If you try this around noon in the Kgalagadi, when the effect is amplified, you'll be amazed to see the amount of detail under the wings of the birds.

- The light in the Kgalagadi is beautiful in the mornings and late afternoon but gets harsh quickly. It also gets hot quickly so you are often faced with birds sitting on top of trees with harsh shadows across their faces or sitting in the shade of the tree with a bright background. Both conditions are not great for bird photography, but applying some fill-flash will bring life back to the photograph by balancing the light.

- The sandy roads in the park are sunken with high walls of sand along the edges. This means that you are almost looking at the environment from ground level – a great angle from which to photograph animals or birds. Unfortunately the ground gets hot quickly in the morning, creating heat waves that make fuzzy and blurry images. Avoid photographing birds at this level any time after 9am.

- The Kgalagadi Transfrontier Park has become a very popular destination with wildlife photographers. If you plan a trip to the park over long weekends or school holidays, make sure you book in advance.

- Both the Nossob River Road and Auob River Road are good for bird photography. But personally I've had good success everywhere in the Park and can't say one area is better than another – I take good sightings as a matter of luck.

- Look for owls in the rest camps and ask at reception if they know about any.

Okavango River in Botswana

The Okavango River in Botswana, also known as the Panhandle of the Delta, is a mecca for fishing and bird photography, especially in the dry season when the river becomes the only source of water in a large and dry landscape. The river is a paradise for jacanas, kingfishers, herons, egrets, bee-eaters, African Fish Eagles and African Skimmers that have become habituated and approachable with the number of local fishermen they see every day. There are a good number of birds to be photographed all year round, but the place becomes special for photographers in September and October when large colonies of Southern Carmine Bee-eaters breed in the banks of the river. During that time the river water drops to its lowest level and exposes sandbanks that becomes the breeding terrain for African Skimmers, while the region's African Fish Eagle population congregates around the river. Some of the special birds that can be photographed on the river include Lesser Jacana, Rufous-bellied Heron and African Pygmy Goose.

The Okavango River is fed by water from the Angolan highlands and enters Botswana at its north-western corner. The river itself is only about 100 metres wide but winds its way south in a 10-kilometre-wide floodplain for about a 100 kilometres before reaching the Okavango Delta where the river splits up into smaller channels.

Summer, from November to April, is the rainy season and the local rains create enough water in the floodplain and surrounding areas for birds to be dispersed. From May the summer rainwater from Angola reaches the Panhandle and floods the floodplain which then keeps the birdlife dispersed until August when the water starts subsiding. This becomes an exciting time for bird photographers. All the water from the surrounding areas starts to disappear, except for the Okavango River

and a few smaller channels and pools that remain. The large number of birds that find a home in the areas surrounding the river now congregate on the Okavango River itself. In October the annual barbel run takes place where huge numbers of barbel make their way down the river in tight groups. This attracts the attention of herons, egrets and African Fish Eagles. Lots of birds concentrated in a small area, making this is paradise for bird photographers.

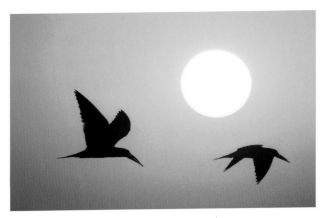

African Skimmers, Okavango River in Botswana | *1/3200 sec at f/8, ISO 250* | *Canon 1D Mark III + 400mmf/5.6 lens* | *Aperture Priority, 0 ev*

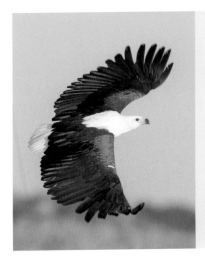

African Fish Eagle, Okavango River in Botswana | *1/800 sec at f/7.1, ISO 500 Canon 1D Mark III + 600mmf/4 lens Aperture Priority, 0 ev*

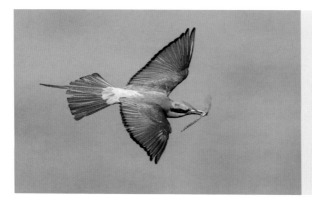

Southern Carmine Bee-eater, Okavango River in Botswana | 1/2000 sec at f/5.6, ISO 500 | Canon 1D Mark III + 600mmf/4 lens | Manual Mode

The Okavango River is lined with papyrus, which makes for great perches for all birds.

Most of the bird photography is done from boats. Small boats with guides can be booked through various lodges along the river. Accommodation varies from luxury lodges to self-catering chalets and camping. You make your way up and down the river by boat, photographing birds when you see them. There are a number of protected bays where the water is calmer and this is a good spot to spend some time photographing African Jacanas, African Pygmy Geese and kingfishers. African Fish Eagles can be found on the edge of the river every few hundred metres with their numbers picking up dramatically during September and October. It's common practice to bait them with fish, where your guide will whistle, wave the fish in the air, and then throw it into the river where the eagle will swoop down and take it right in front of you for the quintessential photo. This

baiting had been done for many years and, although you might find the eagles waiting for breakfast from the boats in the morning, this has not altered their natural behaviour – they still disappear into the floodplain from November to August where they rely on their natural hunting abilities. Some people frown on this baiting, but for them it is still the best chance to capture natural fishing during these months.

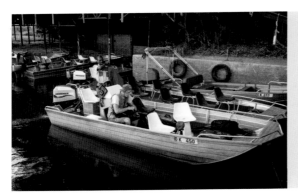

The lodges on the river all have small boats that can be rented for the two most popular activities on the river – fishing and bird photography.

African Skimmers can be seen at a number of exposed sandbanks along the river. There are usually breeding pairs and if you're lucky you might see a chick camouflaged in the bright sand. The skimmers often take off from the sand when boats go past, then fly around in circles around the boat a few times before returning to the sandbank to land. This is a great time to get the in-flight and landing photographs. The ultimate skimmer photo is where they skim the water as part of their natural and unique behaviour. This mostly happens late afternoon and early evening and is rare to see. Your best chance to capture this in camera is to spend an afternoon with the skimmers and to be patient.

Southern Carmine Bee-eaters are another of the main attractions on the Okavango River. Huge colonies of these birds migrate from central Africa to breed in burrows in the riverbanks in September and October. Each year the nest sites change as the banks of the river erode at different places. It is an incredible sight to see thousands of bee-eaters with their stunning colours flying back and forth, in and out of the nests and catching

insects along the river. Photographing them can be quite tricky though as they are small and fast and when they come in to land at the nests (or swoop straight into their nests), their flight path is often erratic and unpredictable. You need very sharp reactions to capture this in camera, but after trying to photograph a hundred birds, every now and again one will surprise you and fly slow and straight, making it possible for you to get the shot. Positioning the boat on the bank right next to the colony where you don't photograph the nests face-on but rather at an angle increases your chances of capturing them leaving the nests as they fly almost parallel to you. From this angle you also have a background that is far behind the birds which helps to isolate them from the clutter. Your best chance of capturing some in-flight shots is to stand on the bank above the nest. Not only do you have a beautiful background with the river or papyrus to contrast the bright red colours of the bird, but standing on solid ground and eliminating the rocking movements of the boat makes panning the lens much easier. You will quickly pick up the repeated circular flight paths of the birds as they fly out to the riverbanks at a slow speed with wings fully stretched and then they return. They do this over and over again and you will quickly get into the motion of moving your lens in the same way.

Long lenses, such as 400mm to 600mm, are essential for photographing on the Okavango River. Bee-eaters are small birds where long focal length is required. African Skimmers have a very large wingspan but even so you don't get very close to them. For the African Fish Eagles you need a shorter lens, a 70-200mm or 300mm lens as they become surprisingly large in the frame when they catch a fish, wings extended, right in front for you. You don't want to clip the wings to spoil this iconic shot. The boat is a stable platform where a tripod with a gimbal or fluid head works very well. Apart from the occasional hippo or crocodile, there are no animals to be photographed here, so you don't have to bring equipment to photograph them.

Drotsky's Cabins | http://www.drotskycabins.com | +27 (0) 21 855 0395

Nxameseri Island Lodge | http://www.nxamaseri.com | +267 (0) 7132 6619

ISAK'S TIPS

- The African Fish Eagle with its bright white chest and dark wings is difficult to expose in harsh light. It feeds mostly in the mornings so your best chance is to capture it in golden early morning light when you can see detail over the entire body.

- For the shot of it catching fish, you need to consider the angle of the sun, the direction of the wind, and the direction that the water flows. The eagle will fly into the wind, so the ideal situation would be to have the sun behind you and have wind that comes from the direction of the sun – not exactly from the sun as you don't want the eagle coming straight at you, but rather at a 45-degree angle, i.e. having the wind coming from 45 degrees left or right of the sun. When a fish is thrown it will drift with the current for a few seconds before the eagle takes it. If it drifts too close to you or too far away, it will spoil the photograph. Finding a protected bay is ideal to eliminate this variable.

- October is called 'suicide month' in Botswana for a good reason as temperatures soar. The best photography is done in the early morning and late afternoon, but even then if can get very hot on the boat even if you're only centimetres above the cool water of the river. Be prepared for the heat and drink enough water to keep hydrated.

- Ask your guide to show you a Pel's Fishing Owl. These birds are rare and are a big 'tick' on any birder's lifer list. There are a few of them around the river and they love to rest in the day high up in large trees on the river's edge. There won't be much action but it's great to get a photo and just to see these special birds.

- September and October usually mean clear skies in Botswana. The stable light source combined with the requirement that a specific fast shutter speed, such as 1/3200 sec, is required for sharp photos of flying birds, makes it the ideal opportunity to fine tune your settings in manual mode. Start with 1/2000 sec at f/4, ISO 800 early in the morning and then adjust regularly as the light gets stronger. Shooting in manual mode (without auto-ISO) allows you to be in control of good speed, depth of field and quality without being caught out by the camera overexposing the white on the chest of an African Fish Eagle.

Okavango Delta
in Botswana

The Okavango Delta is the quintessential unspoiled wilderness of southern Africa. It ranks as one of the most scenic places on the continent – it is untouched by human hand and is a magnet for birds. The network of water channels and wetlands creates an ideal locality for bird photographers where the major drawcard is not only the abundance of birds but also the varieties found. Here you can not only photograph the 'Delta specials', such as Wattled Crane, Pel's Fishing Owl, Slaty Egret and African Pygmy Geese, but also get great photos of the other typical waterbirds like kingfishers, storks and egrets. The Delta should, however, not be confused with the Okavango River as such which is where bird photographers gets the iconic shots of African Fish Eagles catching fish, thousands of Southern Carmine Bee-eaters breeding in the banks of the river and African Skimmers skimming. These shots are not impossible to get in the Okavango Delta, but much easier at the Panhandle of the Delta where the Okavango River is deep and narrow.

The Okavango Delta, like the name suggests, is an inland delta fed by the Okavango River coming from Angola and entering Botswana at its north-western corner. The river cuts through the flat land of Botswana in a south-easterly direction and drops into a flat depression bordered by major fault lines. This creates the effect of the river breaking up into a network of channels and flooding an area half the size of Switzerland. From this point most of the water slowly disappear into the Kalahari sand creating an oasis in the middle of the Kalahari Desert. Most of the Delta is government land and allocated as concessions to safari operators, while a small section forms part of the Moremi National Park.

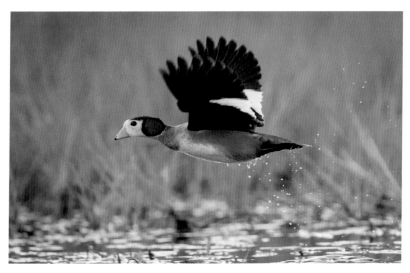

African Pygmy Goose, Okavango Delta in Botswana | 1/2000 sec at f/4, ISO 1000
Canon 1D Mark IV + 600mmf/4 lens | Manual Mode

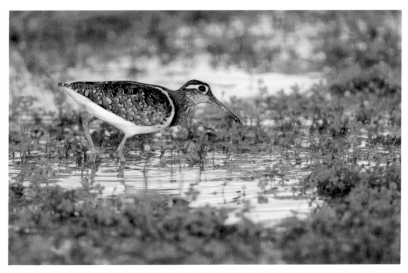

Greater Painted-snipe, Okavango Delta in Botswana | 1/1250 sec at f/5.6, ISO 800
Canon 1D Mark IV + 600mmf/4 lens + 1.4x | Aperture Priority, 0 ev

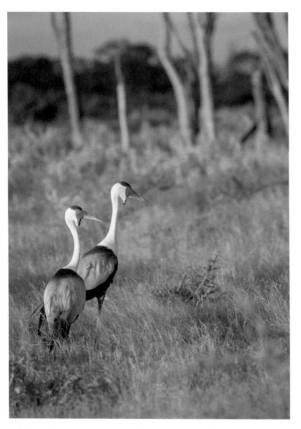

Wattled Cranes, Okavango Delta in Botswana | 1/500 sec at f/7.1, ISO 1250
Canon 1D Mark III + 300mmf/4 lens + 1.4x | Aperture Priority, 0 ev

Summer rains from the Angola highlands feed the Okavango River and only reach the Delta from June. The water level then starts to rise in the Okavango Delta, submerging most of the land and leaving only a few islands for the animals to escape to. This is the most iconic time in the Delta when you can fly over it and see elephants and giraffe wading through the flat and shallow water that looks like a giant mirror from the air. The flood reaches a peak in August and then the water level slowly subsides until it reaches its lowest level just before the summer rains arrive in November. At this time most of the land is dry and exposed except for

a few of the channels and depressions that still hold some water. Every season offers something else for the bird photographer. In the winter when the water is high, the birds and animals are more concentrated on the islands, although it is difficult to get to them through the deep water. The dry season in November is very productive as you find lots of birds along the few remaining channels of water, although you miss out on the beauty of the floods that make it so unique. The height of summer from December to February has its own appeal where you experience lots of rain, stunning thunderstorms with dramatic skies, and the birds in a frenzy of activity trying to make the most of the abundance of food and insects.

Bird photographers have the option of doing a self-drive through the Moremi National Park where accommodation can vary from camping to luxury lodges. This is only accessible with a 4x4 vehicle. The two-track dirt roads can be tricky to negotiate and vary between deep hot sand to deep water crossings through the water channels. In the flood season the network of roads becomes limited, while off-road driving is strictly prohibited in the National Park all year round. The advantage of the self-drive option is that you are totally in control of where you want to photograph and how long you want to spend at a sighting. However, your options and access are limited. The other alternative for bird photographers is to stay at a lodge in the concessions in the Okavango Delta. These lodges are very exclusive and expensive, but have a small footprint on the environment. They are accessed through chartered flights from Maun airport which is the gateway to the Delta. Chartered flights means weight restrictions with luggage and camera equipment, so you have to study the rules for each lodge to see what you can take, unless you buy extra luggage allowance or an extra seat on the plane. The lodges in the concessions offer game drives, walking and boating activities, but I found the game drives to be most productive for photography as the animals are used to the shapes and sounds of the vehicles. The guides have an expert knowledge of the birds and the area. Like all wildlife there is a degree of luck involved, but chances are good that your guide will get you into position for the birds that you would like to see and photograph.

This is one of the typical lodges in the Okavango Delta that is built in the middle of the Delta system overlooking the water channels and floodplains.

For the self-drive option through the Moremi National Park I suggest to take a good variety of lenses although the long lenses, such as 400mm to 600mm, will be most used. If you are restricted by the weight allowance on the small chartered flights into the lodges of the Delta, then my suggestion would be to take a long lens first, then a medium zoom like a 70-200mm lens and a wide-angle lens for the landscapes. Although the birds are very approachable, sometimes the terrain limits you in getting very close to them, so a long lens is a necessity.

The unspoiled beauty and abundance of birds in the Okavango Delta is something to be experienced even if you don't take any photos.

Wilderness Safaris | http://www.wilderness-safaris.com | +27 (0)11 807 1800

Great Plains | http://www.greatplainsconservation.com | +27 (0)87 354 6591

&Beyond | http://www.andbeyond.com | +27 (0)11 809 4300

Sanctuary Retreats | http://www.sanctuaryretreats.com | +27 (0)11 438 4650

Kwando Safaris | http://www.kwando.com | + 267 (0) 686 1449

Botswana Department of Wildlife and National Parks | http://www.mewt.gov.bw | +267 (0) 397 1405

 ISAK'S TIPS

- A beanbag is the easiest support system to use at the lodges in the Okavango Delta. Empty the bags before you fly to eliminate any additional weight on the plane and then ask the chef to fill it for you with rice or beans. Request this on your booking form so that they are prepared.

- When you fly to your camp over the Okavango Delta on the chartered flight, make sure you keep a camera and wide-angle lens handy. Even if it's not ideal to take photos through the window of the plane, you'll be amazed at the quality you can get.

- The chartered flight from Maun airport over the Okavango Delta offers fantastic landscape opportunities. Just make sure you choose a seat next to a clean window.

- When you book your accommodation at a lodge, make sure you tell them in advance that you are a photographer and interested in birds. The lodge will then allocate a guide to you that is knowledgeable about birds and photographers. You will then be allocated to a vehicle with other guests with the same interests.

- The bird photography during your stay is not limited to the game drives – have your camera ready in the camp as well. They are unintentionally a magnet for birds as they come to feed on the leftover or otherwise natural food. They are used to people so you can get very close to them.

- If you are planning to do a self-drive trip to the Moremi National Park, then make sure you have a good 4x4 fitted with a snorkel. This will make the water crossings less stressful. At the campsites there are no facilities or fences and this is considered 'wild camping'. Beware of dangerous animals, so zip your tent closed at night. Also make sure you have enough food and water with you to last the trip.

Chobe River in Namibia

Bird photography of waterbirds from a boat is a great thrill and can occupy a bird photographer's attention for hours at a time. Combine this with warmth, sunshine, thousands of birds, and kilometres of riverfront and you've got the Chobe River in Namibia. African Fish Eagles, African Skimmers and African Jacanas are some of the major attractions and have become very habituated with the boat traffic on the river. This allows for excellent bird photography of these species as well as other birds that Chobe is famous for, such as the African Openbill, Rosy-throated Longclaw, Giant Kingfisher and Yellow-billed Storks. The photography is mostly done from small boats that are launched from lodges on the edge of the river or from the houseboats on the river.

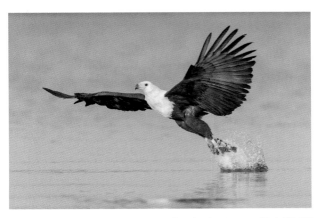

African Fish Eagle, Chobe River in Namibia | 1/2000 sec at f/5.0, ISO 800
Canon 1D Mark III + 600mmf/4 lens | Manual Mode

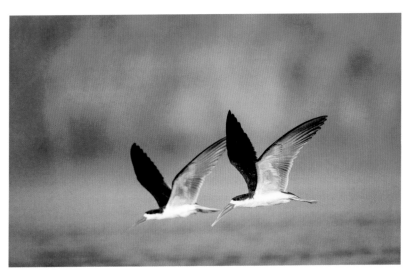

African Skimmers, Chobe River in Namibia | 1/2500 sec at f/4, ISO 400 | Canon 1D Mark IV + 500mmf/4 lens | Manual Mode

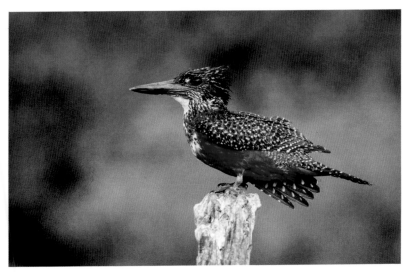

Giant Kingfisher, Chobe River in Namibia | 1/500 sec at f/5.6, ISO 2000 | Canon 1D Mark III + 600mmf/4 lens | Aperture Priority, -1/3 ev

339

The Chobe River in the Caprivi region is the border between Namibia and Botswana with the Chobe National Park on the one side and community land on the other. Huge herds of elephant and buffalo can be seen coming down to the water to drink from the Botswana side. If you are lucky you might see them swim across to the other side. The Chobe River flows into the Zambezi River at a point where four countries meet: Namibia, Botswana, Zambia and Zimbabwe. The water is very calm as most of the year it's not flowing as a river but rather acts as a backwater of the Zambezi. It's deep and wide for kilometres as it extends away from the Zambezi, allowing for a controlled number of houseboats to be stationed on the river.

The town of Kasane on the Botswana side of the river has become a gateway for travellers to this part of the world. The main attractions are fishing and photography along the river, whether this is from a boat or from game drives through the Chobe National Park. Travellers are spoilt for choice when it comes to accommodation, which ranges from camping to self-catering, luxury lodges on the river shore and luxury houseboats on the river. If you are keen on doing game drives through the Chobe National Park in addition to bird photography on the river, then being land based is probably the easiest. The houseboats on the Chobe River offer luxury accommodation with the added benefit of having small boats with a guide that you can use to do the photography

A small boat on the calm water of the Chobe River offers a steady support for long lenses mounted on tripods.

The luxury houseboats on the Chobe River not only offer comfortable accommodation but they all have smaller boats from which to photograph birds.

from. Being right there in the shooting location, you don't need to make the trek back and forth along the river to get to the bird photography hotspots.

September and October is the height of the dry season with the best bird activity along the shore. It's also the time when the level of the river drops to its lowest, exposing the sandbanks on which the endangered African Skimmers build their nests. Most of the other birds also start breeding during this time, making it the most popular season for photographers. That said, any other time of the year is pretty good also and, along with the river's resident population of hippos and crocodiles, as well as the elephant, buffalo, roan antelope and other game that come down to the river to drink, there is always good bird photography to be had.

The guides understand photography so it's best to tell them what you're looking for – they will get the boat into position for you and angle it correctly with the sun. It is often rewarding to spend some time in one position and see how nature unfolds around you, rather than racing from one spot to the next, chasing specific birds. The guide will find a quiet bay where the water is calm and you can sit and wait for the birds to come to you. African Jacanas with their long toes walking on the lilies is a great highlight. If you sit still and wait they will carry on walking around, sometimes away from you but at some stage coming close to you, so be ready with your lens. An African Fish Eagle catching a fish must be the ultimate photo trophy on the Chobe River. There are many of them sitting on the trees at the water's edge. They can fish any time of the day, but like most birds are hungriest in the morning so that's when your photography will be most productive. Baiting fish eagles has been banned on the river, so you have to wait for the real thing and that can take time. Natural conditions are uncontrolled, so chances are that after waiting for hours, you might finally get that shot when the bird eventually swoops down, only to find that it has caught the fish while facing away from you or against the light. Remember that they favour flying straight into the wind when they catch the fish, so that should eliminate one of the unknowns in the equation.

The Chobe River can deliver many surprises, so it's best to be observant all the time. Look for repetitive behaviour, such as swallows building a nest and returning to the same place over and over again; or perhaps

finding a Giant Kingfisher taking a bath where he dives into the water and returns to the same perch repeatedly.

It's hard to tell how close you can get to the birds from the boats, but typically is still involves the use of a long lens like a 400mm or 600mm. Rather use a long lens first as you can ask your guide to stop the boat before the birds get too big in the frame. If you only have a short lens, there will definitely be instances where you can't get close enough to some of the birds.

Zambezi Voyager | http://zambezivoyager.com | +27 (0) 83 726 4091

Cresta Mowana Safari Resort & Spa | http://www.mowanasafarilodge.net +267 (0) 625 0300

Sanctuary Retreats | http://www.sanctuaryretreats.com | +27 (0)11 438 4650

 ISAK'S TIPS

- Being such a popular destination for wildlife photographers there are a number of safari operators that have built their own custom photographic boats. These boats have well-designed rotating seats and lens support systems so that you can effortlessly photograph in any direction with a long lens. Some even offer the use of their cameras and long lenses, which makes it an ideal quick getaway destination where you don't even have to take your camera equipment with you on the plane flying in to Kasane – just remember to take your own memory cards!

- A small boat is a great platform from which to do photography. It's stable and you have space. I recommend using a tripod with a gimbal or fluid head. When the boat is moving, you don't even have to take your lens off the tripod – just tilt it down so that no spray falls on the front lens element.

- Another advantage of the boat is that you can get low to the water and on the level of your subjects. When you see African Skimmers sitting on a sandbank, you should rest your lens on the side of the boat to get even lower to the water than from your tripod.

- A day out on the boat can get hot and sunny, so remember to take a broad-rimmed hat and sunscreen.

- There are a number of good spots for birds that the guides will know of. However, if you are interested in photographing elephants and baboons, then the open photogenic area called Elephant Beach is a favourite for most animals to come down for a drink.

Bird Island in
the Seychelles

Imagine a private tropical island with a lodge, long sunny days and thousands of birds to which you can get within metres because they're not afraid of people. That is Bird Island in the Seychelles with its very apt name. There have been only 112 species recorded on this island, but what is impressive is the huge number of birds in total that gets the bird photographers excited. Combine this with the fact that the birds have no fear of people so you've got a chance to do the type of bird photography that you cannot do anywhere else in the world.

Seeing a White Tern feeding its chick in a tree one metre away from you, for example gives you the chance to use a wide lens to include the environment that under normal circumstances would have been taken with a long lens for a tight portrait with an out-of-focus background. White Terns are residents on the island and with their elegant white coats and fairy-like wing shapes, they are some of the most photogenic birds in the world. Brown and Lesser Noddies can also be seen year-round while a million breeding pairs of Sooty Terns arrive in May for the breeding season on Bird Island. Frigatebirds, tropicbirds, the Seychelles Sunbird and the Seychelles Blue Pigeon are some of the other stars on the island.

The islands of the Seychelles are located off the east coast of Africa close to the equator, a five-hour flight away from Johannesburg. The main island of Mahé is the gateway to the rest of the 155 islands, most of which have healthy bird populations. Like on most of the islands around the world, the unintentional introduction of rats and cats has eradicated the bird populations on the islands as the birds through evolution have never built up a resistance towards these predators, nesting on the ground without

343

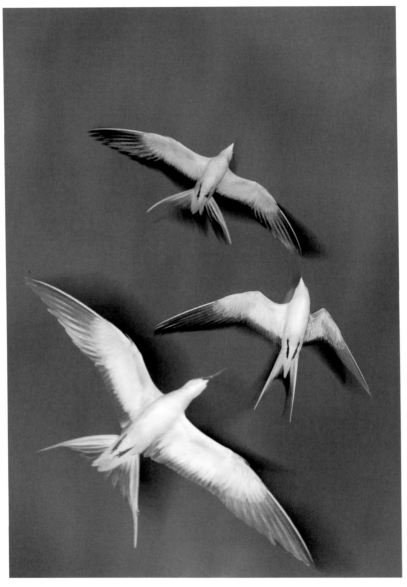

Sooty Terns, Bird Island in the Seychelles | 1/25 sec at f/4.5, ISO 6400 | Canon 1D X + 70-200mmf/4 lens | Shutter Priority, +2/3 ev

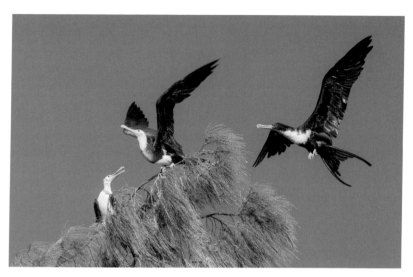

*Greater Frigatebirds, Bird Island in the Seychelles | 1/1000 sec at f/7.1, ISO 640
Canon 1D X + 400mmf/5.6 lens | Aperture Priority, +2/3 ev*

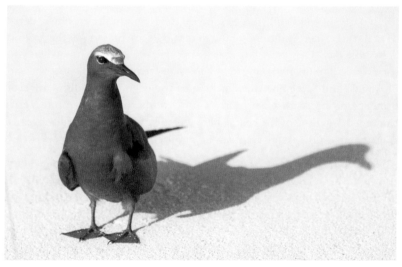

*Brown Noddy, Bird Island in the Seychelles | 1/2000 sec at f/5.6, ISO 500 | Canon 1D X +
400mmf/5.6 lens | Aperture Priority, +1 ev*

A private island, sunshine and millions of birds are what make Bird Island in the Seychelles a bird photographer's paradise.

any defence. In the Seychelles only a few islands are affected while great conservation success stories have restored some islands where bird populations are recovering. This, however, does mean good bird photography is not possible on all the islands, so when you book a trip be sure to do some research in advance. Bird Island, like the name suggests is one of the best for bird photography. It is a privately owned island, about one by two kilometres across with great conservation ethics. There is only one lodge with 24 chalets, which ensures that the impact on nature is kept to a minimum while offering the guests an almost exclusive wildlife experience.

There is something to photograph every month of the year. The main attraction and unique wildlife spectacle of one million breeding pairs of Sooty Terns is best photographed from May when they arrive with the south-easterly wind and start to land on the island in the evenings, every day a little earlier. At the end of the month they are present on the ground the whole day. They start laying eggs in June, hatching in July when you start to see parents returning to the nests to feed their chicks. At the end of August and September the chicks start to fledge. The noddies are ever present and breed just before the Sooty Terns, while the White Terns can breed any time of the year. There will always be some chicks in trees somewhere on the island that can be photographed.

Apart from birds, there are also other creatures like crabs and giant tortoises that make for great photographs. In October the Hawksbill Turtles start emerging from the sea to lay their eggs and this carries on until mid-December. From the beginning of December the eggs start to hatch and you can photograph thousands of baby turtles making their way to the sea over the beach sand. This carries on until March. In December you have a good chance of seeing both laying of eggs and hatching of the eggs that were laid when the season started.

For me the beauty of the Seychelles is that the birds have no fear of people and this allows for very unique bird photos. I almost always use my wide-angle lens on the island and that is such a different perspective on birds that are mostly photographed with long lenses. I remember the first trip I did to the Seychelles where I saw a tropicbird sitting on a nest on the ground with people walking up to it and the bird remaining on the nest undeterred. I thought to myself that this was incredible and spent half an hour taking close-up shots from all angles, thinking that I'll never get a chance again to find such an accommodating subject. It wasn't until I got up and walked another five metres into the forest that I saw the next bird also undeterred that I realised they are all unfazed by people around them. The next moment I walked up to a White Tern chick left on an open branch of a tree, within a metre of me, and when the mother came back, she fed the chick with a fish right in front on me. I was immediately hooked on bird photography in the Seychelles!

Having said that, there are some photos to be done with longer lenses, like 400mm to 600mm of the frigatebirds, for example, or if you want the classic portrait shot with an out-of-focus background. A macro lens will help with close-up shots and remember to take a flash too. Wide-angle lenses like a 16-35mm lens as well as a 70-200mm lens are the real work-horse lenses though. I do enjoy taking my Canon 400mmf5.6 lens as it's lightweight and easy to carry. Most of the photography involves some walking, although you might not have to walk very far, but carrying a tripod around with all the other equipment is a hindrance. If you can manage to take photos without a tripod that will certainly help.

The Seychelles is not a place where you will take photos of many different species, but rather many different angles on the same species. It is a place that requires you to be creative in your approach as the opportunity to get close to your subjects allows for the 'different' shots you're always looking for.

Bird Island Lodge | http://www.birdislandseychelles.com | +248 (0) 422 49 25

ISAK'S TIPS

- In the mornings the White Terns like to fly up and down the beach and hover near the trees where they nest. This is a good chance to capture them in their best fairy-like posture. They do like wind as this makes it easier to both fly and hover, so hold thumbs for early morning wind which can surprisingly be absent at that time.

- One of the creative things that the birds in the Seychelles allow you to do is to try to capture the twilight colours of the sky while exposing the birds with flash to balance the light. This is possible because you get so close to them. White Terns are curious creatures and you may have one hover right in front of you. It is then your chance to either 'freeze' the bird with a fast shutter speed or to create a sense of movement with a slow shutter speed when you mix the blurred wings with a 'frozen' flashed part of the body.

- Even at one by two kilometres big it can take a long time to walk and explore the island. I suggest doing this as soon as you arrive to see where the most birds are perched and to see if you can find any chicks left on the branches of trees that you know will become a photographic opportunity. Also ask the resident conservationist if he or she can show you a few spots where chicks are.

- It's not all about the birds, so take photos of some of the crabs, hermit crabs, giant tortoises and if you're there in the right season, some egg laying or hatching turtles.

- The Seychelles is close to the equator and, although that means nice warm and tropical weather, the sun gets high up in the sky quickly and brings with it the harsh light that photographers avoid. This means your timeframe for good light photography is very limited. The sky is very clear without the dust and smoke that we find on mainland Africa, so the golden hour of great light literally only last a few minutes. Make the most of this and arrive at your shooting location well in advance.

- Leave your long lenses at home and force yourself to be creative. The longest lens I've ever taken was 400mm which I used a lot. But using smaller lenses saves you the trouble of bringing heavy equipment and also forces you to use the wide lenses and come up with unique compositions and a different perspective on bird photography.

Other hotspots

Here is a list of some of my other favourite places for bird photography. Some of these places are in and around the cities and are the 'driving ranges' for bird photography. These are places that we go to over weekends or when we get a chance to practise our skills and satisfy our withdrawal frustrations of not going out on trips regularly enough.

South Africa, Gauteng

- Austin Roberts Bird Sanctuary in Pretoria
 http://www.tshwane.gov.za | +27 (0) 12 440 8316
- Dam at Bonaero Park in Kempton Park
 26°07'01.12" S 28°15'40.32" E
- Irene Country Lodge in Centurion
 http://www.irenecountrylodge.co.za | +27 (0) 12 667 6464
- Dam at LC de Villiers Sports Grounds in Pretoria
 http://web.up.ac.za | +27 (0)12 420 6060
- Mankwe Hide in Pilanesberg National Park
 http://www.pilanesbergnationalpark.org
 25°15'58.12" S 27°07'05.17" E
- Rietvlei Dam Nature Reserve in Pretoria
 http://www.tshwane.gov.za | +27 (0) 12 358 1811
- Vulpro Vulture Hide in Pretoria
 http://www.vulpro.com | +27 (0) 82 808 5113
- Walter Sisulu Botanical Gardens in Johannesburg
 http://www.sanbi.org/gardens/walter-sisulu | +27 (0) 86 100 1278

South Africa, KwaZulu-Natal

- Zimanga Private Game Reserve, close to Pongola
 http://www.zimanga.com | +27 (0) 21 461 2941

South Africa, Western Cape

- Bird Island Nature Reserve in Lambert's Bay
 http://www.capenature.co.za | +27 (0) 21 483 0190

- Boulders Beach in Simon's Town
 www.sanparks.org | +27 (0) 12 428 9111

- Intaka Island in Cape Town
 http://intaka.co.za | +27 (0) 21 552 6889

- Kirstenbosch Botanical Gardens in Cape Town
 http://www.sanbi.org/gardens/kirstenbosch | +27 (0) 21 799 8783

- Milnerton Lagoon in Cape Town
 33°52'25.08" S 18°29'32.81" E

- Strandfontien Sewerage Works in Cape Town
 34°04'56.99" S 18°30'56.25" E

Botswana

- Mashatu Game Reserve in the Tuli Block
 http://www.mashatu.com | +27 (0) 31 761 3440

Namibia

- Etosha National Park
 http://www.nwr.com.na | +264 (0) 61 285 7200

- The Bay at Walvis Bay
 22°57'41.54" S 14°26'24.86" E

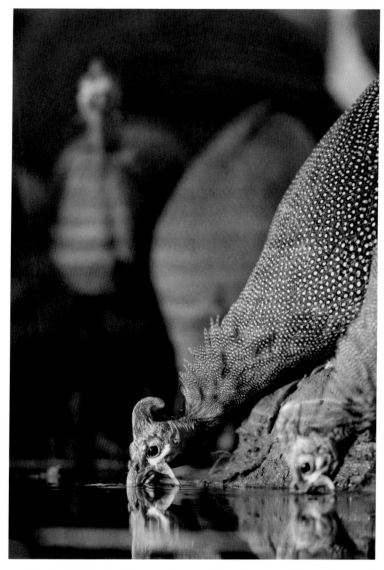

Mashatu Game Reserve in Botswana is only a 5-hour drive from Johannesburg and offers a number of purpose-built photography hides.

Helmeted Guineafowl, Mashatu Game Reserve in Botswana | *1/320 sec at f/4, ISO 400*
Canon 1D Mark IV + 600mmf/4 lens | *Aperture Priority, -1/3 ev*

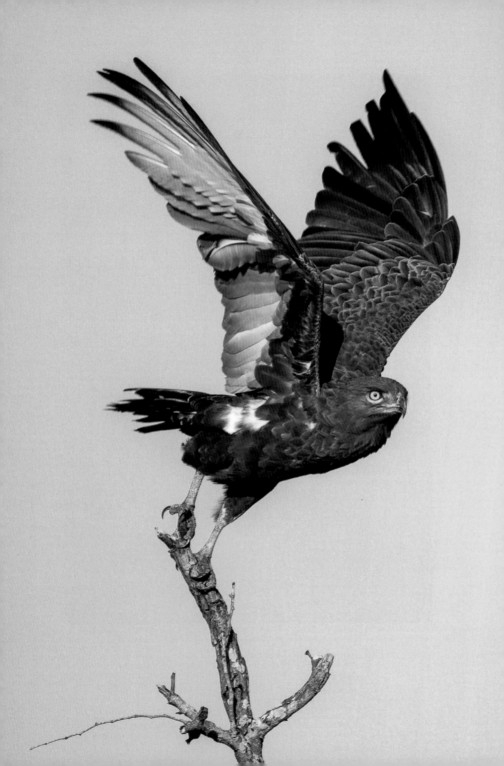

Chapter 10

Different settings for different shots

Introduction

Photography is part technical and part creative. Bird photography can become very technical but that's not the fun part. You want to be out there taking photographs and being inspired by what you see and what shots you envisage. This chapter has some cheat cards for you that serve as both a technical reference for specific types of photographs and a guide of inspiration so that you can try different shots the next time you're out photographing.

 KEY POINTS

- **All bird photographs** can be taken using **aperture priority mode**, with the exception of the slow-motion panning shots where shutter priority mode is used.
- To capture **action or behaviour,** use a **fast shutter speed** in the region of **1/2000 sec.** To achieve this you choose a wide aperture, like f/4, and increase the ISO from ISO 100 to ISO 800 or higher until you reach the desired shutter speed.
- **Portraits** of static or slow-moving birds do **not require a fast shutter speed.** **1/500 sec** shutter speed is a good benchmark. Choose an aperture for the desired depth of field, like f/5.6. Keep the ISO as low as possible while still maintaining the desired shutter speed, from ISO 800 to ISO 400, for example.
- For a soft **out-of-focus background or foreground** use a **wide aperture,** such as f/4, for a shallow depth of field.
- A deep depth of field where **both the bird and the background are in focus** is not common in bird photography and only used in wide shots where you want to show the bird in its environment. Use an aperture of f/16 for these shots.
- To create **intentional blur** from a moving bird in the photo, use a **slow shutter speed**, such as 1/25 sec, for example. Depth of field is irrelevant in these shots so use shutter priority to choose the desired shutter speed and keep the ISO at 100.

Bird portrait

Exposure Program		Exposure Bias
Aperture Priority		**0 EV**

Aperture	Shutter Speed	ISO
f/5.6	**1/400 - 1/640**	**200**

Select wide APERTURE for shallow DEPTH OF FIELD. Select higher ISO if SHUTTER SPEED drops below 1/400 sec.

Bird in flight

Exposure Program		Exposure Bias
Aperture Priority		**0 EV**

Aperture	Shutter Speed	ISO
f/5.6	**1/1600 - 1/2500**	**800**

Select wide APERTURE and high ISO for fast SHUTTER SPEED. Select higher ISO if SHUTTER SPEED drops below 1/1600 sec.

Bird portrait in low light

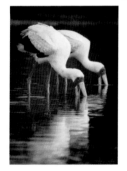

Exposure Program
Aperture Priority

Exposure Bias
0 EV

Aperture
f/5.6

Shutter Speed
1/200 - 1/320

ISO
800

Select wide APERTURE for shallow DEPTH OF FIELD. Select wider APERTURE or higher ISO if SHUTTER SPEED drops below 1/200 sec.

Bird in flight in low light

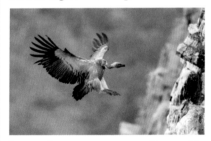

Exposure Program		Exposure Bias
Aperture Priority		**0 EV**

Aperture	Shutter Speed	ISO
f/5.6	**1/800 - 1/1250**	**1600**

Select widest APERTURE and high ISO for fast SHUTTER SPEED. Select higher ISO if SHUTTER SPEED drops below 1/800 sec.

Bird portrait with bright background

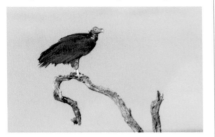

Exposure Program		Exposure Bias
Aperture Priority		**+ 1 EV**

Aperture	Shutter Speed	ISO
f/8	**1/400 - 1/640**	**200**

Review image to confirm EXPOSURE on bird. Background can be BRIGHT. Control brightness with EXPOSURE COMPENSATION; (+) to make BRIGHTER, (-) to make DARKER.

Bird portrait with dark background

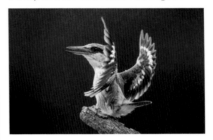

Exposure Program		Exposure Bias
Aperture Priority		**- 1 EV**

Aperture	Shutter Speed	ISO
f/5.6	**1/400 - 1/640**	**200**

Review image to confirm EXPOSURE on bird. Background can be DARK. Control brightness with EXPOSURE COMPENSATION; (+) to make BRIGHTER, (-) to make DARKER.

Bird in environment

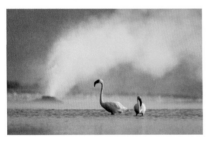

Exposure Program		Exposure Bias
Aperture Priority		**0 EV**

Aperture	Shutter Speed	ISO
f/8	**1/400 - 1/640**	**400**

Select medium APERTURE for deeper DEPTH OF FIELD. COMPOSITION should accuentuate environment. Select higher ISO if SHUTTER SPEED drops below 1/400 sec.

Bird in flight with bright background

Exposure Program		Exposure Bias
Aperture Priority		**+ 1 EV**

Aperture	Shutter Speed	ISO
f/5.6	**1/1600 - 1/2500**	**800**

Select higher ISO if SHUTTER SPEED drops below 1/1600 sec. Review image to confirm EXPOSURE on bird. Use EXPOSURE COMPENSATION to make image DARKER or BRIGHTER.

Bird in flight with dark background

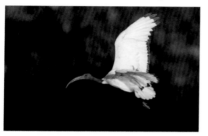

Exposure Program

Aperture Priority

Exposure Bias

- 1 EV

Aperture	Shutter Speed	ISO
f/5.6	1/1600 - 1/2500	800

Select higher ISO if SHUTTER SPEED drops below 1/1600sec. Review image to confirm EXPOSURE on bird. Use EXPOSURE COMPENSATION to make image DARKER or BRIGHTER.

Small and fast bird in flight

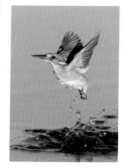

Exposure Program

Aperture Priority

Exposure Bias

0 EV

Aperture

f/4

Shutter Speed	ISO
1/3200	800

Select wideset APERTURE and high ISO for fastest SHUTTER SPEED. QUICK reactions are required. Select higher ISO if SHUTTER SPEED drops below 1/3200 sec.

Bird in flight with motion blur

Exposure Program

Shutter Priority

Exposure Bias

0 EV

Aperture	Shutter Speed	ISO
f/11	1/25	100

Select slow SHUTTER SPEED of 1/25 sec. Slower motion requires slower SHUTTER SPEED. Select faster SHUTTER SPEED when image starts to OVEREXPOSE.

Bird portrait with fill flash

Exposure Program

Aperture Priority

Exposure Bias

- 1/3 EV

Aperture	Shutter Speed	ISO
f/5.6	1/200	400

Do test shots with and without FLASH to see effect. Control brightness of FLASH with FLASH EXPOSURE COMPENSATION; (+) to make BRIGHTER, (-) to make DARKER.

357

Bird portrait with full flash

Exposure Program		Exposure Bias
Manual Mode		-

Aperture	Shutter Speed	ISO
f/5.6	**1/200**	**400**

Review image to confirm EXPOSURE on bird. Background can be DARK. Control brightness with FLASH EXPOSURE COMPENSATION; (+) to make BRIGHTER, (-) to make DARKER.

Bird in flight take-off

Exposure Program
**Aperture
Priority**

Exposure Bias
0 EV

Aperture
f/5.6

Shutter Speed	ISO
1/1600 - 1/2500	**800**

Select wide APERTURE and high ISO for fast SHUTTER SPEED. Select higher ISO if SHUTTER SPEED drops below 1/1600 sec.

Bird portrait backlit

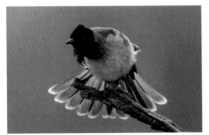

Exposure Program		Exposure Bias
Aperture Priority		**- 2/3 EV**

Aperture	Shutter Speed	ISO
f/5.6	**1/400 - 1/640**	**800**

Review image to confirm EXPOSURE on the rim light. Background can be DARK. Control brightness with EXPOSURE COMPENSATION; (+) to make BRIGHTER, (-) to make DARKER.

Bird portrait backlit with golden dust

Exposure Program		Exposure Bias
Aperture Priority		**- 2/3 EV**

Aperture	Shutter Speed	ISO
f/5.6	**1/400 - 1/640**	**800**

Correct EXPOSURE on BACKGROUND golden light is important. Bird should be DARK. Control brightness with EXPOSURE COMPENSATION. (+) to make BRIGHTER, (-) to make DARKER.

Bird in flight backlit

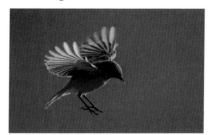

Exposure Program		Exposure Bias
Aperture Priority		- 2/3 EV

Aperture	Shutter Speed	ISO
f/4	1/800 - 1/1250	800

Select higher ISO if SHUTTER SPEED drops below 1/800 sec. Review image to confirm EXPOSURE. Use EXPOSURE COMPENSATION to make image DARKER or BRIGHTER.

Bird close-up detail

Exposure Program		Exposure Bias
Aperture Priority		0 EV

Aperture	Shutter Speed	ISO
f/16	1/200 - 1/320	800

Select narrow APERTURE for deep DEPTH OF FIELD. Select high ISO for adequate SHUTTER SPEED. Use your LONGEST lens or get close with a MACRO lens.

Bird portrait silhouette

Exposure Program		Exposure Bias
Aperture Priority		- 2/3 EV

Aperture	Shutter Speed	ISO
f/8	1/200 - 1/320	800

Correct EXPOSURE on BACKGROUND light is important. Bird can be DARK. Control brightness with EXPOSURE COMPENSATION; (+) to make BRIGHTER, (-) to make DARKER.

Bird portrait with out-of-focus foreground

Exposure Program		Exposure Bias
Aperture Priority		0 EV

Aperture	Shutter Speed	ISO
f/4	1/400 - 1/640	200

Select wideset APERTURE for shallowest DEPTH OF FIELD. CLEAR VIEW of bird is required with OUT OF FOCUS objects in line with bird, close to you.

359

The process of bird photography

The process of bird photography, much like most genres of photography, can be divided into two parts:

- **Collecting photos** – this involves upgrading camera equipment, going on photographic outings, and applying photographic skills to capture a whole lot of images.

- **Post-production** – this involves downloading, organising the photos, processing the images to make them look as beautiful as they could ever be, printing the photos, making books, making slideshows, posting photos on the web, and entering competitions.

This book focuses on how to take great photographs as a first step in the cycle of photography. It is more important to fill your catalogue with great quality images than to spend hours making a mediocre image look pretty. Much like building a solid foundation for a house, to focus on getting good images first is the best foundation for creating something with them later on. It usually takes time to figure out exactly what you want to do with your images and to decide which ones you want to share with the world. In the meantime, focus on getting good shots.

Every RAW photograph requires adjustment in contrast, sharpness and colour. The processing of images in the digital darkroom is very much the same as people did in the film days. "How much editing is allowed?" is probably the most common question I get asked on my photographic safaris. People want to know if they're allowed to clone out a twig from the background, or saturate the colours more than the scene had in reality; or they want to know if they can selectively reduce the noise in the background of the photo with hours of tedious photoshop manipulation. My answer is always: "Each to his own. You can do anything you like, as long as you're honest about what you did."

Some people don't get that many chances to go out and photograph, but might have more time to process an image that is nearly perfect and requires the photographer to carefully remove something from the background, for example. Sometimes you can make one great photo by combining two photos where different parts of the bird have been cut off. What it boils down to, however, is that the audience never wants to feel cheated. Most people don't care what's been done to an image, but naturalists looking at bird images want to know what they look at is believable. If you're not honest about what you did to an image and you get caught out, you will ruin your reputation.

Think about why you are taking photos and what you'd like to do with them. These answers will govern how much time you'll spend on photography, how much money you'll spend on camera gear and photographic trips, how much processing you'll do, and where you'll draw the line on how much image manipulation you'll allow yourself to do.

GLOSSARY

Advanced amateur camera body	A digital single lens reflex camera body with features sophisticated enough to satisfy the requirements of an amateur photographer that consider themselves to have skills more advanced than a beginner photographer.
AF lock (AFL)	A feature on a camera that allows you to press and hold a button that will temporarily disable the lens from focusing, keeping the focus locked at the focal distance of the lens at the time that the button was pressed.
Aperture (F-Stop)	Diaphram inside a lens that can change in size to allow more or less light to enter through the lens. The size of the hole is measured in F-Stops where f/2 means a large hole and f/22 means a small hole.
Aperture priority (Av or A)	A mode in which the photographer chooses the aperture value and ISO while the camera chooses the shutter speed to ensure correct exposure.
Auto-ISO	A selectable feature on most modern DSLR cameras where the camera will choose the ISO automatically to ensure correct exposure. This can be used in aperture priority and shutter priority, and on some cameras in manual mode.
Autofocus	The ability of the lens to focus automatically based on electronic signals from the camera body.
Background	The area in the frame behind the object that is being photographed. The background is the backdrop to the subject.
Blur	The boundaries between zones of different tones or colours where the boundaries are gradual and not crisp steps.
Blurred images	Images that lack sharpness because of movement.

Bokeh	The aesthetic quality of the blur produced in the out-of-focus parts of an image produced by a lens.
Buffer memory	The digital storage space available for images to be stored in a camera's internal memory before they are transferred to a memory card.
Bulb mode	A mode in which the photographer chooses the aperture value and ISO and where the shutter speed is controlled by how long the shutter button is held in. This mode is usually used for photographs where the shutter speed exceeds 30 seconds.
Burst rate	The rate at which photos are taken continuously when using the multiple frame mode. It is measured in frames per second.
Compact flash (CF) memory card	A small card that is inserted into a camera body to store ditigal images. It is physically larger than an SD card.
Composition	The arrangement of objects in your frame.
Crop factor	The factor to which a camera's digital sensor is smaller than the conventional 35mm sensor size. The different sizes are full frame, 1.3x, 1.5x and 1.6x crop factors.
Depth of field	The distance between the nearest and furtherest objects in a scene that appear sharp in the image.
Digital zoom	Artifical increase in focal length, making an object appear larger in the viewfinder by adding detail based on an algorythm.
Diopter	The adjustment wheel at the back of the camera to adjust the focus of the viewfinder.
DPI (Dots Per Inch)	A measure of resolution for printing purposes.
Drive mode	A mode that can be selected to either make the camera take one photo at a time when the shutter button is fully depressed, or make the camera take a sequence of photos in rapid succession for the duration that the shutter button is depressed.
DX	A name used by Nikon to indicate a sensor size 1.5 times smaller than a full-frame sensor. It measures 24mm wide as opposed to the 35mm width of a full-frame sensor.
EF (Electro Focus) lens	Canon lenses designed for full-frame cameras. Crop factor camera bodies can use EF lenses.

EF-S	Canon lenses designed for crop factor cameras. EF-S lenses can only be used on crop factor camera bodies.
Entry-level camera body	A digital single lens reflex camera body with features simple enough for easy use by a beginner photographer.
EXIF (Exchangeable Image File Format)	A standard that specifies the formats for image tags used by digital cameras.
Exposure	The amount of light per unit area that reaches a digital sensor.
Exposure compensation	A technique for adjusting the exposure indicated by a photographic exposure meter, to make an image birghter or darker.
Fisheye lens	An ultra-wide-angle lens that produces strong visual distortion intended to create a wide panoramic or hemispherical image.
Fixed focal length lens (prime lens)	A photographic lens where the focal length is fixed; also refered to as a prime lens.
Flare (lens flare)	The light scattered in lens systems through generally unwanted image formation mechanisms, such as internal reflection caused by direct light on the front element of the lens.
Flash exposure compensation	A technique for adjusting the power of a flash to create a darker or brighter light.
Flash syncronisation speed	The maximum shutter speed in the camera that allows the sensor to capture the full power of the flash.
Focal distance (plane)	The distance from the lens to the actual area where focus is achieved. This is measured in metres and indicated at the top of the lens.
Focal length	The length of the lens, measured from the digital sensor plane to the optical centre of the lens when it is focused to infinity. It is measured in millimetres and is an indication of the relative size of the lens, from super telephoto lenses to super-wide-angle lenses.

Focus (in focus)	The property of an image where the elements inside the lens shifted in such way that light from an object converged as much as was possible.This creates a well-defined object in the image.
Focus and recompose	A technique where the photographer focuses to an object and then locks the focus. The frame is then recomposed without any adjustment of focus when the photo is taken.
Focus drive	The mode in which the camera is set up in order to focus. It will either focus when the shutter button is half pressed or will continuously focus on the area in the frame controlled by the focus point.
Focus point	The highlighted icon inside the viewfinder that is moveable and controlled by the photographer. This icon indicates which object inside the frame the camera will focus on.
FP	The setting on a Nikon external flash where the flash will not control the shutter speed to be within the flash syncronisation speed. The flash will fire regardless of the shutter speed.
Full frame	An image sensor that is the same size as a 35mm film frame.
FX	A name used by Nikon to indicate a full-frame digital sensor with a width of 35mm.
High key	An image that primarily consists of light tones without dark shadows.
High-speed sync	The setting on a Canon external flash so that the flash will not limit the shutter speed to be within the flash syncronisation speed – usually 1/200 sec. The flash will fire regardless of the shutter speed.
Histogram	A graphical representation of the distribution of tones in an image.
Hue	The variation of a pure colour, for example, light blue, pastel blue or vivid blue.
Image stabiliser (IS)	Canon's term for a mechanism inside a lens that reduces judder that is associated with the movement of the lens.

ISO (International Standards Organisation)	The sensitivity level to light of an image sensor that can be set.
JPEG (Joint Photographic Experts Group) files	The way in which a camera records an image as a digital processed image as opposed to unprocessed data.
Landscape (landscape format)	A frame where the proportions are such that the width is greater than the height.
Low key	An image that primarily consists of dark tones without bright highlights.
Manual mode	A mode in which the photographer chooses the aperture value, shutter speed and ISO in order to make an exposure.
Megapixel	A measurement of the amount of pixels located on a digtial sensor; 10 000 pixels is 10 megapixels.
Memory card	A small card that is inserted into a camera body to store ditigal images.
Metering	The way in which a camera reads the amount of light in a scene by using its built-in light meter.
Midtone	Brightness levels that are not dark and not bright, but somewhere in the middle of the two.
Mirror	The device inside a digital single lens reflex camera that reflects light from the lens to the viewfinder.
Motion blur	An image that is blurred, not because of the movement of the lens, but because of the movement of the subject when using slow shutter speeds.
Noise (image noise)	Random variations of bright and colourful artifacts in an image.
Overexposure	The act of making an image appear brighter than normal.
Out of focus	The property of an image where light from an object is not well converged. The object is not clear in the image.
Normal lens	A lens with an average focal length that makes the subject appear normal in size in the viewfinder.

Panning	The technique used to move the lens sideways to follow a moving subject through the viewfinder.
Pixel	The smallest element that captures the intensity of light as part of an array across a digital sensor.
Portrait (portrait format)	A frame where the proportions are such that the height is greater than the width.
Prime lens	A photographic lens where the focal length is fixed.
Professional camera body	A digital single lens reflex camera body with features sophisticated enough for the requirements of a professional photographer.
Program mode	A mode in which the camera controls the aperture, shutter speed and ISO. All other functions are available for the photographer to set.
RAW files	The way in which a camera records an image as unprocessed data as opposes to a processed image.
Resolution	The amount of detail that is captured in an image, measured by the amount of pixels on the sensor.
Rule of thirds	A composition guideline where you draw two imaginary lines across a photo, both horizontally and vertically, and then place something of interest over one of the intersecting points.
Saturation	The intensity of colour in an image.
SD (Secure Digital) memory card	A small card that is inserted into a camera body to store ditigal images. It is physically smaller than a CF card.
Sensor	A device that converts an optical image into an electronic signal.
Sharpness	The boundaries between zones of different tones or colours where the boundaries are crisp steps and not gradual.
Shutter	A device that allows light to pass for a determined period of time, exposing a light-sensitive electronic sensor to light in order to capture a permanent image of a scene.
Shutter button	The button located at the top of the camera used for focusing and releasing the shutter. This is the button you press to take the photo.

Shutter priority (Tv or S)	A mode in which the photographer chooses the shutter speed and ISO, while the camera chooses the aperture value to ensure correct exposure.
Shutter speed	The duration that the shutter stays open to allow light to create an exposure on the camera sensor.
Silhouette	The dark shape of an object outlined against a bright background.
Slow-motion panning	A technique where you move the lens to keep a moving animal in the frame, while using a slow shutter speed to create a blurred effect.
SLR or DSLR (Digital Single Lens Reflex) camera	A camera that uses interchangeable lenses with a mirror and prism that allows the photographer to see through the lens.
Soft image	An image that is not sharp with defined borders caused by camera or subject movement.
Stop (stop of light)	A measure to indicate the doubling or halving of the amount of light, controlled by either the aperture, shutter speed or ISO.
Super telephoto lens	A lens with a long focal length that makes a subject that is far away appear large in the viewfinder. It is longer than a telephoto lens.
Tele-converter / tele-extender / lens-extender	A secondary lens that can be mounted between the camera and the lens to enlarge the central part of the image.
Telephoto lens	A lens with a long focal length that makes a subject that is far away appear large in the viewfinder.
Temperature (colour temperature)	A characteristic of light where an image feels cool with bluish whites or warm with yellowish whites. Colour temperature is measured in kelvin.
Tint	A shade or variety of a colour. In Lightroom it refers to the purple or green colour of an image.
Tones	The brightness level of an area inside a photograph.

Tonal range	The region where most of the tones are present in a photograph.
TTL or ETTL (Electronic Through The Lens)	A feature where the camera can adjust the brightness of the flash according to the amount of light it can meter in a scene.
Twilight	The illumination of the earth's atmosphere in beautiful dark blue or purple when the sun itself is not directly visible because it is below the horizon.
Super-wide-angle lens	A lens with a short focal length that makes a subject appear small in the viewfinder in a wide view. It is wider than a regular wide-angle lens.
Underexposure	The act of making an image appear darker than normal.
USM (Ultrasonic Motor)	An electric motor powered by ultrasonic vibrations used to move lens elements as part of the auto-focus system inside a lens.
Vibration reduction (VR)	Nikon's term for a mechanism inside a lens that reduces judder associated with the movement of the lens.
Viewfinder	The opening located at the back of the camera that a photographer looks through to see and compose the photograph.
Warm	A characteristic of light where an image feels warm with yellowish whites.
White balance	The general mix of colours in an image to render the neutral colours correctly. This can be set in the camera or adjusted afterwards. In Lightroom it refers to the combination of colour temperature and tint.
Wide-angle lens	A lens with a short focal length that makes a subject appear small in the viewfinder in a wide view.
Zoom lens	A lens that can change focal length by twisting the zoom ring on the barrel of the lens.

ABOUT THE AUTHOR

Isak Pretorius was born to be a photographer, but before he discovered this, he became an engineer. Once he picked up a camera, his engineering career came to an end, and Isak has now established himself as one of the top bird photographers in Africa. The benefit of his engineering training is his flawless technical knowledge of camera systems and the post-processing software that accompanies them. He combines these skills to focus on birds-in-flight photography, where he has excelled to the point of receiving an unprecedented eight awards in the FujiFilm-Getaway Photo Competition in just one year. His highest accolade came in 2013 when he was winner of the BBC Wildlife Photographer of the Year in the Bird Behaviour category.

Today, Isak is a sought-after specialist wildlife photographic guide and full-time professional wildlife photographer. His passion for nature is fuelled by the reminiscence of a classic Africa and his aim is to create conservation awareness for his continent's natural wonders. His discovery of nature's special moments at a young age shaped his aspirations of today: to showcase the beauty of his continent's pristine wonders in a creative way. He believes that this is the best way to protect Africa's natural heritage.

"We protect what we care about, so my objective is to get enough people to care about African wildlife by showing them how beautiful nature is."

What sets Isak apart as a specialist wildlife photographic guide is his ability to get clients to take their own top photographs. If you want to improve your bird photography, Isak will guide you from approaching your subject all the way through to managing your files and editing them to produce the highest quality image possible. His simple and structured approach when tutoring clients enables immediate understanding of techniques and concepts.

www.theafricanphotographer.com